D1361172

NYC PET PROJECT

A COLLECTION OF PORTRAITS AND LETTERS FROM THE HEART

NYC
PET PROJECT

A COLLECTION OF PORTRAITS AND LETTERS FROM THE HEART

MICHAEL J. LA RUE
EDWARD J. KACZMAREK, III

PHOTOGRAPHS BY JASON LINDBERG AND RON MONK

GOOD BOOKS
PUBLISHING, INC.

NYC Pet Project
Copyright © 2002, Good Books Publishing, Inc.
Published in the United States 2002 by
Good Books Publishing, Inc.
560 West 43rd Street
Suite 7-J
New York, New York 10036
(917) 521-0820
www.GoodBooksPub.com

FIRST EDITION

Library of Congress

Cataloging information available at www.GoodBooksPub.com

ISBN 0–9724259–0–X

Cover and book design by *The Book Design Group*
Copyedited by Catherine Petrovic
Photographs of authors by Jason Lindberg
Photographs of photographers by Michael J. La Rue

Note about the letters:
Letters are printed exactly as written by the subjects. The editors believe the original
letters are so powerful and revealing that to edit them, clean them up, or censor them,
would be to do the book a disservice.

Printed and assembled in China

To my lost loves: Diva, Buddha, and Java—MJL

To Joe and Winston (aka "Nu Nu" and "Zippy")
Thanks for your friendship and teaching me the joy of playing "Daddies and Babies." I love you and miss you!
Ed xox

In memory of the pets within these pages who are no longer with us:
Boudreaux ("Boo") — "He's a good boy!"
Diesel — "Everyone loved him."
Zadoveme and Mashu

ACKNOWLEDGEMENTS

(In no particular order, except God, He's always first)

God – for giving us a second chance; Ed and Louise Kaczmarek, for surrounding me with love, always being there for me, and for providing us a sanctuary in Mt. Carmel to edit the book; Willa Porter, for always believing in me; Maria and Cameron Michalski, for your counsel and love; Mam and Pap Hutnick, for just being there; Jim and Tressa Hutnick; Carol and Dick La Rue, for believing in me and not telling me to get a job, for the credit card, and for paying the bill; Kathy La Rue, for the cash and constant support; Ken and Carrie La Rue, for the cash at a crucial time; Karen La Rue-Tellez, for wanting to give me cash; Mason La Rue Kamp and Emily La Rue Tellez, for shining in my heart; Harmony, Beth, and Brian Hansen, for keeping pieces of Sharon in my life; Lexi La Rue, for unconditional love; Yellow bird; Rosie; Rainier; Shawn Perine; Cinnamon Stix of Mt. Carmel, PA, for keeping us in caffeine and carbs while editing; Matt Ratto and The Book Design Group, for educating us and holding our hands the entire way; Al Silverstein, for being the impetus that started the ball rolling.

Mike Berry, for your friendship, advice, trust and faith in us and The NYC Pet Project; Jeff, Fred, Darbin and the rest of the staff at FotoCare, for believing in our dream and making it possible; Karen Dixon and Tara at One Source Printing, for magnificent service and quick turnaround; Terry Sims; Maureen Moore, for hooking us up at Broadway Barks; Malaika Vereen; The Market Diner, for feeding us almost on a daily basis; The staff at Riverbank West; Lexington Labs; Laurent Girard, for developing our dreams into a reality; Jason Lindberg and Ron Monk, we had our ups and downs, but the final product is a shining example of true teamwork; MTA; Marc Babej; NYC taxi cabs and drivers who assisted in lifting equipment; Scott and Bear Shields; Sue Kuester and Chrissy Gordon, for your friendship and excitement about this project; Dennis Adamson, for your friendship and support during one of the most difficult times of my life; Starbucks and The Coffee Pot, for being our conference rooms and caffeine suppliers; Carol and Melissa, for "Lucy;" Boneau/Bryan-Brown.

Mr. Softee, for those emotionally challenging days; Rainbow Room; Friends of the program; Ken Dingledine; Scooter, Daemon, Mike and Jason; Daryl Roth and Greg Raby, for opening doors; Bill Guerri, for listening, giving advice, and helping me grow; DSY, for the laughter and for always being my bestest GF; David Woodward; Cameron Dubes; Rue, for being the first celebrity to come onboard with the NYC Pet Project; Julia Snider; Morrow Wilson; Ilsa Jule; David Breeden and Cara Oates, Planet Hollywood, NYC; Chris Williams; Biscuits and Bath; Broadway Barks; Justin Wakefield at Colorprint, Nora Quinn; Rubinstein Public Relations; Courtney and Dominic at Gotham PR; Ed Kaczmarek, for giving it his all, supporting me when I melt down, and being my best friend; Michael J. La Rue, for sharing a dream, pushing for perfection, doing the next right thing, and being the best friend anyone could ask for; Ms. Buckley's assistant, Cathy; Vincent Spinola, B.A.R.C.; Marilyn Teres, Pet-I-Care; Marcello Forte, Animal Haven; Doreen and Paul Eiseman, Loving Touch; Chief Roy Gross, Suffolk County SPCA; Holly Staver, City Critters; Richard Ball, Barbara Fox and Teri Frisch, Stray from the Heart; Laurie Perla, SICAW; Grace Lerner and Tony Raimondo, A Cause for Paws; Judy Katz, Devyn Velardi, and Chris Economakos, Broadway Barks; Staff at Morton's of Chicago, for patiently listening to every step in the process; Koroni Realty, for not complaining about the late rent; And most of all – all the subjects and their pets that patiently posed for portraits and lovingly wrote their letters.

INTRODUCTION

The NYC Pet Project has always been a labor of love. We wanted to offer readers around the country an extraordinary glimpse into the lives of New Yorkers, from all walks of life, and their pets and to raise money for New York City animal charities.

Little did we know that our book was also destined to become a record of everyday life in New York during an extraordinary time. On 9/11, New York City was shaken to the core. But in the year that followed, the New York City pets in this book—and hundreds of thousands just like them all over the city—helped people cope and move on with their lives. For the most part, they did this, not through feats of heroism, but simply by *being there*—as anchors of normalcy in a time of crisis.

We had just started production when 9/11 happened. For weeks after the attacks we couldn't get ourselves to pick up the reins and continue. A pet book seemed trivial compared to what was happening downtown and in the rest of the World. But the more perspective we gained, the more we realized this project was not trivial at all. By coincidence rather than design, this was no longer a pet book, but a first-hand account of the bond between New Yorkers and their pets during an historically significant period.

The people of this supposedly abrasive city were more willing than ever to pose with their pets and write to them about their feelings. That was when we realized that this is a book about love, and what could be more important than love?

We feel honored to bring you these portraits and letters—enjoy!

Edward J. Kaczmarek, III Michael J. La Rue

Good Books Publishing, Inc.

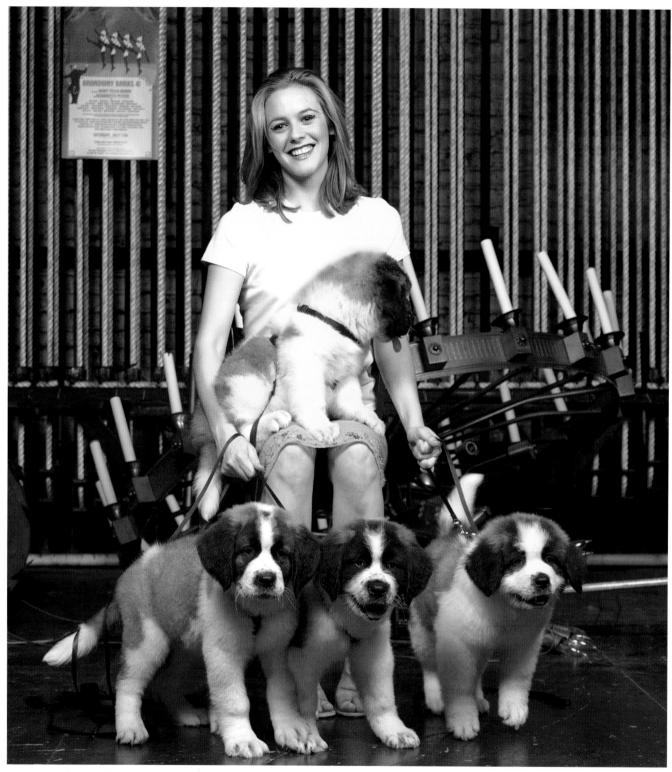

Actress Alicia Silverstone, with Lulu, Horatio, Hudson and Barnaby, St. Bernard puppies up for adoption at The Humane Society of New York.

Another day begins and another time of determination and conviction that our work and the work of all other rescue groups will continue and succeed in ever finding more welcoming homes for our beloved animal friends.

Our past has brought together many joyous and rewarding adoptions for both families and pets. This, above all else, seems to signify the purpose of our very important endeavor; that we not only fulfill the needs of the animals, but that we bring an answer as well to our own longing for meaningful relationships. You have only to look at the smiles and brightened spirits of any of our new owners to realize that our wish to bring love to all involved has come true.

Perhaps you too would like to fill an empty place in your heart and home, then please join with us at Pet-I-Care in the great discovery of the perfect answer, this unconditional love of an animal.

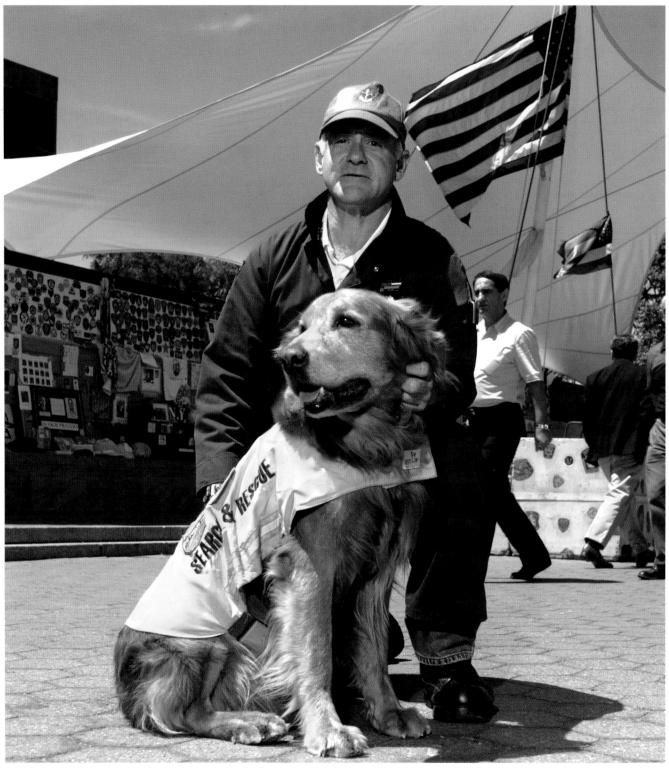

Scott and Bear, a search and rescue dog, in front of a memorial near Ground Zero in Lower Manhattan.

"There were many heroes on September 11, 2001. One such hero was Bear, an eleven year old golden retriever. Bear is credited with being the first search and rescue dog inside the devastated area at Ground Zero. He is acknowledged as having found the most victims, including the body of Peter Ganci, Chief of the New York City Fire Department.

A day after the World Trade Center attack, a golden retriever was seen carrying his handler's helmet in his mouth. This brought smiles to even the grimmest of faces. The dog was Bear.

Captain Scott Shields and Bear worked around the clock at Ground Zero that first week. Bear was trained as a rescue dog after jumping from a boat to save a child ten years earlier."

Rochelle Lesser, www.landofpuregold.com
"Worlds Largest Golden Retriever Site"

"To Whom it May Concern:

The following is an account of my activities during the week of September 11, 2001 with respect to my friend, Captain Scott Shields and his search and rescue dog Bear. From the first hours after the tragedy through the week that followed, Scott, Bear, and I worked to find bodies in the pile. As a steel worker, I was cutting steel and helping the firemen extract bodies after they were found.

I had met Scott the previous year while volunteering with the retired fireboat John J. Harvey at Pier 63 in New York City. Scott had the role of marine safety coordinator on the pier, and made significant contributions for ensuring safety there. He is the kind of fellow you want to have around in case of an emergency. He is able to anticipate problems and risks, and has a gentle, respectful personality that helps people in trouble. Whenever I needed to find Scott at the trade center site, all I needed to do was describe him as the fellow with the search and rescue dog, and I was able to locate him quickly.

Bear shares the same characteristics as Scott. Just observing him on the pile and comparing him to some of the other rescue dogs, he was clearly in his element. He was at peace, agile, and didn't slow down until it was time to rest. Other dogs I noticed behaved erratically, emotionally, and were apparently overwhelmed with the amount of possible bodies so they were less effective. Watching Scott and Bear interact told me something about their relationship and personalities.

Scott, Bear, and I interacted frequently during the course of the week. We were friends before meeting on the pile, and we were excited to see people we recognized from different times. Scott and Bear were clearly working hard, putting in extraordinary hours, and focused on saving lives. At some point in the chaos, the three of us were taking a break on the waterfront. I couldn't imagine how poorly Bear must have been doing since all of us had dust masks on, but he had his nose right down in the thick of it the whole week. I tried to support them both as the time progressed, getting water for Bear, checking on Scott's well-being, and trying to be generally supportive. They were a tremendous asset to the rescue effort."

Andrew Furber (sculptor, poet, steel worker, volunteer rescue worker)

Bear,
 You looked like a little bear as I delivered you into this world. I've had two loves in my life – your mother, Honey and you. Your Mother passed away two months before 9/11 and I really miss her, as I'm sure you do, too. Thankfully, we have each other. Thanks for being strong and gentle. You're very special and mean the world to me. We leave her behind, but we'll always take her with us. I'm so proud - you're both the Best of the Best.
 Love, Scott

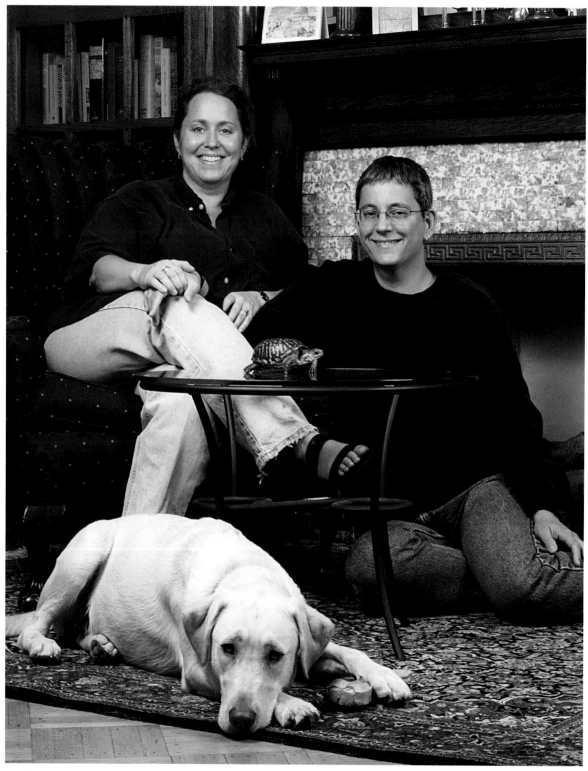

Carol (in chair), with Melissa next to her; spending time with Stretch, a decorated box turtle, and Tess, a yellow Labrador retriever, in their townhouse in the Park Slope neighborhood of Brooklyn, NY.

Tess and Stretch:

Imagine our surprise that two creatures could bring such joy, excitement and fun into our lives....

Stretch, who would ever have thought that we could warm up to a "hard child" like you. But we did. We love to watch you zip around the backyard throughout the hot, summer days or to troll the perimeter of the yard and house on the appointed rounds of your guard duty. In fact, the neighbors love to watch you, too. We shudder as you eat bugs and slugs; dancing around with them hanging from your mouth. You're not a vegetarian after all!!! We laugh as you tear into a nectarine with vim and vigor; sticking your neck out in unimaginable proportion to your body. Then we watch you scramble into the house to sleep for months and months, awaiting the spring and driving your nice Jewish mom crazy for not being able to feed you. How old are you? Quite certainly, you'll outlive us all.

Tess, you came into our lives as a tiny puppy and instantly captured our hearts. The sparkle in your eyes and your gusto for life have taught us both to remember the joy and laughter life brings and how simple it can be if you let it - play time is critical! You are always "on"; always happy and always willing to share your love, toys, delicious affection and sticks with us. Even when you sleep, you do it with gusto - on your back, legs apart, snoring like mad, or paws flailing as you run and play with your friends in your dreams, or make facial contortions as you imagine you are chewing on something delightful. You have introduced us to our neighbors, our block, a whole community. You guarantee us fresh air and sunshine every day. You were the missing piece.

So here we are, assembled as the modern American family. We wouldn't have it any other way!

We love you, Melissa & Carol

7

Bernadette and her rescued pit bull, Stella.

Dearest, Darling Stella,

You have enriched my life 10 fold! When I'm away from you there is a big void that I feel, making me realize how healing loving pets are! Thank you for that!

Your kindness to little dogs when you crawl up to them to kiss them is another part of your personality that is a wonder!

I know you were abused when you were little - but the choice you have made to be kind and loving makes me very proud.

Thank you for all the love you give every me!

OXOX

Bernadette

9

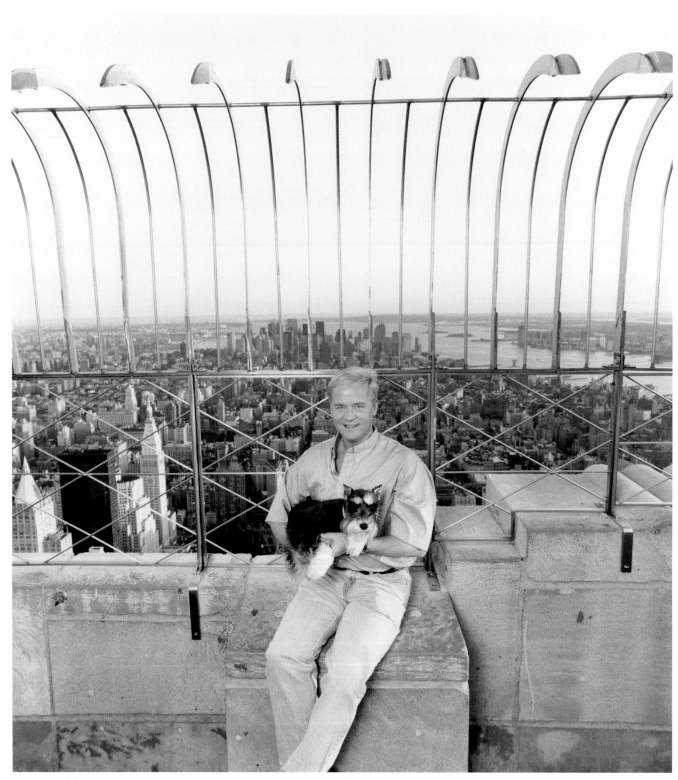

Chris and his miniature schnauzer, Suejohn, on the top of The Empire State Building (Lower Manhattan view).

Dear Suejohn—

Just writing your name brings a big smile to my face, as you were named after my 2 best friends — mom and dad — Johnny and Sue.

You came into my life suddenly, as while I was on a six month stay in Florida, my beloved schauzer of ten years became sick. The vet said that the addition of a puppy to the household might help keep Oscar "young," and prolong his life. In just 2 short months after you arrived, "Oskie" had a terrible seizure and I was asked if I loved him enough to let him go — to make what was perhaps the most difficult decision of my life. I did, and I was heartbroken.

However, you immediately came to the rescue. The day Oscar went to heaven, I arrived home to find you had suddenly "grown up." Your "puppy" mentality had vanished, and you were nuturing and loving in a way I had never encountered. That night, you slept on the bed for the first time, knowing you would never take Oskie's place, but you would make a place of your own, with your unconditional love.

You had been immediately accepted into our family. I mean, why wouldn't you be since you were named after mom and dad. They love you as much as I do. And together, we are grateful for them, Bill and Sandy. Aunt Doris and Aunt Jo.

I always tell people my relationship with you is the best relationship one could ever hope for in a lifetime. You listen, never judge, are always in a good mood, and never complain. You are quick to forgive and forget, and know that you just move on in life and enjoy the day at hand. Having you, I wonder why there would ever be people in the world who are cruel to animals? Like an innocent child, you are a blessing and a special gift from God.

Our photo shoot was on top of the Empire State Building because as I was a child in Tennessee growing up, I always dreamed of visiting there. And today, it is also home to my office. You and I must thank Lydia Ruth and Olivia Veth for allowing us to take you there for this opportunity. We also thank Janet, Meredith, Chris H. and Forrest for helping you to immediatly feel at home in the big city. And we thank Michael C. for teaching you that strangers can quickly become wonderful friends.

Thank Suejohn — for all you are to me — and for just being you!

Love,
Chris Williams
your dad

11

Megumi, Vincent and Tiger ("Tig"), a stray found on the steps of their apartment building in Manhattan's Harlem section.

TIGER YOU BRING REAL JOY INTO MY LIFE
I FOUND YOU AS A LITTLE KITTEN ON MY STOOP
AND I KNEW I WOULD ENJOY YOU IN MY HOME.
 I LOVE PLAYING WITH YOU, AND WATCHING YOU
PLAY WITH YOUR TOYS.
I LOVE CARRYING YOU ON MY SHOULDER AS I WALK
FROM ROOM TO ROOM.

SOMETIMES YOU JUMP ON MY STOMACH AS I LIE DOWN,
YOU LAY THERE SO QUIET AND PEACEFUL, IT MAKES ME
FEEL QUIET AND PEACEFUL.
THE VET SAID YOU ARE "REGAL". I KNOW SHE IS RIGHT.
TIG YOU ARE TRULY ADORED AND LOVED.

LOVE ☺
MEGUMI & VINCENT

13

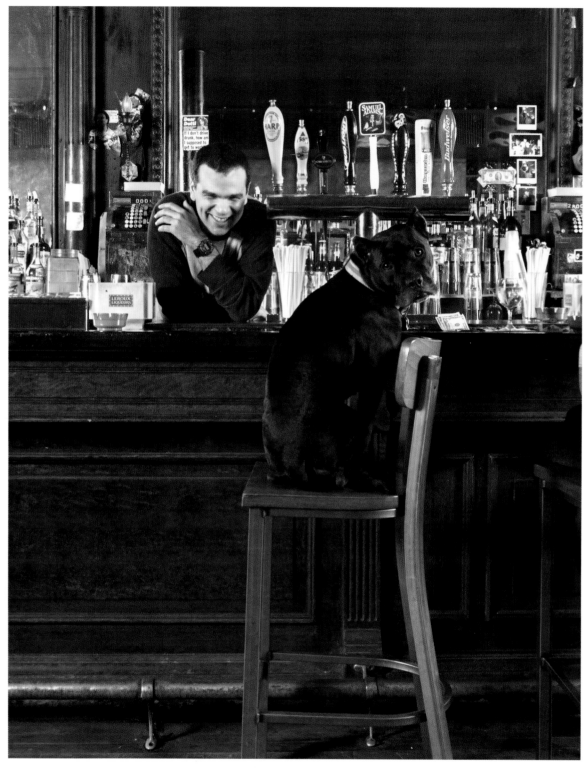

James and his pit bull, Nikko, at work in NYC's East Village.

Nikko —

If you could READ,
I'd HAVE ALREADY
WRITTEN you
A million LOVE LETTERS.

XO

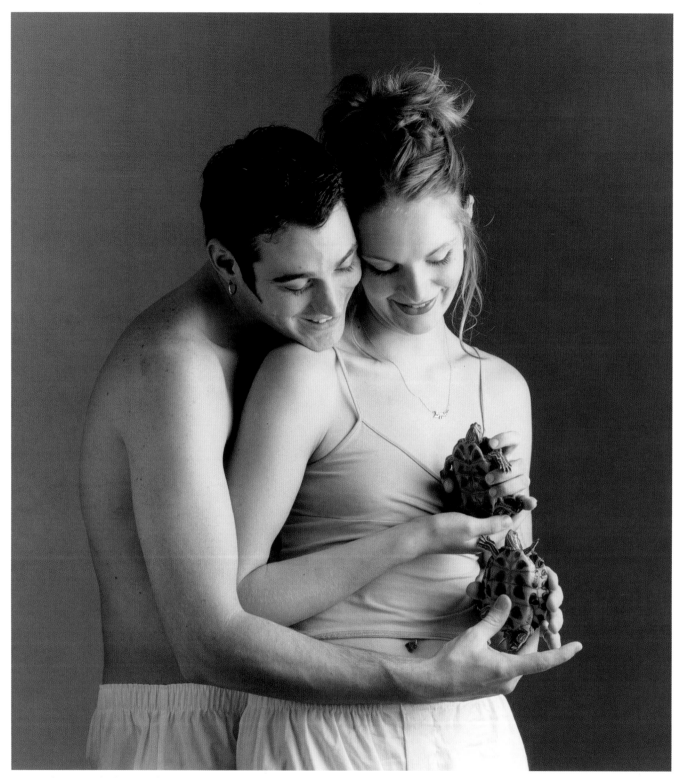

Liz and Joe with their red-eared slider turtles, Bob and Jay.

Dear Jay & Bob —

When Mota the water dragon died we were so lonely. Then one hot day in a cloud of NY smoke you appeared in a big bowl in Chinatown. You were the size of a ½ dollar & I wanted to get 4... Joe thought 2... my brother, O... "They'll die too," he said. But here you are, a year later getting bigger every day. We love it when you dance for shrimp treats, & spaz out in your cage when we come home. We hope you don't get hurt when you bounce into the glass like that. We are so glad you are a part of our little family. XOXOXOXO

Love, Liz & Joe

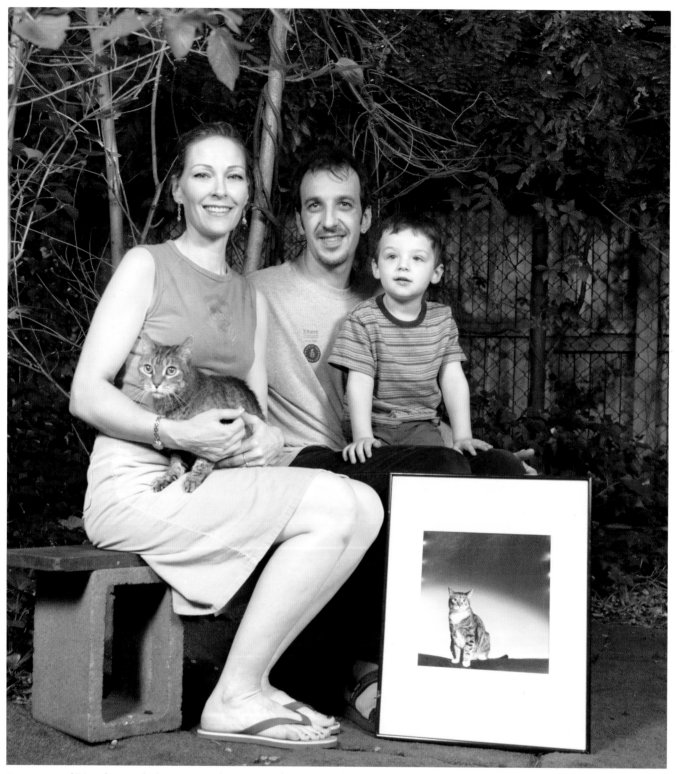

Laurent and Heather with their son, Clayton, and 15 year-old cat, Hortense; with a portrait of the recently deceased Scruffilina.

Dear Hortense,

You've been with me since I moved to New York 15 years ago, you and Scruffalina, so little when I found you, barely 4 weeks old. Look at you now! All grown up, lived all around the city, even the west coast for a while. And always you adapted to your new environment. Always there, loving and cute as can be. You and your departed sister sat on my lap through the best of times, you've sat on my lap through the worst of times.

I know Clayton's arrival wasn't easy, but if it makes you feel any better, I used to call him Kitten instead of Clayton, and not on purpose, I had been calling you that for years before. And thank you for letting Heather adopt you over 10 years ago, if Scruffalina was still here I'd thank her too. You loved Heather so much when you first saw her, it made me want to marry her.

I miss Scruffalina too, Laurent

Hortense:

When I adopted you & your sister, Scruffalina, in 1991, your names — "Thisne" for you & "Lulu" for Scruffalina — just seemed too-too for me. From the moment we met you were such a sweet-tempered, beautiful & loving little cat, I thought you deserved a sweet, old-fashioned name to match. And Scruffalina, she had the bold yet loveable personality, white bib & boots (+ lack of smarts) that reminded me of my cat from when I was in school, "Scruffy." So, her name was an homage. I love you.

 - Kiss Hiss Kiss, Love,
 Little Kittens! - Heather

19

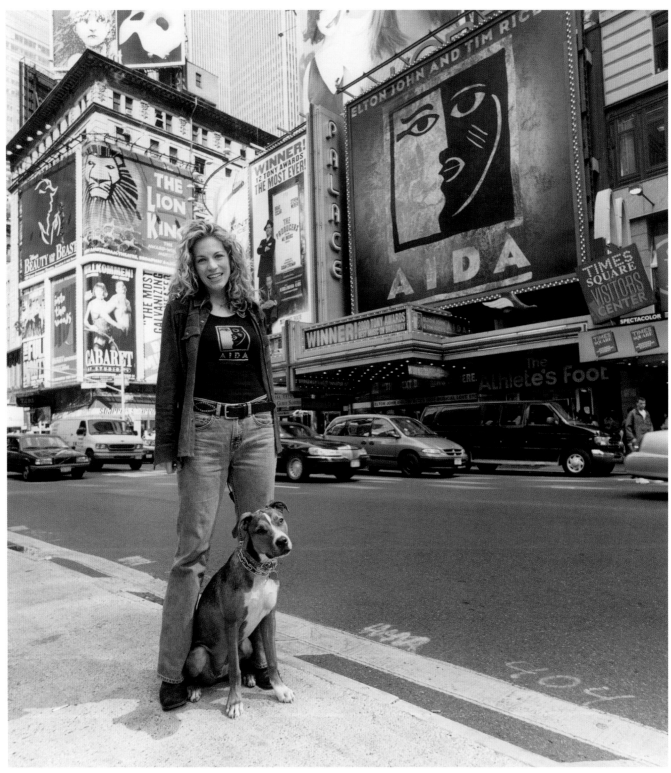

Felicia with her rescued pit bull and boxer mix, Sascha, in Times Square.

To My Little One,

I truly feel like you were sitting in that cage waiting on me to FINALLY take you home. It was never a question of should I take you home, but rather, "What took you so long, Mama?!" That little doe-eyed face sitting there patiently through the squares, starring at me with a look of "Thank GOD!" You've always had a flare for the dramatic -like mother like daughter!

It's only been 5 months now, but you've made my life so happy. I thought there's no way I could do 8 shows a week, hoofing it out there on Broadway, and take care of you. Well, you've proved me wrong. You were a Broadway Baby from day one! When I get to the theatre now people don't say "Hi, Felicia!" NOPE. It's "Hey, where's Sascha?" Between being the Belle at the dog run to showing your "woo-woo" to anyone who would care to look at it, I'm following your act now, KID! I love you more than I thought possible and thank you for making me realize what's truly important. I look at you now asleep (all 60 lbs now!) and thank GOD for the love I feel for my little one.

Felicia Finley and Sascha

21

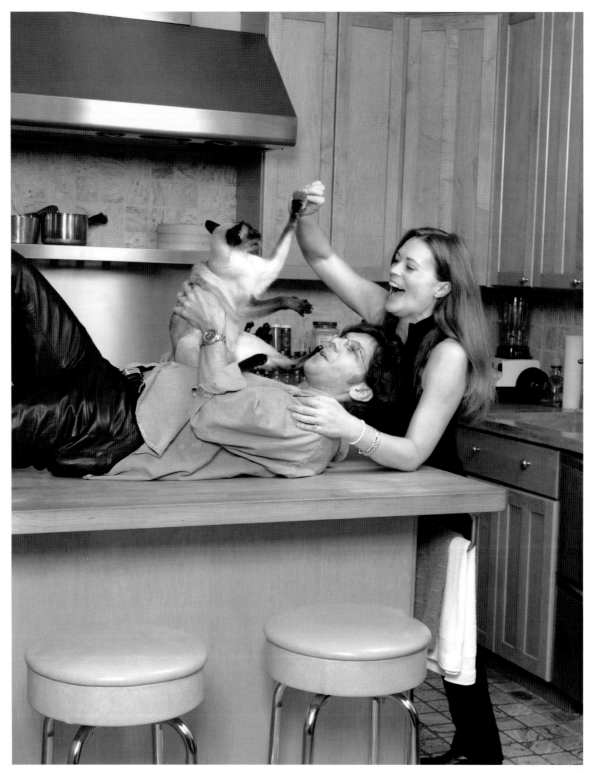

Kathy, Bob and Zoltan ("Zoli") their wedge-head Siamese.

Dear littlest head,

kisses!

xoxo,
Bob & Kathy

23

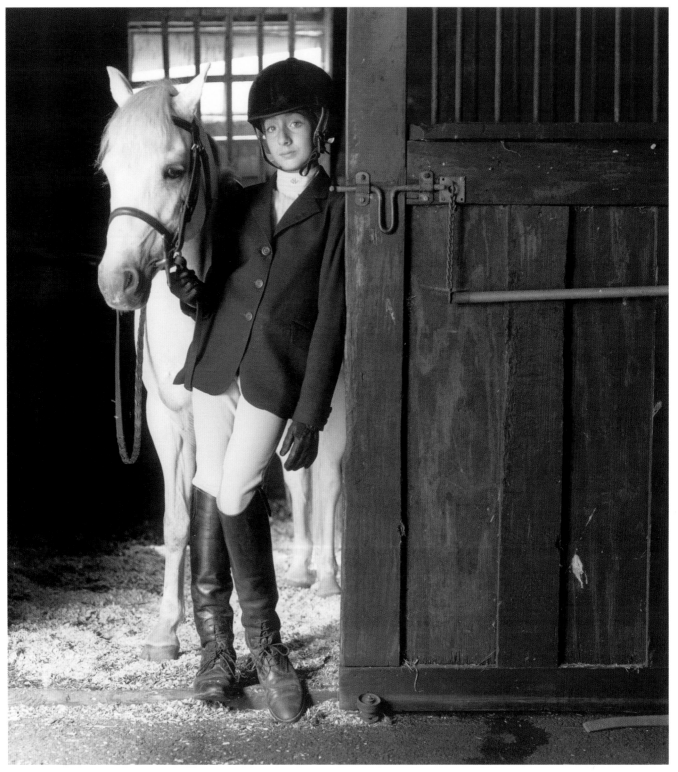

Chelsea and her cross-bred pony, Tippy Toes ("T.T."), at Mar-bel Stables.

Dearest TT,

You came into my life for A Reason. It must have been fate meeting you. You came to me so I could work you into shape. You were a gift for my 12th Birthday. Don't tell anyone, but you were my favorite gift. Instead of me working you into shape we worked each other into shape. You have changed the way I Ride for the better. I am so proud to have a Best friend like you. I love you and hope to be buddies forever.

Hugs and kisses
Chelsea

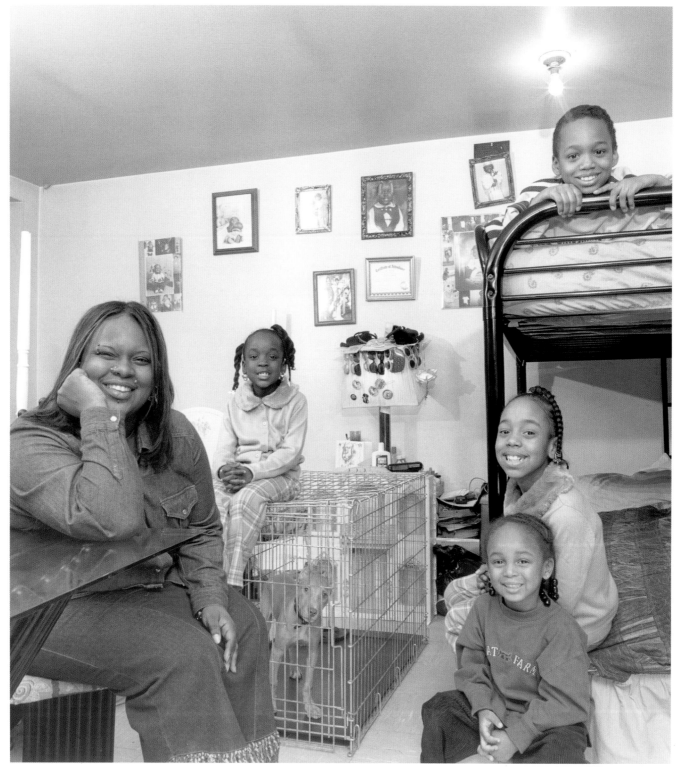

Michelle ("Jingles") with her pit bull puppy, Miz Thang, and her children; Aleyah (sitting on dog's cage), Marquise ("Nu-nu"), and her niece Raquel, and nephew, Roger (top bunk).

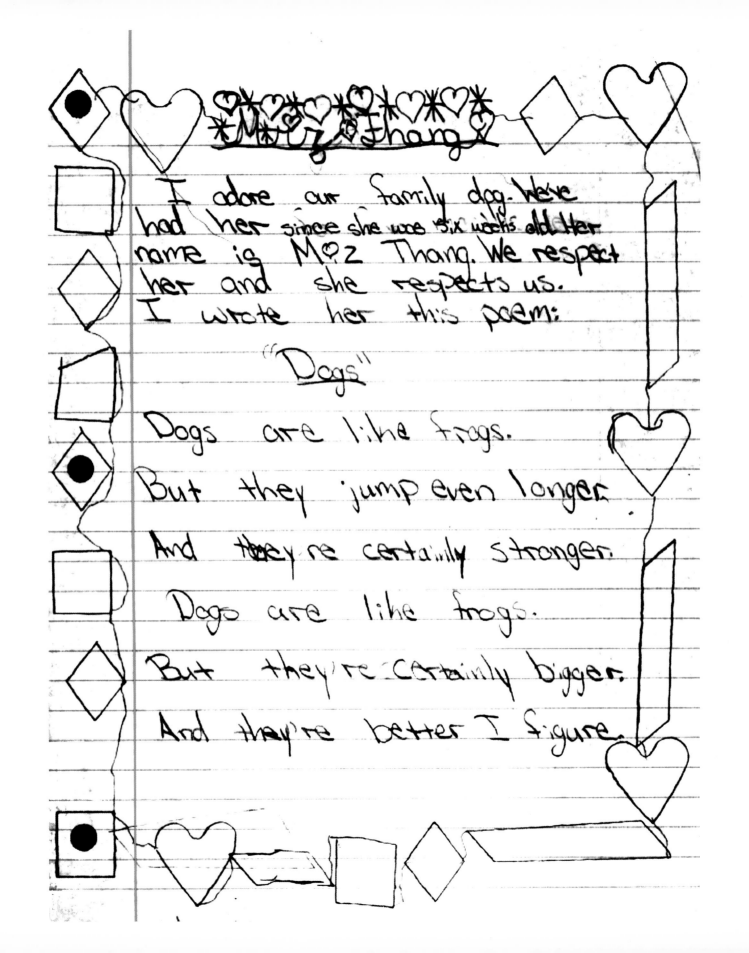

Muay Thang

I adore our family dog. We've had her since she was six weeks old. Her name is Muay Thang. We respect her and she respects us. I wrote her this poem:

"Dogs"

Dogs are like frogs.

But they jump even longer.

And they're certainly stronger.

Dogs are like frogs.

But they're certainly bigger.

And they're better I figure.

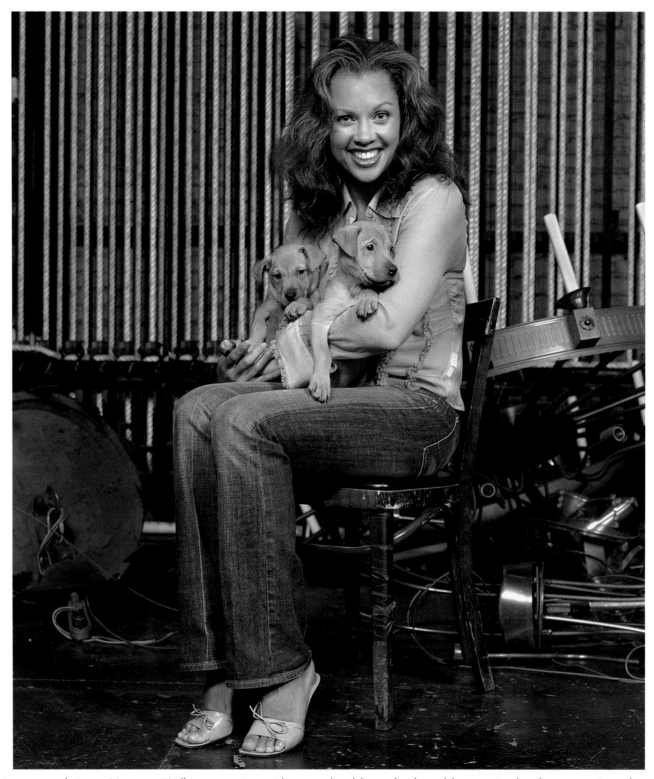

Actress and singer Vanessa Williams, posing with two adorable and adoptable puppies backstage at Broadway Barks. The little Shar Pei mixes, from The Animal Haven Shelter, proved irresistible and Ms. Williams later adopted the lucky dogs.

animal haven

Animal Haven has been finding homes for abandoned cats and dogs throughout the greater New York area and providing lifetime care to animals that can't be placed since 1967. It operates a no-kill shelter in Queens, New York and a sanctuary and rehabilitation center in Delaware County called Animal Haven Acres, where hard to place animals live in a home-like environment until they can find a home of their own and other's needing medial or behavioral rehabilitation get the care they need for as long as they need it.

Through our Mobile Adoption Program, sponsored by Manhattan Mini Storage, Animal Haven brings cats and dogs in need of homes to community events throughout the Tri-State area. Animal Haven University provides long and short courses on positive reinforcement training and Animal Haven will soon open an adoption center at Biscuits and Bath in Midtown Manhattan. Animal Haven does all this work with nine full-time staff, six part-time staff, four consulting veterinarians and over 400 active volunteers.

For more information on Animal Haven, please visit:
www.AnimalHavenShelter.org
or call 718-886-3683

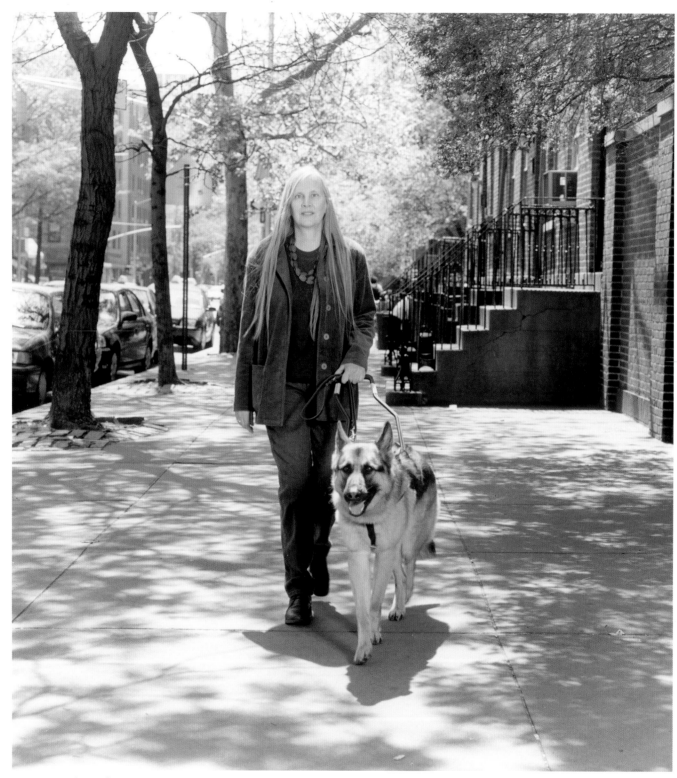

Maria and Graf, her Fidelco guide dog, walking in Manhattan's West Village.

Darling Graf:

The Fidelco Guide Dog Foundation's motto is "Share the Vision," and you eagerly perform this service with pride and panache. When "in harness" and at my side working, you maneuver around obstacles, stay alert to danger, and guide me to my destination. You enable me to travel safely, with poise and confidence.

At home, you sometimes study my face and then gently kiss each eyelid. Through your loving eyes, I am perfect and not flawed or disabled.

When "out of harness" and off duty, you're a silly boy and a remarkable pet. You love to run and play "fetch" in the yard or "rough-house" on the living room floor. While I'm listening to a book or to the radio, you snuggle nearby on one of your pillows. Even while, relaxing, you are aware of my location and comforted by my proximity. You are always watching, never judging.

I love you dearly and appreciate your devotion. I lavish praise on you and shower you with treats and toys. I will do everything in my power to make sure you are well loved, nourished, groomed, exercised, and cared for.

We complement each other. With you by my side, we present a strong, unified image of a winning team.

Your Maria.

⠷⠿

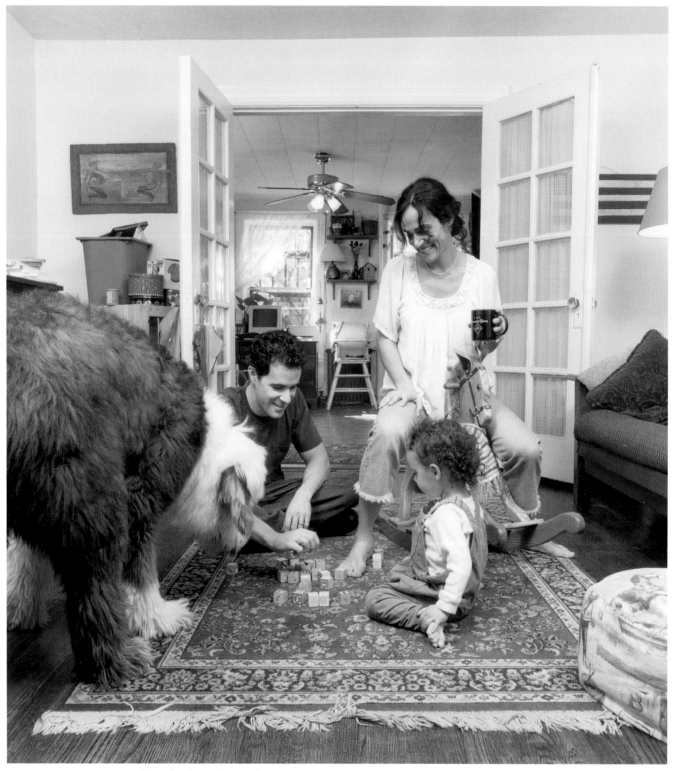

Marjorie ("Marjie") and her husband, Jonathan, playing blocks with their daughter, Louisa, and family dog, Boo, an Old English sheepdog.

Dear Boo,

One might have thought your start with us somewhat inauspicious, having been dubbed "Boo" by one of Marjie's schizophrenic clients. Nevertheless, you seem to have grown into the name, demonstrating the bravery - if not also the eccentricities - of Harper Lee's famous character. When you were trapped alone in a blazing house, you exceeded your own limitations of grace and agility to hurdle an iron gate to safety. No one ever held it against you that you probably started the fire in the first place.

Your heart is as big as your head, and your brain is as big as your tail. Right, you don't have a tail. Still, you're no fool, running around spreading unconditional love. You like to receive as much as give, which means you're always open to a bit of butt scratching. Luckily, you possess a winning charm, so the human denizens of the dog park are usually more than happy to oblige when you proffer your rump.

Of course, Louisa doesn't yet have the developmental skills to accommodate your passion. Her attentions towards you are more of the tormenting-toddler sort. But you tolerate her with canine stoicism. Your gentleness has made her a great fan of you, too. Though you're not clever enough to have done the calculation, you will probably reap huge butt-scratching dividends in the future as a result.

You're a good boy, Boo, and we love you.

Marjie, Jonathan, & Louisa

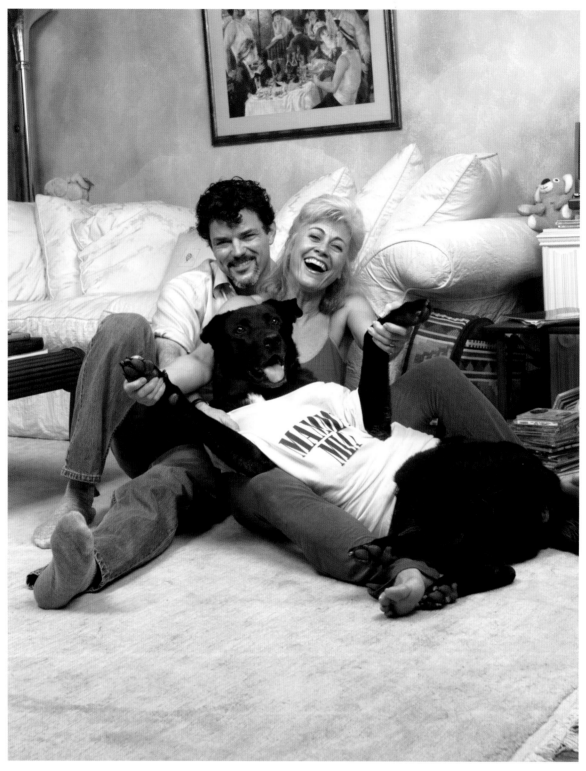

Louise and her husband, Joe, lounging with their German shepherd/black Labrador retriever mix, Tasha.

Tasha,

They say we rescued you - but now, years later, we're not so sure who rescued who.

- The stones we skipped - how would we ever have gotten them back if not for your chasing them.

- the front door, the back door, the kennel, the cage & all these doors might still be closed if you had not learned to open them.

- Glen's stereo oh, perhaps we shouldn't mention that.

- the spice cupboard you emptied ... ah! the backyard smelled like pizza for a week.

- Your "excursions" & agonizing hours — until the pet food store called : "Looking for Tasha ??"

- putting your paw on our shoulder when we lie on the floor with you.

- the poops —— bigger than most lap dogs!

- The singing : not ours but yours! To the saxophone or harmonica, no one sings the blues like you do.

We could go on and on :
 All the joy you give - how can we ever
 repay you?
 We love you Tasha —

 Louise & Joe

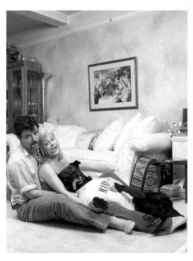

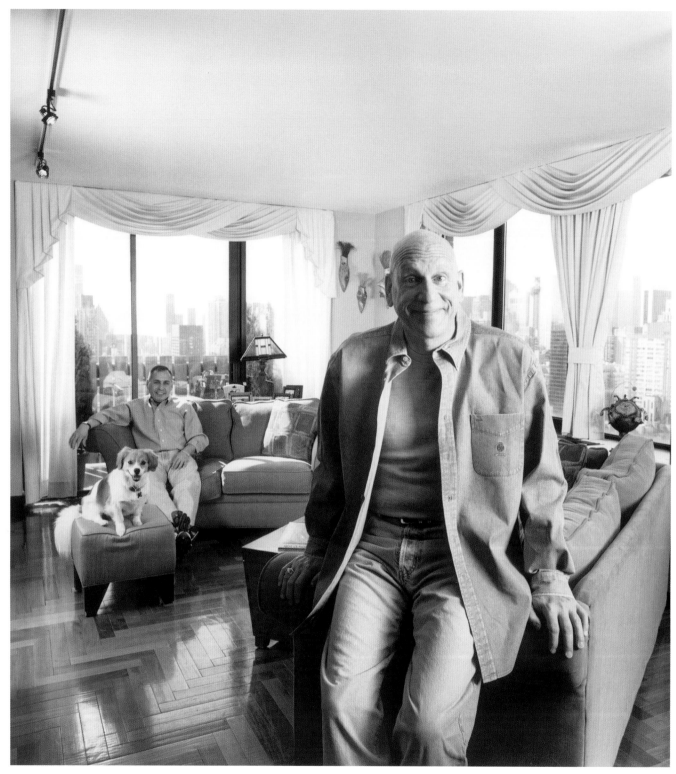

Mike (foreground) and Geraldo with their little mixed breed dog, Woody, on the Upper East Side of Manhattan.

Dear Woody,

It seems like only yesterday that you joined us to make our family complete. We had decided after searching many shelters and municipal pounds, that we would give it one more try on Memorial Day weekend. It was our lucky day, because in the very last cage in the corner, there you sat! You looked so tired and even depressed, as the shelter was clearly not a fun place to be. We considered ourselves the fortunate ones, for as cute and lovable as you were; it was just a matter of time before someone else selected you from the many dogs available at that pound in East L.A.

You made a great first impression being so well behaved when we first met. You were so calm as you sat in the back seat as we took you for a "test drive". Right then and there we decided to take you home with us.

Little did we know that you had something else in mind, not to mention a mind of your own! It didn't take long before we first saw the 'other' side of you, as when you stole the expensive pate, intended for our party guests, right off the serving dish. Having established you culinary tastes, you proceeded to establish your own set of rules, which we have managed to follow in the more than three years since then.

You were always so funny, as every day you ran around and around our house, securing the boundaries from who knows what. It was your turf, and you guarded it with your perimeter runs.

When we relocated to New York you managed to transition extremely well, bringing your East L.A. attitude to the Big Apple. It sure came in handy, as you walked and socialized the streets of the Upper East Side of NYC, schmoozing with all the other dog people on a daily basis. You really love the sights and sounds of New York, and became one of the most popular dogs with all the ladies. You sure are the ladies' man, giving out affectionate pecks to anyone who played with you.

Down deep, you are really a people person. While you enjoy the occasional company of other dogs, it is really people that you crave. You love being right in the middle of everything, with your presence a part of everything we do. You forced us to understand that we were not a couple, but rather a threesome.

Woody, you have made our lives more complete and yes, infinitely more complicated. However, life without the Woodster, Woody Woodpecker, the Woodman, would not be the same. Both your dads wanted the same thing - a dog that would find a home, but more importantly, make our house feel more like a home. In you, we achieved both. I don't think either of us could imagine coming home from work without seeing you waiting at the door - the sign that we are at home, and you are the biggest part of that home.

Hugs to Woody!
Mek Gerardo
xxx

37

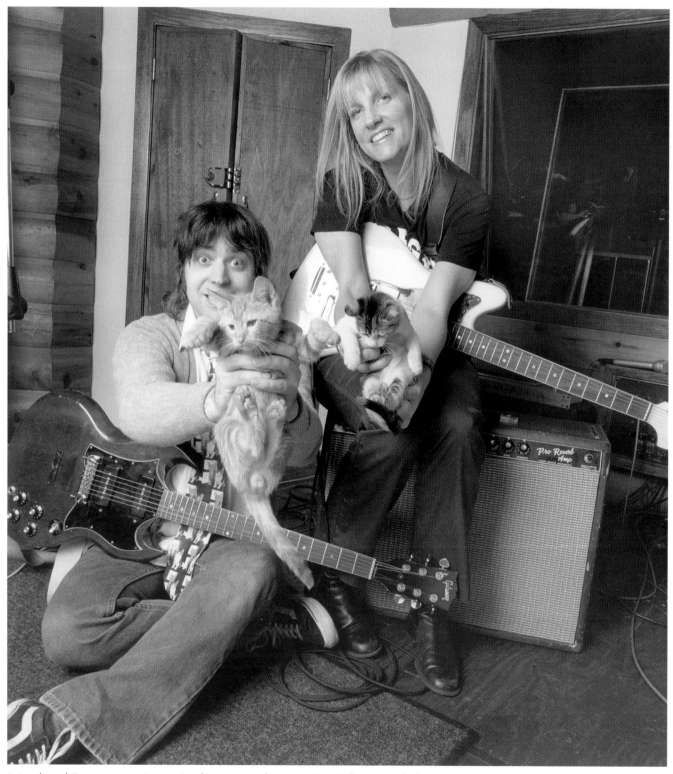

Nigel and Eugeniea at Jarvis Studios in Manhattan's East Village, with their kittens, Ringo James, Jr. and Starrshine.

HOWDY R.J.
WHAT'S THE LATEST?
I'LL CLEAN YOUR LITTER BOX
TOMORROW (POSSIBLY)
PLEASE KEEP AN EYE ON
LITTLE STARSHINE.
THANKS A MILLION FOR
BEING SUCH A SWELL
 PET!
FONDLY, YOUR PAL
 —N

DEAR RINGO JAMES,
YOU ARE SO CUTE!
SOMETIMES I JUST
CAN'T TAKE IT!
I LOVE IT WHEN YOU
TRY TO PLAY MY GUITAR
WITH YOUR PAW...
AND WHEN YOU GET ALL
EXCITED WHEN I PUT
ARLO GUTHRIE ON THE
RECORD PLAYER AND RUN
AROUND.
 BUT THE NICEST THING
IS WHEN YOU TAKE
YOUR LITTLE SISTER TO
THE WINDOW IN THE EVENING
AND WATCH THE MOON
RISE IN THE NIGHT SKY...
YOU LOOK SO WHISTFUL...

 LOVE JENIE

Good morning, starshine, the earth says "Hello"
You twinkle above us, we twinkle below
Good morning, starshine, you lead us along
My love and me as we sing our early morning singing song

 Gliddy, glup, gloopy
 Nibby nabby noopy
 La, la, la, lo, lo
 Sabba sibby sabba
 Nooby abba nabba
 Le, le, lo, lo
 Tooby ooby walla
 Nooby abba nabba
 Early morning singing song

Singing a song, humming a song,
Loving a song, laughing a song,
Sing the song, song the sing
Song, song, song, si-ing, sing, sing, si-ing, song
Sing the song, song the sing
Song, song, song, si-ing, sing, sing, si-ing, song

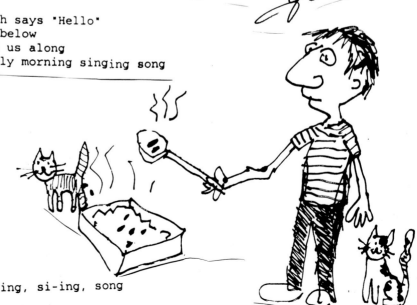

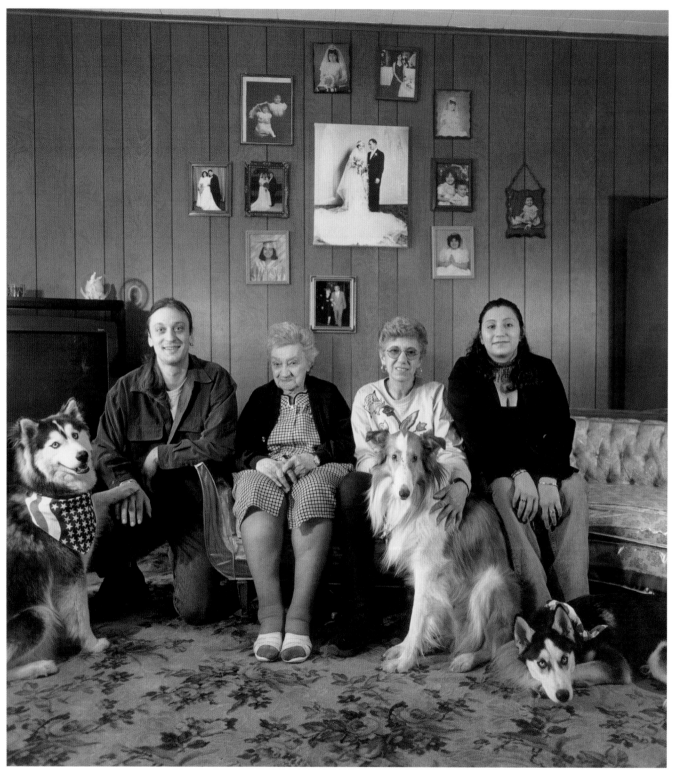

(L to R) Shy, a Siberian husky, Matthew, Nancy, Carol with Dallas, a collie, and Claudia with Smokey, a Siberian husky.

My Dear Sweet Shy:

What can I say? My day would not be complete without the sight of you. I love waking up to your playful smile & those big blue eyes. I especially love it when you cuddle up with me and we sleep late. Of course no matter what we are doing, I enjoy every minute with you.

Sometimes I wonder if you realize how much of an impact you have had on my life. Then I am reminded of just how much you understand me. Each day you find a new way to make me laugh out loud. I adore the way your furry face speaks volumes and the way you always get your point across. Your intelligence never ceases to amaze me. I especially admire your ability to light up a room and "lighten up" all those in it.

ShyBear you have brought so much peace to my heart. My soul smiles at the very thought of you. Every bad emotion melts away when you sit with me. There is nothing in the world like petting your soft little head. There is nothing in the world like having your love.

I thank God for helping us become a family.

I thank daddy for bringing you to me on Valentine's Day &

I thank you for loving me despite all my many flaws.

I love you so much more than words. Please remember that we have always and will always be together.

—Love Mommy

xox

My Dearest Smoky,

It was less then a year ago that I realized your brother Shy needed a playmate. It took a lot of begging, but I finally talked your mother into it. When we went to pick you up, it only took one look and she was hooked. How can you blame her? I knew that you were obviously meant to be my puppy. I remember how much the trouble making look in your eyes added to my excitement.

At first, it was rough for you and I to get used to each other. Yet as the days went by I found myself growing more and more attached to you. I can see now that you feel the same. The more you break out of your shell, the more I see my personality in you. I am grateful that God has granted us such beautiful creatures. I look forward to every day with you. Life just wouldn't be the same without your innocence. Your playful heart really keeps things interesting. Thank you for helping me remember that life can still be enjoyable, no matter what it brings, even a life with me. I love you today and until the day God calls me from this earth.

—Love Daddy

xox

Dallas My Love,

You & I have been together for only 9 short months, in that time you have become my companion and best friend. For the first five years of your life you were confined to a cage never shown love or affection. Getting to know each other has been difficult at times but we have formed a powerful partnership of mutual trust, comfort, respect and love. Each show of affection sends a message that says "I love you so much, and I thank you for loving me." You are a joy in my life and I thank God for sending you to me.

—Love Always Mom

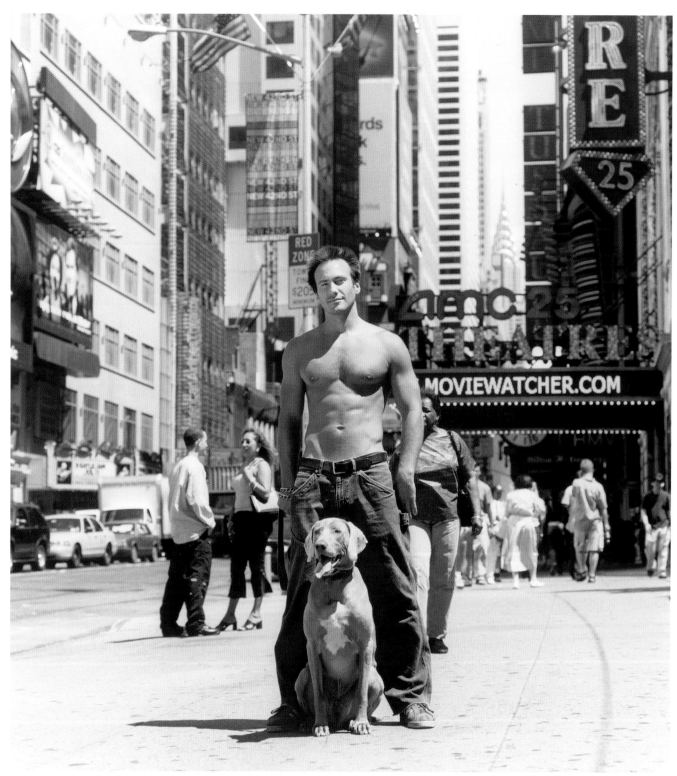

Eric and his Weimaraner, Humphrey, on 42nd Street in NYC.

AN Honest Salute

We honor you for your Loyalty and Companionship

Brighter Days
Safer Nights

Peace and Love are your Only Desires

Humphrey

I Salute you

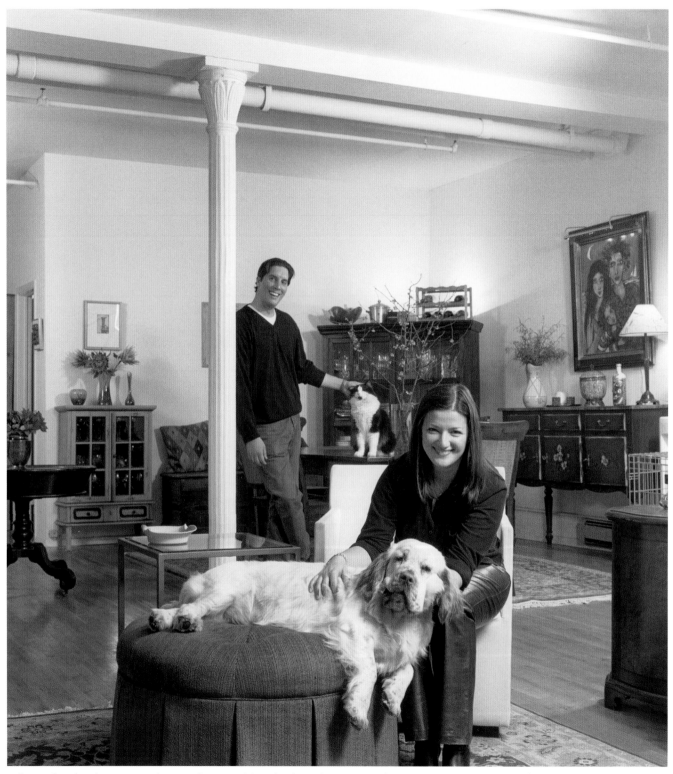

Alla with Clumber spaniel, Bromley, and her husband Kevin, with Maine Coon cat, Fredo.

Dear Fredo & Bromley —

Fredo, it's difficult to believe that when we first brought you home, you were so shy and quiet. How you have changed! We're glad you've picked up many of our own habits -- constant dialogue, love affair with water, social eating and a doctor-prescribed diet! ☺

I'm sorry that just when you had settled into your new home, we introduced you to your new big brother Bromley. But after seeing such an adorable droopy, drooly face, we couldn't resist bringing him home even though we knew there would be hell to pay with you!

We know that no matter how many times both of you scratch each other, drink or eat each other's food/water, or wake each other up, you love each other as much as we do.

To be honest, we don't know what we would have done if you didn't get along. But lucky for us, we ended up with a perfect pair of paw-mates!

Love,
Mom & Dad

45

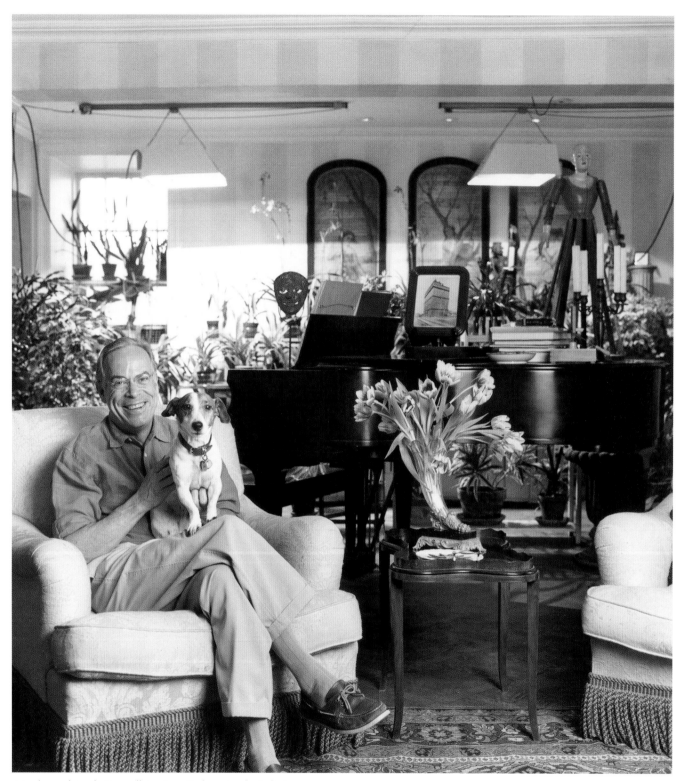

Mark and Jack Russell terrier, Babe, in their living room.

July 14, 2002

Dear Babe,

I have a surprise for you! Your niece is coming to live with us so you'll have a canine companion. She's your sister Sabrina's puppy and was born on December 2, 2001. By the time she gets to New York she'll be three months old.

Her name is Nana. I named her for the dog in *Peter Pan* who looks after the children. She's very beautiful—not as beautiful as you are, of course--but who is?

We have so much to teach her! Where the good hiding places are, what time cooking usually takes place so she can snag a few treats and how to jump onto the bed and burrow under the covers. When we go to the country you can show her through the woods and down to the beach. But please don't encourage her to roll around in dead fish. I know it's one of your favorite pastimes, but I'd appreciate it if you kept that to yourself.

Also, please keep your wee and poo spots on the living room carpet a secret? I like to think of that rug as your personal territory. Besides, it couldn't take any more stains.

All my love,

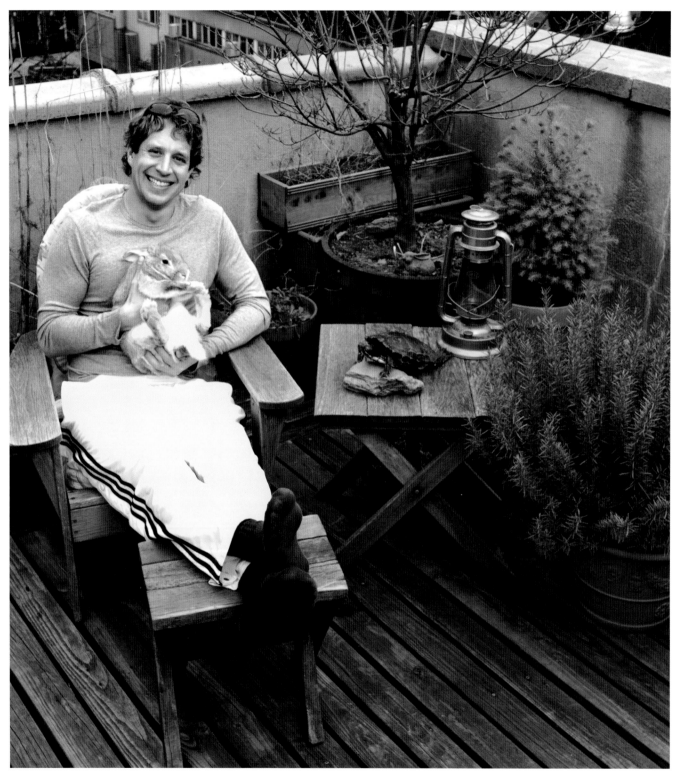

Daniel with his farm bunny, Rascal, and red-eared slider turtle, Bert, on his rooftop deck.

Rascal + Bert;

No boring pet food and no confining cages or Aquariums for you two. In the winter you romp around the apartment and in the summer its up to the deck garden. If only you'd let me enjoy those flowers a few more days before you ecstatically mow them down! But then again, with its pond, vegetables, wildflowers and shrubs, the deck is more your habitat than mine. Besides I know better than to expect you two to conform to the cute or cuddly stereotype of Hollywood and childrens stories. Independent, Mischievous with a strong sense of self is a more accurate portrait. Like me you are individuals.

In fact it was you two who inspired me to transform an old deck into a peaceful wildlife sanctuary. Your reminders that even the most modest of God's creatures can acclimate and thrive in the big city. Sort of like a metaphor for life if you think about it.

Rascal + Bert you make me smile each time I come home. It may sound like a simple thing, but in exchange for the good moods you put me in, I promise to take care of your forever.

your friend,

Daniel

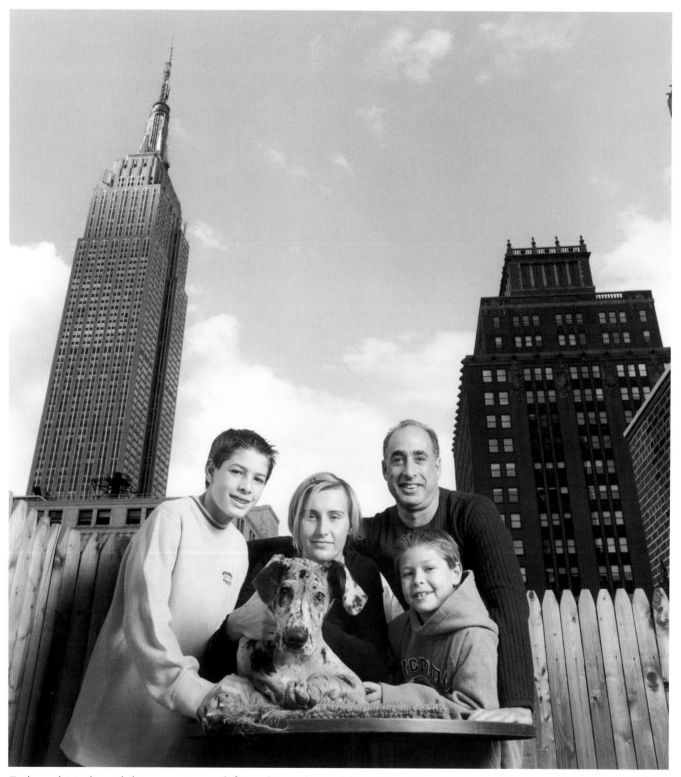

Trish and Mark, with his sons, Jason (left) and Joseph, and their Great Dane puppy, Mouse, on the terrace of their Manhattan penthouse.

Dear Mouse,

Your the best dog two boys could ever have. You can be crazy sometimes, but your always cute. You're so much fun to play, with even if Joey is your chew-toy. From the day of Halloween when Dad and Trish brought you home from Nyack, we all fell in love with you. You were so small when you first came into our lives. I remember when you wouldnt walk, Jason had to carry you up and down streets. Now your huge and you still think we could carry you and could sit on our laps. Also since you are too big to ride in a taxi cab we would like to ride on top of your back instead of walking to central park. We love to go running with you. Mouse we love you, you're so much fun.

Love,
Jay
+
Joey

Dear Mouse,
 The short time you've been in my life, You've completely changed it LITERALY!!! There's less room, but more love.
 The thing about you putting your......well let's say "derriere" on the couch and your big paws on the carpet, This has to go. Or the fact that, to this day, you still try to sit on my lap, SOMEHOW, I don't think this is still a puppy thing anymore.
 Besides, at 110 lbs., you almost weigh as much as me!!! (that's like one of my girlfriends sitting on me).
 Nonetheless, you've brought more color and love into my life, not to mention a few pieces of chewed up furniture!!!
 But I love you anyway
 YOU ARE MY MOUSE........Forever,
 Much love,
 Your Mommy
 Trish

51

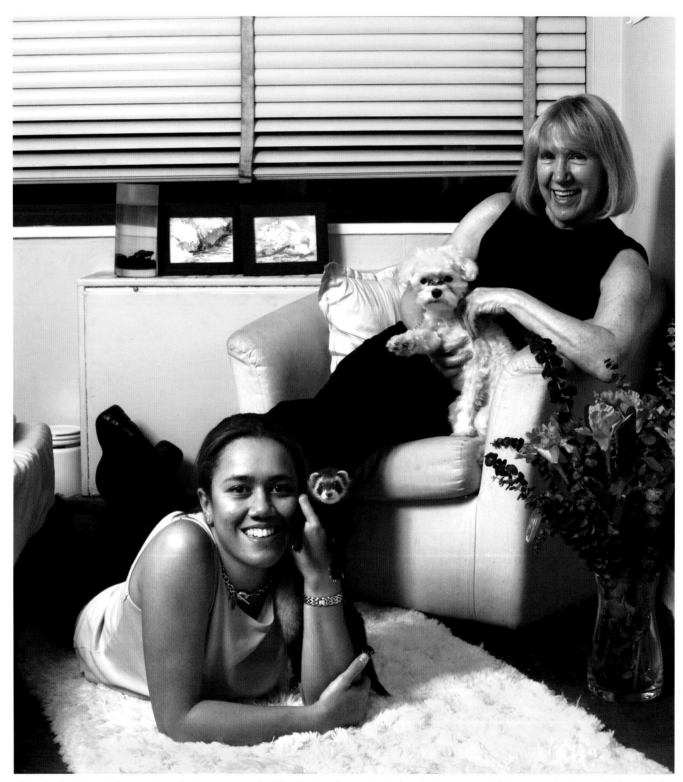

Shephathiah and her mother, Nannette, with Charlie the ferret, Jack the Maltese, and Maximus the beta fighting fish.

To Charlie the ferret, Jack the dog, and Maximus the Japanese Fighting Fish. You should know that you all have special names. Charlie, you are named after my father, Shephathiah's grandfather, and since he owned ferrets, we decided to name you after him. A little odd, but it had a lot of meaning for us. We are English and during World War II, when we were running out of food in the village, he would go hunting with his two ferrets to catch rabbits, bringing them back to the village to feed everyone. The two ferrets were fierce and would chase the rabbits out of hiding. Many years later, my daughter brought you home. Very different from the two in England. Charlie, you are the sweetest, dearest, smartest ferret I have every known. Now Jack the dog. Not as smart as, Charlie, but very charming, alert and always ready to please. Jack, you are named after Shephathiah's car, who, in turn, was named after John F. Kennedy. And finally, Maximus, our Japanese fighting fish, you are named after the great gladiator in the film by the same name.

May we have no more pets, because we are running out of names!

- Nannette

SORRY JACK, BUT CHARLIE IS NUMBER ONE! YES YOU ARE SWEET AND CUTE, BUT IT IS CHARLIE WHO WILL ALWAYS HAVE MY HEART. MY LITTLE CONTRABAND FERRET. WHAT DID YOU EVER DO THAT MADE YOU ILLEGAL? YOU HAVE BROUGHT NOTHING BUT JOY TO MY LIFE. YOU WERE THERE THROUGH MY HORRIBLE COLLEGE CLASSES, PUTTING A SMILE ON MY FACE WHEN NO ONE ELSE COULD. CAN YOU EVER FORGIVE ME FOR BRINGING HOME THE FLUFFY WHITE HORROR THAT IS MY LITTLE MALTESE DOG? OH THAT HE IS THE BANE OF YOUR EXISTENCE. PULLING YOU FROM A RESTFUL SLEEP BY THE TIP OF YOUR EAR. FORCING YOU TO COME AND PLAY WHETHER YOU LIKE IT OR NOT. BUT READER BEWARE, DO NOT BE FOOLED BY OUR HEROINE. SHE IS NOT AS HELPLESS AS YOU MIGHT THINK. FOR AT THE END OF EVERY PLAY FIGHT SHE IS ALWAYS THE VICTOR. YES JACK YOU ARE THE STAR... BUT IT IS CHARLIE WHO IS MY PERFECT PET.

- SHEPHATHIAH

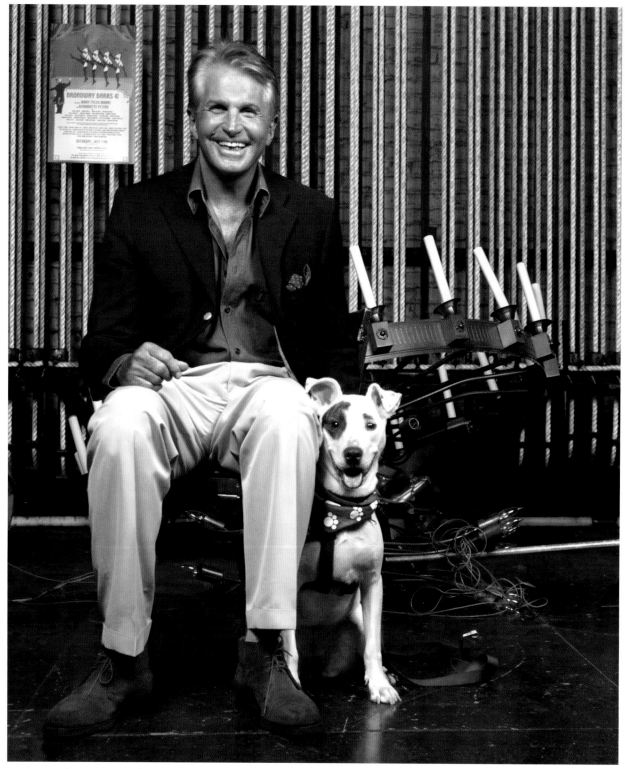

George Hamilton, a multi-faceted star, currently appearing in Chicago on Broadway with Faith, a rescued terrier mix from Loving Touch.

Mary Tyler Moore and **Bernadette Peters** lend helping hands every year when they host **BROADWAY BARKS!**, a star-studded dog and cat adoption event benefiting New York City animal shelters and rescue groups. A galaxy of stars from the Broadway community join Moore and Peters, presenting the animals for adoption. The event is produced by Broadway Cares/Equity Fights AIDS.

BROADWAY BARKS!, helps many of New York City's shelter animals find permanent homes by informing New Yorkers about the plight of the thousands of "homeless" dogs and cats in the metropolitan area. The event also stresses the importance of spaying and neutering. Last year's **BROADWAY BARKS!** attracted an audience of 6,000 theater fans, pet owners, and animal lovers.

"We have a real chance to make a difference," Moore explains, "We can turn the enthusiasm about pet-adoption that we've been able to generate through Broadway Barks, into a movement to save the lives of the 40,000 potential 'best friends' needlessly put to death every year here in New York. Through our individual acts of kindness and our joined voices in this important cause, we can make New York a 'no kill' city, and by doing so, make it a better place, a kinder place for us all."

All proceeds from and donations to Broadway Barks will benefit these shelters and organizations: **A Cause for Paws, Animal Haven, ASPCA, BARC Shelter, Bide-A-Wee, Bobbi and the Strays, CACC, City Critters, The Humane Society of New York, Kitty Kind, Long Island Greyhound Rescue, Loving Touch, Manhattan Valley Cat Rescue, Northeastern Boxer, New York Pet-I-Care, PLUTO Rescue, Stray from the Heart,** and **The Tigger Foundation.**

For more information about **BROADWAY BARKS** visit *www.officialbroadwaybarks.org*

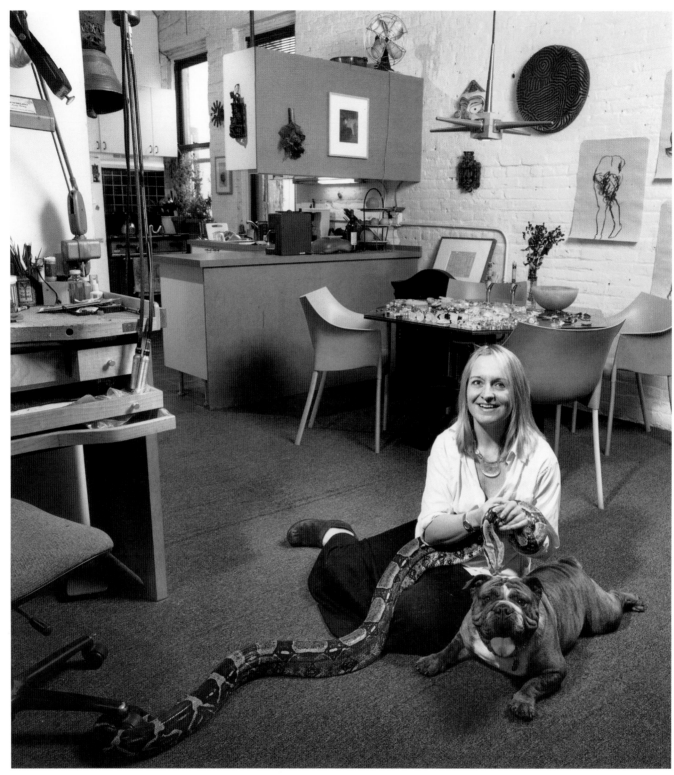

Karen and her 23 year-old boa constrictor, Herod, and Beulah, her red brindle bulldog.

Dear Beulah,

"♪ Cause you're once, twice, three times a bulldog...and I love you..."
"More than a bulldog...more than a bulldog to me... ♪"

How do I love thee? let me count the ways... I love your underbite, your wet bulldog kisses, the short red hairs you leave all over the furniture and my clothes, the food that falls out of your mouth when you eat, the dainty way you drip water all over the floor when you drink, the toys you leave all over for me to trip on, your snoring, grunting and your pretty smile. I love your wonderful sense of humor and joie de vivre – your obsession with chasing balls, reflections and the way you try to bite the water that comes out of the garden hose... Your gasiness is not so great, but hey, no one's perfect...

I'd wanted a bulldog all my life and waited a long time for you. When you finally came to me, it was after a particularly rough period. You've filled my life with joy and drool. You make me (& pretty much everyone who meets you) smile. You're such a puff! I'm proud to be your mom!

Dear Herod ~~~~~~~,

You've been with me 20 years! Since art school! When I got you, I wanted a beautiful, exotic pet. You have been that and more. You were only 1 meter long when I got you & now look at you! 12 feet long & 35 lbs! You are a big snake and alot of people are freaked out by you... they say things like "he'd make a great pair of boots", etc. I just ignore them. Boa constrictors have feelings too (no pun intended). Don't you listen to those people (actually, you can't...you don't have ears.). Herod, you can be annoying...like the time you got stuck behind the refrigerator or coiled up in the bookcase, refusing to come out. But I know that you're just looking for a tight place to feel secure. I'm not sure that you know me like Beulah does, but I still feel very protective of you. Now you are old and losing your eyesight, but don't worry – I will love and take care of you and Beulah always...

My love to you both,
Karen

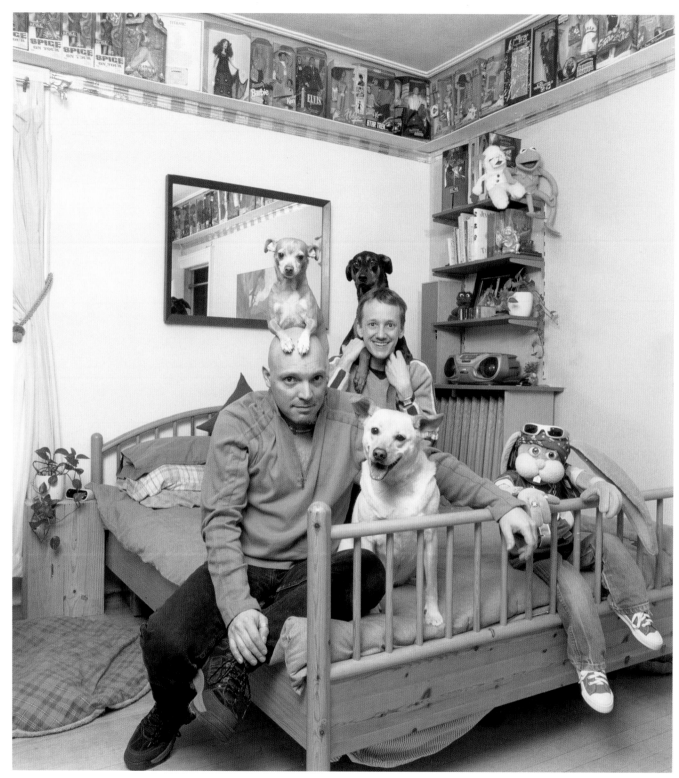

Mario, with Xanadu, the chihuahua, on his head, Jason with Chino and Lef T. Jones next to Mario's puppet, "Kool Rock."

Dear LEFTY, XANADU, & CHINO: 7/12/02

How did this happen? How did each of you convince us that having a dog (let alone 3) in a New York City apartment wasn't such a crazy idea? Clearly you worked some kind of "Doggy-Mojo" on us. Oh, we know your game. We're on to you guys.

First, there is <u>LEFTY JONES</u>, code name: *Da' LOVER!* I'll never forget that fateful day I innocently walked into the Bide-A-Wee shelter - just to look. An unassuming Doberman was politely sitting in his cage with his left ear cocked. Unbeknownst to me, he was secretly mesmerizing me with his psychic powers of persuasion. I was rendered helpless in a hypnotic state. Resistance was futile.

Before Jason and I knew it, a year had passed. This was sufficient time for Lefty to weaken Jason's initial resistance. He would wield his mind control powers...again! Lefty, you would convince us you needed a partner! That's right, a "ying" for your "yang"--someone to "complete" you. Once again, mysteriously, I found myself at the shelter--this time with Jason by my side. "Good," I thought, "Jason is methodical. Sensible. He'll be strong!"

We entered the doggy prison. I braced myself, but alas, it was too late. A white Lab-mix had targeted her sights on Jason. <u>XANADU</u>, code name: *SPAZ ATTACK!* Poor, naive Jason was powerless. He was lured to her--ensnared in her licking love frenzy! All was lost.

Lefty was pleased.

Two years went by. We thought we were safe. Then one day LEFTY and XANADU sat strangely staring at the front door. It was as if you knew something big was about to happen. Of course you knew. You were creating a doggy mind meld!! Just then, Jason swung open the door and desperately told the sad tale of a misunderstood Chihuahua he had met on the street. How he was wrongfully being sent to the CHAIR! What could we do? We were weak from mind control! Jason recalled the little dog's big brown eyes, his wagging tail, and his soft whimper of pathos. Like zombies we consulted LEFTY and XANADU. LEFTY ripped up his rubber New York Times and you, XANADU, neurotically licked LEFTY'S face. Obviously, the decision had already been made. Ah, what fools we were!! Little did we know, the sweet Chihuahua had a past! You! <u>CHINO</u>, Code name: *AL PACINO, A.K.A. THE GODFATHER!!*

Okay, so now we know that your secret mission to infiltrate our lives and lock yourselves into our hearts has been accomplished! But, every time someone compliments us on how cute and well-behaved the three of you are, we will know that you are only conspiring to work your collective "Doggy-Mojo" on the unsuspecting public! We will warn the masses before the three of you conquer the world! The madness must end!......................Who's a good dog? Yes you are! Yes you are! Yes......Oh no!

Your obedient hostages on the Upper West Side,

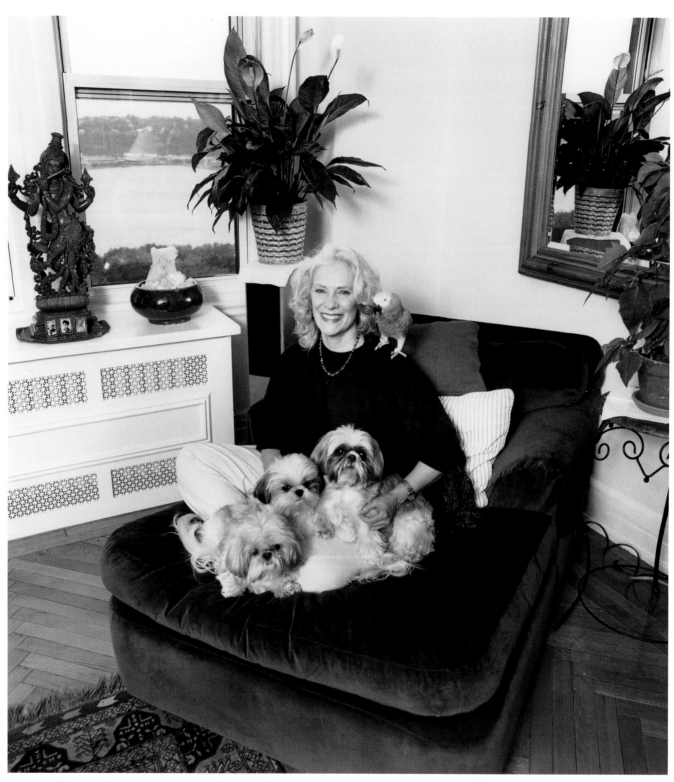

Betty with her African grey parrot, Blue, and her shih tzus (top to bottom) Gemma, Madison, and Jesse.

TO JESSE, GEMMA, MADISON & BLUE

Dear ones:

My girls and my main man Blueness.

Thank you for your abiding love and friendship. You bring such sweetness, light and joy to my life. Our hang-out times are the best moments of every day. And you guys are the most patient travel companions. I could not do it all without you.

And you guys are the funniest. You make me laugh. And you are so pretty. Thank you, thank you with all my heart.

Love your buddy, X Y O O

Betty Lynn

Betty Lynn

P.S. And in memoriam:

Bridget I miss you so much. And with great gratitude and love and in remembrance of:

Black Bucket, Rags, Cappuchine, Maggie, Claude, Jake, Kelly 1, 2 & 3, Tiger, Liga, Blaze, Red, Duke, Crash, Byline, Bozo, Blackie Whitefoot, Gigi, Jay Jay, Jo Jo, Cinnamon, Sugar & Spice, Salty Pepper, Monty, Mark and Noel (who went to live with Alicia.)

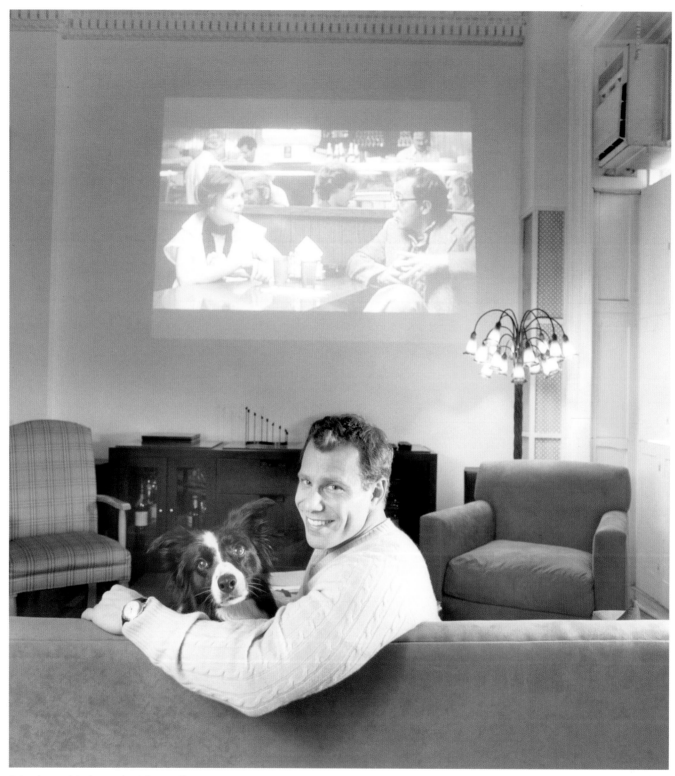

Noah and Lola, a border collie.

Lola Lolita,

Compatriot, partner, confessor, friend. My morning Sun, my evening shadow. Quotidian hub, the days wheel about your needs. Morning brings circles tight and fast in your joyous expectancy. Speed gives way to Size under the cooling moonshine as the arcs expand outward to the great, universal perimeter of your Shepherd mind. When it is ALL within your ken, then will you have done your work, then will you rest.

What was my life before you? What was yours before mine? A shattered plan, a whimsical trip; chance and a woman crossed, tangled our lives. Yours newly rescued, mine shortly to be in need, did she know she was replacing herself? Could she have conceived her perfection of choice? Like a triumph of prestidigitation, her card withdrew from the deck and yours slipped in to save the deal.

At five years of age you came to me, a street survivor for over a year. You chose the floor over a bed. Tu comprends Francaise. You breathe for the satisfaction of completing your art: gather, protect, keep them inside the circle. Your lesson: artists perfect through undiluted passion, unquenchable thirst for the quotidian practice of art. You are a herding artist. How many more lessons could you teach me? Many, perhaps, but a dog is a sphinx and in this is your final lesson. Neither in peals of laughter nor torrents of tears, but in the profound silence between does true friendship live.

Your Shepherd, your sheep,

Noah

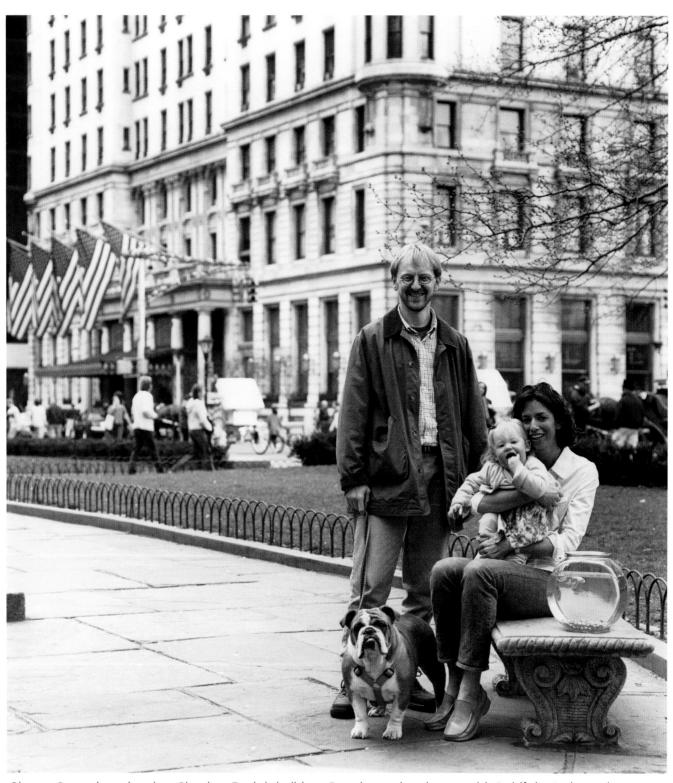

Chrissy, Peter, their daughter Phoebe, English bulldog, Brenda, and eight year-old Goldfish, Spike in the square across from The Plaza Hotel.

Dear Brenda,

It was after we had two miscarriages that Daddy and I decided to get a dog. We wanted to share our love with something, and if a baby wasn't possible, a dog would be the next best thing. We did lots of research into what breed to get, and ended up picking a bulldog.

Bulldogs seemed like a perfect match for us. They hate exercising as much as we do, so walks can be quite short. They love to laze around the house, like we do, and also like us, they need air-conditioning all the time in the summer. They are at the top of the chart for affection and playfulness, but most important is that they are known for being great with children of all ages. Sure, they snore and need their wrinkles cleaned, and there's the whole problem with the gas, but no dog is perfect. So we set out to find a bulldog, and after a few months we got Lily.

By the time we got Lily, I was pregnant again. It was after that pregnancy failed that I fell in love with Lily. After getting home from the doctor's office with the bad news, Lily was excited to see us (as always), but she knew something was wrong. All she wanted was for us to be happy. She helped us get through a tough time.

Several months later, things were going much better. I was pregnant again, and this time there were no problems. Soon, I thought, I'd have a baby and a bulldog to care for. My belly was getting quite large. I was sitting on the couch one day when Lily came over and tried to jump up, something she never did. She nuzzled her way under my shirt and pushed it up to reveal my bulging tummy, and started sniffing. It was as if she was telling us she knew that there was a baby in there, and that she had done her job. A week later, less that a month before the due date, Lily died suddenly of a heart attack. Did she know she was sick and would die, and wanted to let us know that everything would be okay with our baby? Daddy and I will never know for sure, but we'll never stop believing that.

The next month our precious daughter, Phoebe, was finally born. It took us months before we could think about getting another dog. We even considered other breeds, but after meeting you, and seeing how beautifully you and Phoebe took to each other, we knew we had to have another bulldog.

We've had you now for nine months. We didn't know it, but at the time of this photo, you were pregnant. In just a week, you're going to be a mommy, too! We're so glad to be able to return the support during your bulldog pregnancy that our bulldog, Lily, gave to us during our people pregnancy.

The breeder we got you from is taking care of you now while you prepare to have your puppies. We miss you so much. Sure, we haven't missed the chewing of Phoebe's toys, the end-of-pregnancy need for middle-of-the-night walks, the wrinkle cleaning, and the horrific pregnancy-induced gas, but we sure miss *you*. And now when Phoebe spills food on the floor, we actually have to clean it up! Plus, Phoebe just doesn't seem to enjoy a good belly-scratch as much as you do.

Brenda, the truth is we can't wait to have you follow us from room to room just so you can plop down on the floor and nap at our side. We can't wait to have you jump for joy when we come home. We can't wait to hear your soothing snoring again at night. And we can't wait to see Phoebe react to seeing you again after a month away. We look forward to you both spending years of playtime together. We love you.

Mommy

Dear Spike the Goldfish,

I've known you longer than I've known my wife and daughter combined! Never has 39¢ been worth so much to me. Glug, glug, glug!

Love, *Daddy*

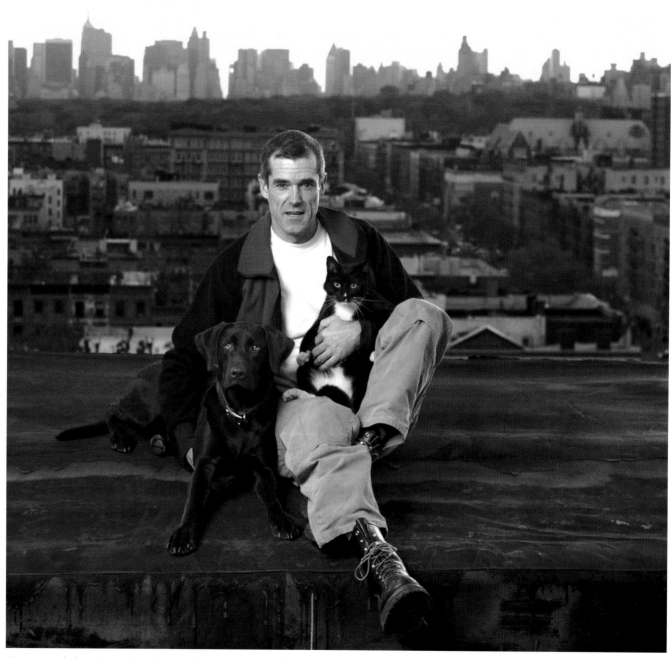

Steve, with his chocolate Labrador retriever, Birch, and cat, Elmo, from the rooftop of his Harlem building in NYC, with Central Park in the background.

To Birch and Elmo:

Thank you for being around; without you I would be alone.

love,
Steve

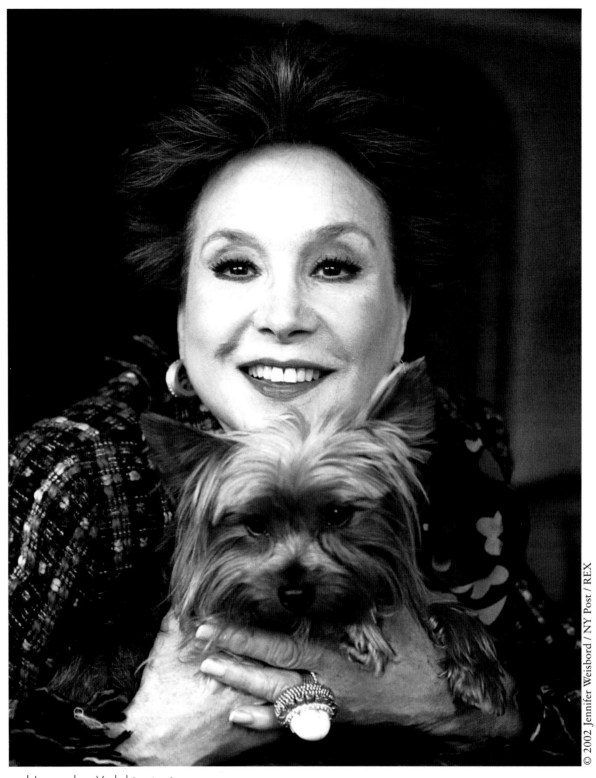

Cindy and Jazzy, her Yorkshire terrier.

Why do I love Jazzy?

"Seven days after Joey, my husband of a lifetime passed on, a friend delivered this three month old Yorky to me. He wasn't expected. Wasn't requested.

He was 2.2 pounds and he arrived in back of a limo.

The minute I took him in my arms a warm feeling came over me.

Jazzy peed on me.

And he's been doing it ever since. Jazzy is the master of my world. He runs my house. He is still training me three years later.

Jazzy is my only blood relative. It isn't that I love him. I am IN love with him. I'd leave him my apartment in my will if I thought he could pay the maintenance."

From St. Martin's book "The Gift of Jazzy" by Cindy Adams to be published February 2002.

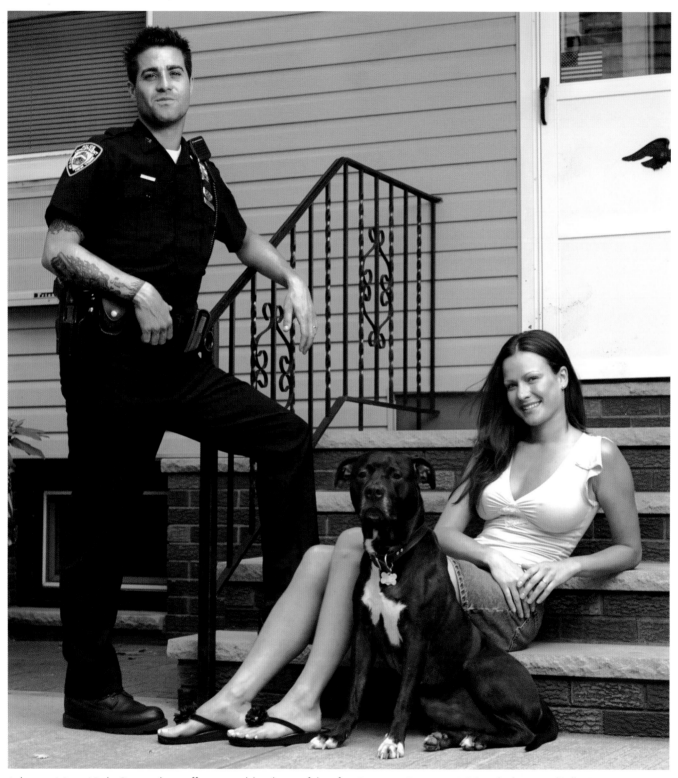

John, a New York City police officer, and his beautiful wife, Amy, in Queens, NY with their pit bull, Geronimo.

DEAR GERONIMO

I just WANTED to THANK you
AGAIN FOR THIS PAST WEEKEND. YOU MADE A
GREAT TIME EVEN BETTER. YOUR MOTHER
AND I WERE ESPECIALLY IMPRESSED
WITH THE WAY YOU HANDLED THAT INCIDENT
AT THE BEACH. THAT OTHER DOG WAS
ABSOLUTELY RUDE. THANKS FOR NOT
SNAPPING, LITERALLY, AND CAUSING
A HORRIBLE SCEENE. I DIDN'T KNOW A
FIVE YEAR OLD WAS CAPABLE OF
BEHAVING SO WELL. SO JUST TO RETURN
A FAVOR, I'M GOING TO TAKE YOU TO
GRANDMA'S HOUSE THIS WEEKEND. TRY
NOT TO EAT YOUR SELF SICK
THIS TIME. OK.
MOMMY AND I REALLY LOVE YOU.
YOUR MY LITTLE MAN.

LOVE DADDY

Amy and her sheltie puppy, Nibbles, in Manhattan's Gramercy Park.

Hi, my name is Nibbles. I was born on October 29, 2001 near the base of
Mt. Rainier in Washington State. Just in case you were wondering I'm the furry
one in this picture. My Daddy picked me because I was the spunkiest puppy out
of the litter. I traveled with him from Seattle Washington, across the United
States to New York City. I was just seven weeks old. He says I slept most
of the way but, had to stop every few hours so I could go potty. He brought me
home as a surprise birthday present for my Mommy on December 15Th. She had all
this weird salty water stuff coming out of her eyes and kept squishing me. I
was just thinking how good a nice snack might taste at the time.

My Mom named me Nibbles because she says I had this habit of chewing on
everything, even stuff I'm not supposed to chew on. For a while there I
thought my name was "Don't do that" or "Oh my God" but as time has gone by she
calls me Nibbles more and more.

I get to go to work with my Mom sometimes, and play with all the other
dogs that she takes care of. I am developing great social skills and fine
tuning my herding ability, as herding sheep is part of my nature. I try to
herd some of the other dogs but for some strange reason they want to show me
what their teeth look like. Some of those dogs need to brush a little more. We
also go on hikes and even go swimming. I'm not big enough yet to swim by my
myself but some day I would love to go scuba diving with my mom and dad. In
the mean time, I settle for running on the beach and chasing hermit crabs at
Grandmas house.

I know my Mom loves me because she gives me food, water, and those nasty
kelp pills to keep my coat shiny. She also has this habit of smiling a lot when
we wake up in the morning. Yeah, pretty much she's smiling every time I look
at her. I wonder if that hurts?

Anyway, she said we were going to be in a book and that I had to write
this letter so people would know who I am. I guess a book is one of those
square things that people stare at for a long time. I don't know, I'm not old
enough to read yet. So there you have it. That's me, that's my story so far,
as I am only nine months old, but I'm sticking to it.

Nibbles

Dana and his boxer, Roxy, in the Theater District of Manhattan.

Roxy,

"There is only one important time and that is now. The present moment is the only time over which we have dominion. The most important person is always the person you are with, who is right before you, for who knows if you will have dealings with any other person in the future? The most important pursuit is making the person standing at your side happy, for that alone is the pursuit of life."

Thank you for giving me this gift. You remind me to be mindful every day.

Dana

Judith Z. with her Great Dane, Zuli, in Brooklyn.

Dearest Zuli,

My Zuli Petunia, Zuli Monster, Zuli Zu - *Queen* of Zuleland, the Mayor of Flatbush Avenue, and mostly, my *Big Baby* — how can I ever express all that you mean to me?

On a daily basis, I have to put up with at least 10 kids squealing "Wow, look at that big Dalmatian!" men yelling out "Hey, you outta put a saddle on that horse," or "Who's walking *who*?!" People jump out of cars *demanding* to know what kind of dog you are, how much you eat and how much you weigh, and are your toenails really naturally red? People who don't have companion Danes just don't know how delicate and sensitive you creatures are. Some people race across the street in fear, and some foolish kids grab your tail, just because they can ... because of all this, you've introduced me to just about *everyone* I know.

I sometimes teasingly ask the gaggle of little kids who are feeling you all at once, "Do you know *why* she's so big?" and they look up at me expectantly, shouting in unison "No, why?!" I always answer, "So everybody can love her all at once!" ... It's true, Zuli — you were made so big just to encompass all that love. *I* sure love feeling your powerful, graceful self, walking calmly down these Brooklyn streets, eager to be petted by every stranger yet equally on guard should there be even a hint of danger.

The truth is, I was afraid to move to big, bad New York City from that isolated farm in Virginia: I was *convinced* I was going to be murdered within the first year; uncertain how to adjust if I wasn't. With you by my side, Zuli, I can walk the streets at 3 AM without a second thought. I can go into a bar filled with strangers and within 15 minutes, you introduce me to every single person inside. Much to my delight, you even get that cute girl in the corner who wouldn't even *look* at me if *you* weren't by my side to ooh and aah over how beautiful you are, telling me you should be in pictures... I just wish I could be a model-type babe like you!

You've gotten me through my saddest times: through devastating break-ups and all sorts of unmentionable difficulties. I sometimes wonder if I would have gotten my sorry ass out of my desk chair and away from work if I didn't know I would have to face a huge "gift" from you on *this* side of our front door!

I adore hugging your big, beautiful self. I adore looking into your sweet, sad eyes; the way you put your head on my knee and gaze up at me lovingly. There's *nothing* like that look, Zuli; nothing. I've grown so used to living with a big powerful and agile lioness that it's just too weird and painful to watch you age. Now you have a degenerative disease of the spine, my heart breaks watching you painfully drag your back legs down the street. Sweetheart, I know I need to start to imagine my life without you, but I just *can't*.

Thank you for teaching me how to be powerful, playful and gentle all at the same time. Thank you from the bottom of my heart for always accepting me for who I am. Thank you for defending me and being loyal. My darling Zu-Zu, you are truly my very *best* friend.

Love,
Judith Z.

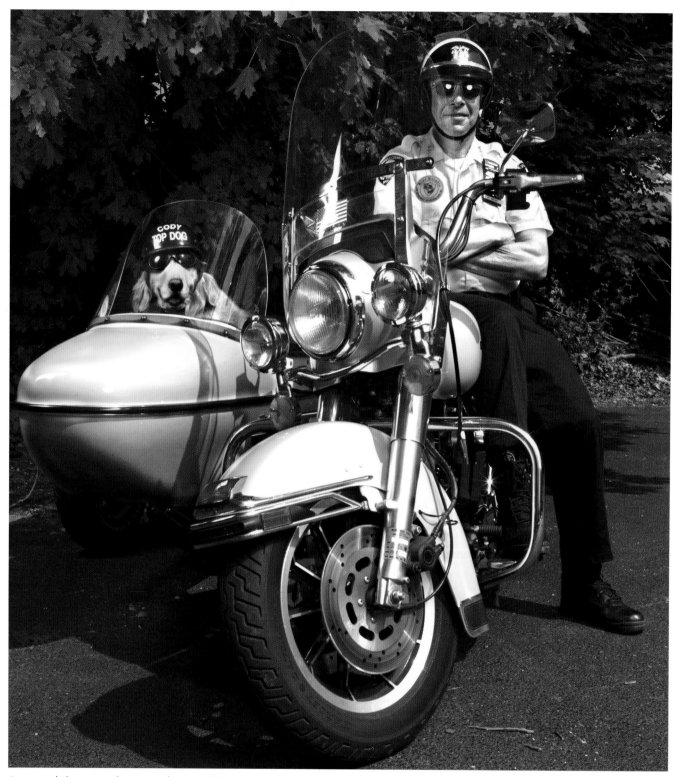

Roy and therapy dog, Cody, a golden retriever, on their Harley-Davidson.

Dear Cody,

You and I met 6 ½ years ago and we bonded immediately. You were returned like a defective piece of merchandise because they didn't understand that you were just a precocious, inquisitive puppy. I was the lucky one.

You are more than just a partner to me. We enjoy going for rides together on the Harley. The side car is just for you. You are a big hit in parades and events. With your unique personality everyone recognizes you. Everyone knows you by name in the nursing homes and look forward to seeing you to brighten their day.

When our unit was called into NYC on Sept. 11th to respond to the terrorist attack on the World Trade Center, I faced horror that there are no words to describe. After the first few days I decided to bring you with me to help as a therapy dog to help relieve the stress from the workers down there. Maybe I was a bit selfish . You made me feel better being there with me as well as helping others. You responded like a true soldier. I have been called a hero for my efforts at Ground Zero, however, you are my hero!

People say dogs are man's best friend. That is an understatement. You are not just my partner—you are truly my best friend, my other son. Thank you. I love you.

363 ROUTE 111, SUITE 5
SMITHTOWN, NEW YORK, 11787
Phone: 631-382-7722
Fax: 631-382-4042

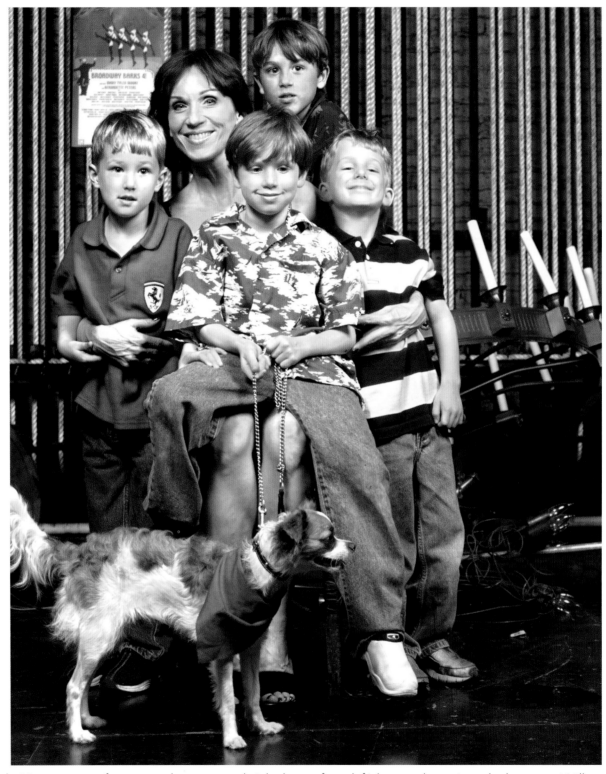

Marilu Henner, star of stage and screen, with (clockwise from left) her nephew, Joseph, her son, William, her nephew, Nicholas, and her son, Christopher. On the leash is Betty Davis, a rescued dog.

City Critters, Inc.

City Critters, Inc., is a small 501(c)(3) cat rescue and adoption organization based in the Borough of Manhattan in New York City. Formed in 1994, it is an all-volunteer organization that depends on the hard work and passionate commitment of about 50 volunteers. City Critters' mission is to reduce the suffering and death of animals in New York City by rescuing and placing stray and abandoned cats and kittens, promoting the spay/neuter of all companion animals, educating the public on local animal issues, and offering advice or assistance to individuals in our area who are struggling with problems involving homeless cats.

City Critters, Inc. has no shelter; when cats are received, they are immediately taken to one of several local veterinary practices to receive whatever care they need to prepare them for adoption. Then they are moved to foster homes, shown for adoption on the PetFinder website and through pet supply store adoption centers, and eventually find carefully screened, permanent homes. If for any reason an adopter cannot keep an animal, City Critters, Inc. will always take the cat back.

Like all grassroots rescue and adoption groups, City Critters, Inc. is always in need of donations, including donations of cat supplies, and always needs more foster caregivers, adopters, and assistance transporting cats.

City Critters Inc.
P.O. Box 1345
Canal Street Station
New York NY 10013
212-252-3183
www.citycritters.org

Email: info@citycritters.org

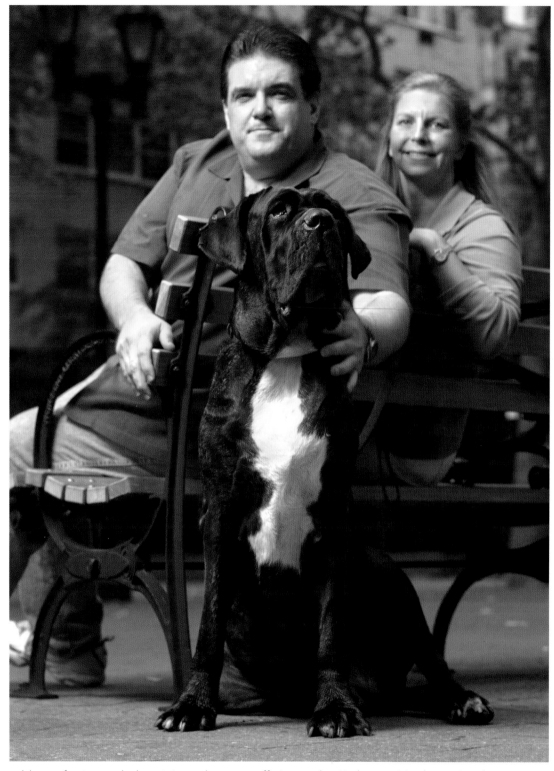

George and his wife, Ivi, with their Neapolitan mastiff, Jet, at the Katherine Hepburn Gardens in NYC.

Dear Jet:

When you were a puppy you melted our hearts and we brought you home. Four years later, we love you more than ever. You are loving and loyal. You make us laugh with your silliness and proud with your protectiveness. You are stubborn, who isn't? You drool, who doesn't? We love you just the same. You have brought so much joy to our lives and are a very special part of our family. You lift our spirits, comfort our souls, and will forever be in our hearts.

Love,

George and Ivi

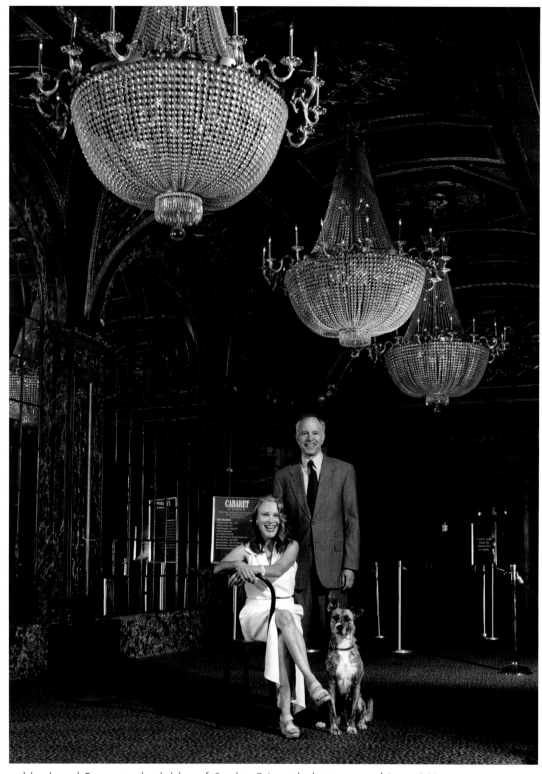

Maureen and husband Barry, in the lobby of Studio 54, with their rescued "mutt," Kenya.

Kenya,

When we lost the first dog of our married lives, Torch the most glorious German Shepherd, our hearts were so broken we couldn't imagine when we would be strong enough to have another dog. Then Destiny went on a spree and you journied into our lives. The sheer number of events that had to occur in their exact order to bring us together is mind boggling. Firstly, you are a mutt! How many dogs had to be attracted to one another to create you? And how is it on the very last day of your alloted grace time at the Municipal Pound we saw you, Stripes, and brought you home? Now two years later we know how your incredible personality and tremendous warmth have enriched our lives beyond our wildest dreams,

We are all so very lucky,

Barry and Maureen Moore Vener

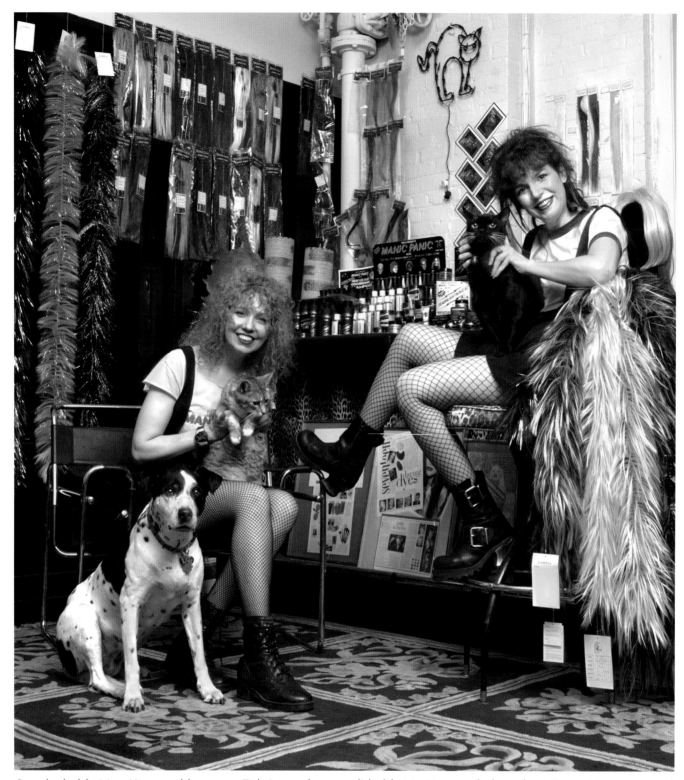

Snooky holds Mrs. Kitty, and her sister Tish (seated on stool) holds Mr. Kitty; with their dog, Daisy Mae, a mixed breed "Pitmation" in their showroom.

Dear Daisy Mae,

I love you very, very, very, very much! You are the love of my life! I never knew it could be like this!

When I found you running by the highway in the Bronx you were very thin and had pieces of tar stuck to your back. I lured you into my car with cat food, (for which you still have a taste!).

Tish and I have rescued lots of animals from the streets of N.Y.C., and have found them all wonderful homes. We kept quite a few of the cats we rescued, but you were the first dog we kept. You've been our constant companion at work, our protector on the streets of N.Y. at night, you've "modelled" for our Manic Panic catalogue and even appeared with us in the movie "Die Hard 3", where you were dyed (temporarily) pink! Most recently you were the ring-bearer at my wedding! I'm so lucky I found you!

Love,
Snooky

Dear Mr & Mrs Kitty,

About 11 years ago, our friend Susann Dalton told us about a beautiful, sweet man named Miles who was going through the final stages of AIDS & could not keep his adorable cats. Although it broke his heart to give you two up, he knew that he could visit you during the day at our business "Manic Panic."

When you first arrived, Mr Kitty, you had only one white whisker & now your Choobers* are covered with them! They make you look even cuter! And Mrs. Kitty, as a desk cat you are doing an excellent job getting us through that boring paper work by pushing all those unimportant documents onto the floor so that we can pat you properly! You both give us joy, therapeutic cuddles and tender loving Goobs*! We can feel Miles looking down at us all with a big smile. Love, kisses, & Goobs,
Tish

≋: Animal Language Dictionary :≋

* "Choobers" \ chōēbers \ - cheeks of mammals where whiskers grow

* Goob \ gōēb \ - the act of a cat rubbing the side of its mouth against someone or something, leaving a slightly wet trail, often smelling like fish or liver.

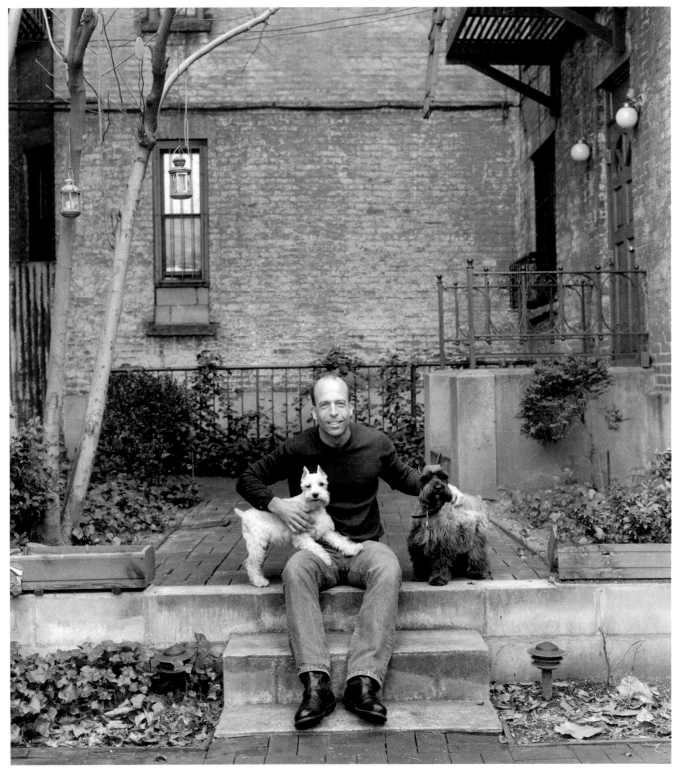

David with his two miniature schnauzers, Electra (white) and Strauss, in their courtyard.

August 4, 2002

Dear Strauss and Flektra:

It is funny how sometimes I get so busy I don't even remember what I had for dinner yesterday, yet I remember in vivid detail the moment I first laid eyes on each on you, and those first moments we spent together: Strauss, sleeping on my lap during that long drive back from Massachusetts, and Flektra, so little and scared, clinging to my sweater as we walked back to the apartment in the snow

My only hope is that I am able to give you half the love you give me, and that I am able to take care of you both as well as you take care and protect me.

Daddy

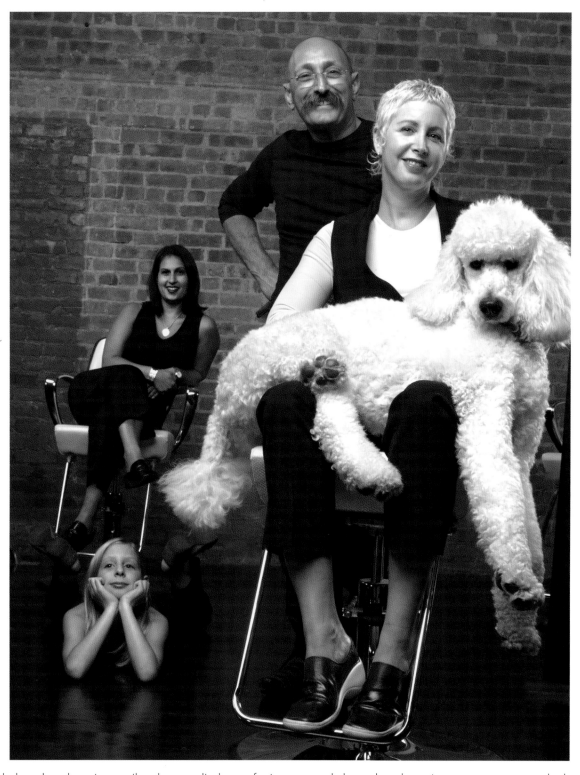

Richard, his daugther Laura (background), his wife Joyce, and their daughter Anastasia, pose with the family standard poodle, Remy, at Maximus Salon in Manhattan's Soho district.

Dear Remy,

What is it about me that makes you want to lie at my feet for hours at a time?

What is it about me that makes you do cartwheels whenever you see me, even though only 5 minutes have passed?

What is it about me that makes you gladly get up out of a dead sleep just so you can escort me to the front door to say "goodbye"?

What is it about me that makes you want to follow me from room to room even when your food is elsewhere?

What is it about me that makes you want to accompany me on every car ride even for a quick 2 minutes to the bus stop?

But finally, what is it about me that you never seem to tire of, want to replace with another, and accept me unconditionally with all my moods and mishagas?

Do I have such a magnetic personality? Am I that charming and irresistible? Or is it because you have this uncanny ability to bring out the best in me?

You disarm me in a way that no one else can. The big question is "What is it about you"?

Why can I look at you with such pride and amazement and truly feel that you are the most handsome, smartest, exceptional dog in the world?

Why can I sit and stroke your beautiful fur, bury my bare feet in your luxurious coat, and simply just look at your face for limitless amounts of time without tiring?

You're able to soothe and comfort like a fireplace on a cold winter night. You're medicine for the soul with only the greatest side effects. If we could bottle your magic, the Rx would read: " take 1 dose every morning, everyday, for the rest of your life and recommend it to everyone you know. I'd pay you forward. What a wonderful world this could be…

We love you Remy boy,

Love, Mommy Joyce xoxoxoxoxo

Leslie and his mixed breed dog, Ellie, in their apartment in NYC.

6/20/02

DEAR ELLIE,

WHEN YOU WERE 10 MONTHS OLD, YOU WERE IN THE MARKET FOR YOU 4th OWNER. AT THE AGE OF 45, I WAS IN THE MARKET FOR MY 1st PET. YOU WERE LIVING IN A BROWN STONE ON ST. MARKS PLACE. YOUR OWNER AT THE TIME WAS MOVING TO CALIFORNIA AND COULD NOT TAKE YOU WITH HIM. MY FRIEND DROVE ME TO PICK YOU UP. YOUR OWNER GAVE ME YOUR FOOD, WATER + FOOD BOWL, BRUSH, LEASH AND NAIL CLIPPERS. I WAS CLUELESS ON HOW TO TAKE CARE OF YOU, BUT I GOT HELP + DIRECTION FROM MY FRIEND.

WHEN I GOT YOU I WAS SUFFERING FROM MANIC DEPRESSIVE ILLNESS. I WAS AT TIMES AFRAID TO LEAVE THE HOUSE. YOU MADE ME DO THINGS I WAS AFRAID OF. I HAD TO WALK YOU EVEN THOUGH I WAS AFRAID TO INTERACT WITH PEOPLE. ~~The~~ BECAUSE YOU ARE SO LOVEABLE PEOPLE WERE ATTRACTED TO YOU. I WAS FORCED TO SAY A FEW WORDS TO THEM. AS THE YEARS WENT BY, YOU HELPED ME ACQUIRE MORE COURAGE AND WILLINESS TO TAKE MORE CHANCES.

TODAY I LOVE GOING OUT WITH YOU. WE GO OUT 5-6 TIMES A DAY AND I LOOK FORWARD TO MEETING NEW PEOPLE, ESPECIALLY PEOPLE WITH DOGS. YOU RECENTLY HAD SURGERY AND YOU HANDLED IT SO WELL. YOU PUT ME IN A POSITION OF TAKING SPECIAL CARE OF YOU. I HAVE NEVER TAKEN CARE OF ANYONE OR ANYTHING, BEFORE I GOT YOU.

ELLIE YOU MEAN SO MUCH TO ME. IT WOULD BE A LONELY LIFE WITHOUT YOU.

ELLIE YOU ARE THE GREATEST THING THAT EVER HAPPENED TO ME.

ELLIE, I LOVE YOU VERY MUCH.

Leslie

Marilyn (drying hair) and Ashen in their Queens, NY bathroom with their mixed breed dog, Jackson Oliver Coolibali, or "Jack" for short.

Dear Jack,

Attached please find a copy of this month's invoice for all of the property and personal items you have chewed, ripped and/or destroyed. Please remit payment at once.

We still love you,
Marilyn & Ash

P.S.
Stop peeing in the neighbor's yard.

377939

INVOICE

Customer's Order No. _____

Name **JACKSON OLIVER COOLIBALI**

Date ____ 3/1 ~~19~~ 2002

Address **FOREST HILLS, N.Y.**

QUAN.	DESCRIPTION	SOLD BY	CASH	C.O.D.	CHARGE	ON ACCT.	MDSE. RETD.	PAID OUT	PRICE		AMOUNT
12	DISHRAGS								18.	00	
1	ASHEN'S MICKEY MOUSE T-SHIRT								15.	00	
1	SONY PLAYSTATION JOYSTICK								34.	00	
3	PAIRS OF SLIPPERS								29.	99	
1	MARILYN'S FAVORITE METS CAP!								25.	00	
1	COTTON COMFORTER								69.	95	
4	GLASS CANDLE HOLDER								9.	95	
2	COUCH PILLOWS								60.	00	
1	PAIRS OF GLOVES								12.	00	
1	MARILYN'S NEW SUEDE SHOE								39.	00	
1	PAIR PUMA SNEAKERS								54.	00	
4	TOASTER OVEN								59.	95	
1	VHS TAPES								39.	80	
	JASON'S ABERCROMBIE HAT (DAY OF SHOOT)								20.	00	

ALL claims and returned goods MUST be accompanied by this bill.

Rec'd By _____

$486.64

95

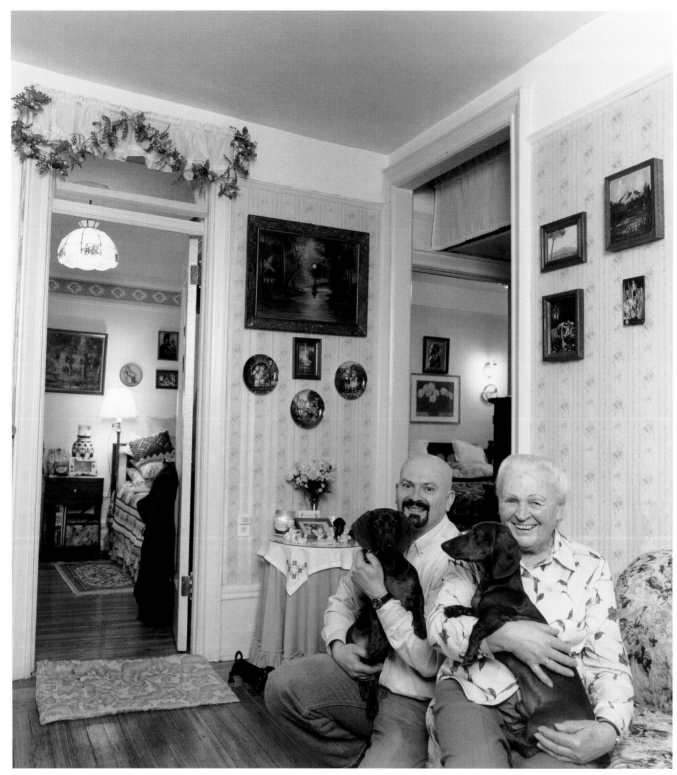

Roman and his mother, Natalia, with dachshund puppies, Jerry and Brevko.

A Dachshund Tail..... 2002

I think it's the break of day..... sun creeping in through a crack in my blinds, but that's not what's waking me up. I stir and already you've washing my face with your sloppy, wet dachshund kisses. There's no hiding from you... I pull the covers over my head, dig deep into my pillows, but you persist and you're STILL able to get to me! OK... I give up.... happily (but I don't let you know that). I'm getting dressed, you run around searching for your leash, all the while looking at me. I carry you down the stairs, you wrap your paws around my neck and the kisses continue. We get outside and you lead ME around, tails high in the air, a Gene Kelly skip't each step & you show me where we need to go. Strangers pass by and giggle as they look at you. Some call you a hotdog, others a weiner dog, others stoop to pet you, but you don't cave & just turn away.... you've saving this time for me and you've letting me know that. Every once in a while you turn around to see if I'm still behind you. Your paws are so fast, they're like a blur I can barely keep up..... yeh..... I'm here... You notice other dogs, but you quickly turn away.... you have another purpose already in mind. Your curiosity is intense, you're on guard. Your appreciation for time spent with me is immeasureable, your love.... unconditionable. It's then I realize I want to spend the rest of my day with you.... and maybe share my lunch with you.....

Are you really man's best friends ?? Nah Brovko Yarko.... just MY best friends!

Damn... I love you both.... Ron

You came into my life when my heart was broken. You brought back to me happiness and tranquility. Both of you, such small puppies, and yet you delivered such strength. There are so many beautiful stories written about Dachshunds, and they are about your love, devotion, curiosity, mischief, attachment and unparalled loyalty to your owner. But I am not your owner,... I am your MAMA! Your stubborness makes me laugh, your mischief gets me flustered, but your sad, forlorn gaze, makes me quickly forget about the mess you just made. You are philosopher, moreso than Plato or Socrates, and you definitely have a mind of your own. I know that I am spoiling you, but that is what love is know to do, and I am finding more ways to spoil you each day. I guess I am giving back to you what you have given to me — somehow you're still ahead of me. I realize too, that anyone who hasn't loved a dog like you, Brovko and Yarku, probably doesn't know what love is!

MAMA

97

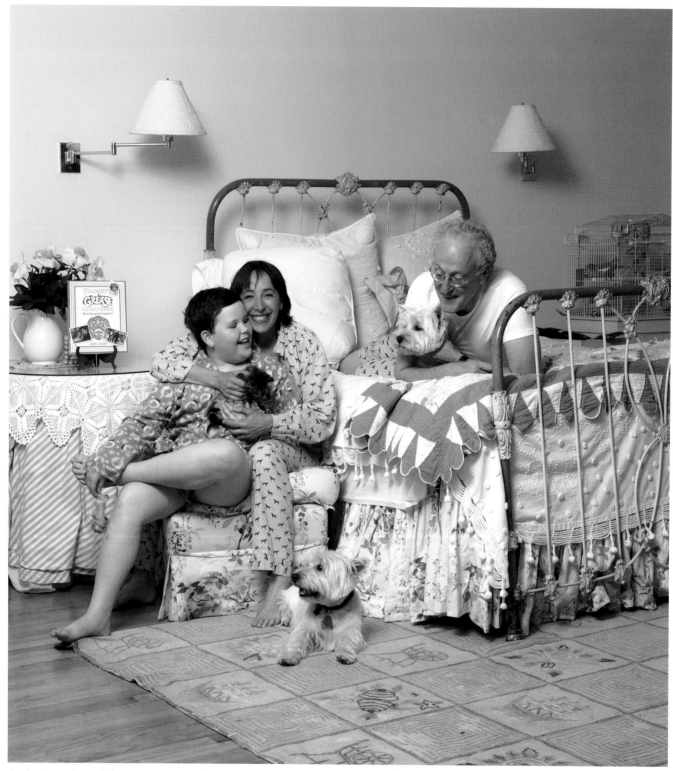

Didi, David and their son, Daniel, with Yorkshire terriers, Romeo and Moses, and kitten, Ms. Kitty. In the cage is their bird, Ricky II (not pictured is the hiding cat, Mr. Lacey).

Dear Pets...

(for Romeo, Moses, Mr. Lacey, Ms. Kitty and Rikki Tikki Tembo II)

Words and music by
David Shire

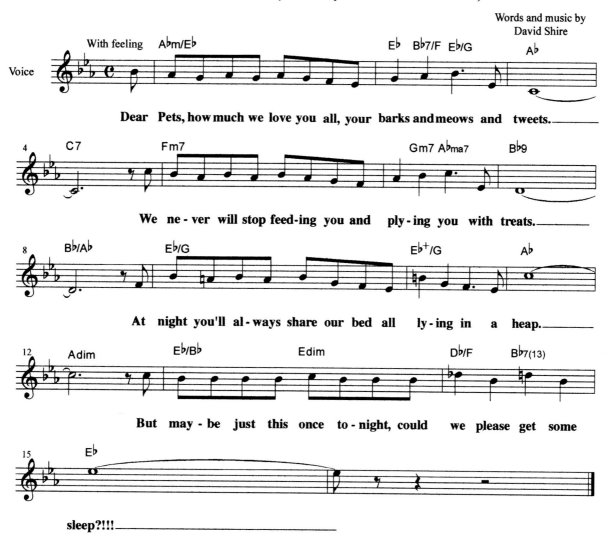

Dear Pets, how much we love you all, your barks and meows and tweets.

We ne-ver will stop feed-ing you and ply-ing you with treats.

At night you'll al-ways share our bed all ly-ing in a heap.

But may-be just this once to-night, could we please get some

sleep?!!!

With much love,

[signature] and Didi and Danny

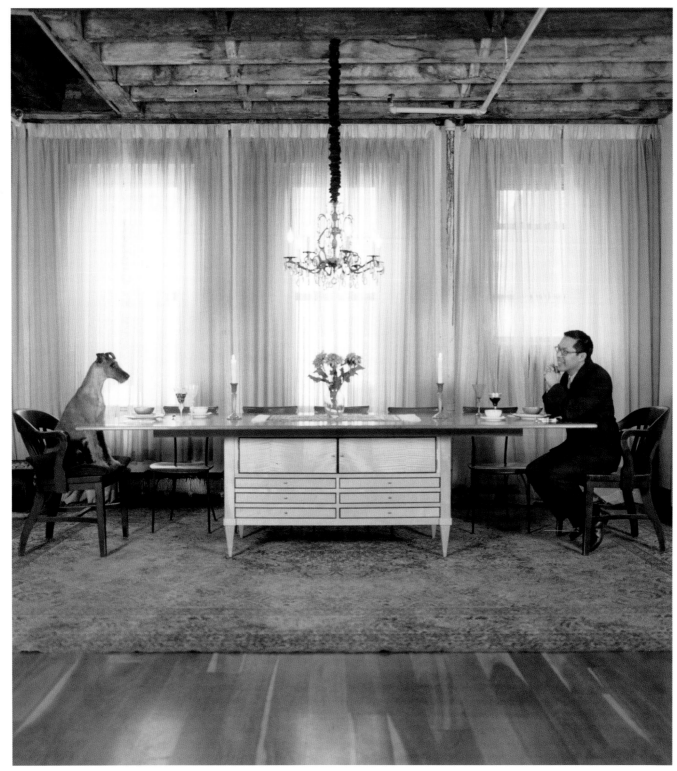

Lance and Irish terrier, Buster, in their loft in Manhattan's Soho district.

My dear sweet Buster,

 I still remember the first time we went to visit you. When seeing all of
your adorable baby brothers and sisters, we immediately connected. I
remember saying to Guy, "I hope the puppy looking at me is our Buster!" All
of the other pups were just lying there and your intense gaze caught my eye.
Then you walked across the patio to say "hello" to me. From the first
second we saw each other we have been connected on such a profound
level that words cannot express the love I feel for you. I know the relationship
between pet and owner is a remarkable union with such unconditional love,
but what we share goes far deeper than what anyone can imagine.

 Your companionship at the gallery and every minute of the day gives my
life reason. Sometimes when walking through SoHo I imagine the two of us as
the dynamic duo. Certainly all of our friends can imagine that situation since
we are inseparable. I love sharing all of my secrets with you too. You truly are
my best friend.

 I have always felt that someone sent you to me as my guardian angel.
Thanks for protecting me, bringing such joy and happiness into my life, and
making me smile. Your many expressions and actions remind me that life is
short and to make every minute count. I have enjoyed the past six and a half
years with you by my side and look forward to the many years we still have
to learn and enjoy from each other. You are truly my soul mate and I know
there will be nothing that could replace you.

I love you Buster, now and forever,

Daddy Lance

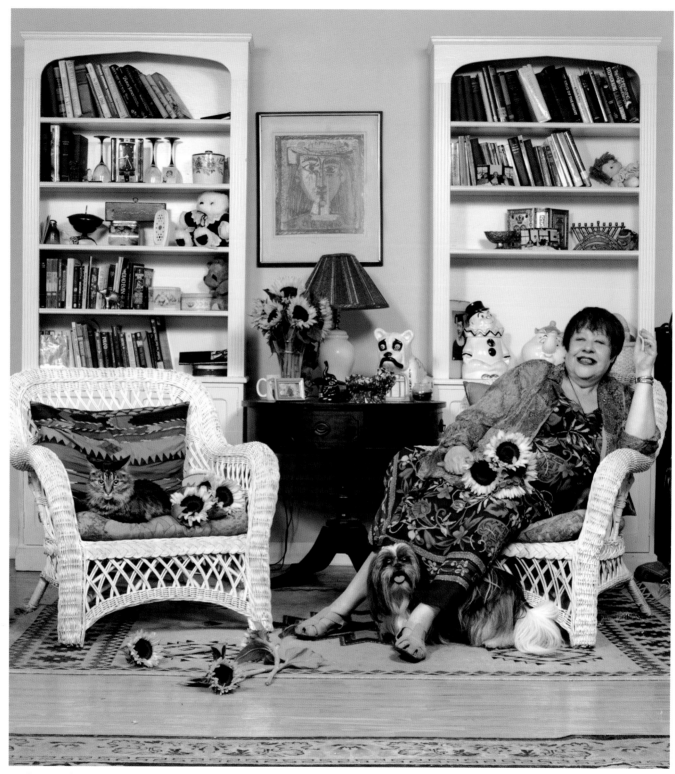

Helen and her shih tzu, Miranda, and rescued Maine Coon cat, Humphrey.

Dear Arturo,

Did you ever know that you're my hero? You fell seven stories, and endured a broken pelvis, silently suffering. I created a hospital room for you, foam rubber mattress, flowers and soft music. This was too boring for you. You crawled into a closet, pulled down a dress of mine, and rested there alone in the dark till you felt strong again. I love you. My handsome Patient boy.

Dear Miranda; –

I found you in a pet shop when you were three months old, and my life was in a lot of disarray. I had never bought a dog from a pet shop, I always adopted them. I regret nothing. You have been a joy in my life, my shining star. We even have birthdays one day apart.

You are stubborn, you are smart and you are my sweet loving girl.

— Helen Hawks –

103

David with Buffy and Princess, his cocker spaniels, at the Port Washington Rail Yard.

Dear Buffy,

You are number one and will always be my sweetheart. You are so loving and smart and loyal to your Daddy. You take care of your little sister Princess and tolerate all of her mischievousness and annoying ways. You patiently wait for me to arrive everyday. There are no boundaries or conditions to your devotion and your sensitivity to all situations. You are not humane, you are beyond explanation.

I will love you forever.
Daddy

Dear Princess,

You are the baby and I now know you will never grow up. Your day consists of when you will eat, when you will get treats and how much you can kiss and show your affection. There could never be another so determined to get in, get out of just have it your way. You give and require constant attention and can never be left alone. You are my shadow.

I will take care of you forever.
Daddy

Togetherness

Dear Buffy and Princess,

Together you light up my life and I know you both love me too! There is only happiness when we are all together we are free-------

Love Forever,
Daddy

Dearest Buffy,

Of all the dogs we have even known, you are the best! You are so smart and faithful and cute. People stop and pat your back. You brighten our days with your presence and tricks. You are friendly and adorable and so funny. When I'm eating, you scratch my legs, asking for food. When I'm sitting on the couch, you jump up and lick my hands and face because you appreciate how I care for you. When I'm working, you let me know when someone is coming to the house because you bark and scratch at the door. You are my watchdog. During the night, you sit at the door, watching for the light of my car that reflects on the wall, waiting for me so excitedly. We hope you will remain as loving, faithful and adorable as you are now. We want you to be strong and healthy so that you can enjoy and appreciate the beauty of life at its best.

With all our love and care,
Ray, your caretaker
Leoni, your housemaid

Dearest Princess,

We love you too. You are the baby and a little darling to us. You make us happy every day performing your tricks and doing funny things. When I walk, you make a circle around me all the time. You are so energetic and always running. You are always hungry and craving for snacks. You are so beautiful and adorable, too.

We will love you always.
Ray, your caretaker
Leoni, your housemaid

Shular Hensley, 2002 Tony Award Winner for his performance in *Oklahoma*, holding Peanut, a rescued dog. With him are his lovely wife, Paula, and sweet daughter, Skylar.

A CAUSE FOR PAWS

rescue & adoption
•NYC•

A CAUSE FOR PAWS is a 100% volunteer, non-profit organization dedicated to rescuing animals from the streets of New York City and the local kill shelters. Because we have no shelter of our own, we foster and board all of our animals until we can find them permanent, loving homes. Our goal is to not only alleviate the suffering of New York's homeless animals and save as many lives as possible, but to educate the public about the importance of spaying and neutering. Additionally, we strive to create awareness about the consequences of breeding and buying. Every penny from donations goes directly towards the care of rescued animals.

In the past two years alone, we have managed to rescue and place over 400 dogs and cats. While we are extremely proud of those numbers, it's obviously not enough. Every day thousands of animals are abused, abandoned and killed for no reason at all. And we feel it's our responsibility as humans to live up to the term man "kind".

If you would like to view our recently rescued animals, please visit:
www.acauseforpaws.com

We are grateful for any donation, large or small.
Every little bit helps. We have been able to give these beautiful animals a second chance, but their survival and happiness wouldn't be possible without your help too.

Matt and his gorgeous wife Nicholle in their apartment in the Turtle Bay section of Manhattan, with Asia, and German shepherd and wolf mix, Kyra.

Dear Asia & Kyra:

Thank you for all the entertainment and the playtime but especially thanks for all your

Love! ♥

Matt & Nicholk

Fran and her Jack Russell terrier, Lira, in her Manhattan penthouse apartment.

Dear Lira,

I have been asked to write you a love letter, not an easy task to put into words my feelings for you.

I think what I love about you most is your independence and indomitable spirit. You play only when you want to play. You allow humans (me included) to pet you only when you are in the mood to be petted. Most of all you exploit every chance you get to be free. Years of being a "New York" dog has not diminished your desire to run like the wind to chase whatever may be out there, real or imagined.

The last time you ran, this past Christmas night, I was sure that I would never see you again. It was pitch dark and freezing cold in those Connecticut woods. Having seen a herd of deer earlier in the day, you bolted out the door first chance you got and were gone in a flash. What incredible survival instinct sent you to a home many miles away where your soul sister was in residence for the holiday? How did you know when you scratched at the door that the owner of a nine year old jack russell who lives in New York and runs away at every chance would be there to greet you?

And so I hang on to your leash even tighter than before. I know that your desire to run is as strong today as it was when you ran away the first time as a four month old pup. Some would say if I really loved you, I would let you do that for which you were bred. I CAN'T. I know its selfish, but I love you too much to lose you that way.

Love,
Fran

111

Scott (on bench) and his partner, Peter, with their 14 year-old Briard mix, Moolly.

July, 2002

Dear Moolly,

We were not sure we were ready for a big furry dog when we adopted you back in 1990. You appeared in the cast of "Annie 2" at the Kennedy Center in Washington, and since the show closed prematurely, you needed a home fast, and found one here on West 43rd St in NYC.

Our decision was a lucky one. Moolly (named after 2 other "Annie" dogs, "MOOSE" & "O'Malley"), You have brought more joy to more people + when we walk down the street with you, people stop, stare, yell, laugh + converse!

We love you always and thank you for the laughs and the love.

Hugs & Licks, Scott & Peter

SCOTT ROBERTSON + PETER FLINT NYC!

113

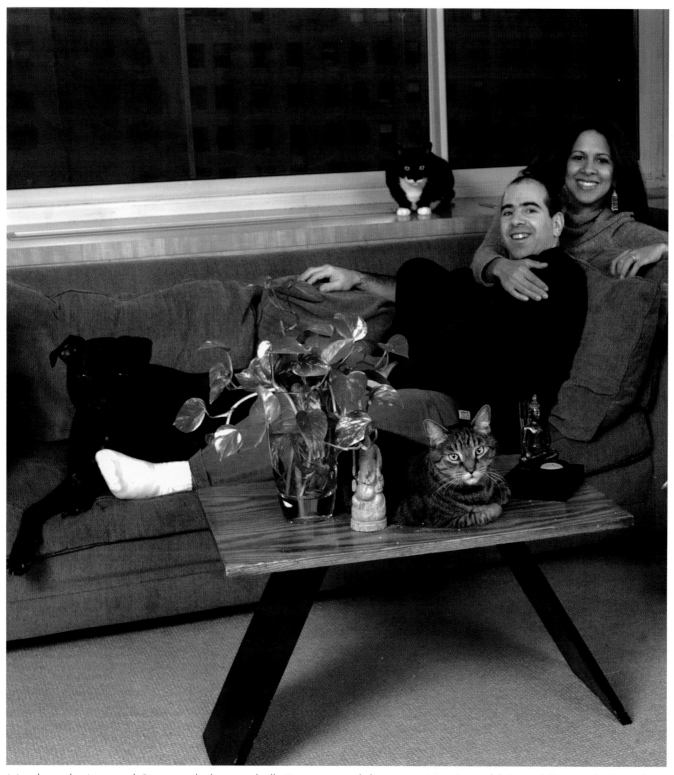

Newlyweds, Lisa and Scott, with their pit bull, Domino, and their cats Max (on table), and Fernando (Ivo, their other cat, refused to pose).

Domino, Ivo, Fernando and Max;

We do so much for you guys daily, and at times it seems you are all secretly plotting against us. On Sept 11th with our home at the center of ground zero you guys and your well being became our immediate concern.

Domino, seeing you Sept 12th was as happy for us as it was for you. At that point we were homeless, dirty and without a plan. Just playing with you was a sweet respite. Within a short period of time we were laughing and playing in a hotel room. It was a far cry from normal, but your presence made it a lot closer.

And to the cats, caring for you down in Battery Park until we could get you out was an adventure Lisa and I will remember forever. In a time of chaos and sadness you guys gave us a purpose. We maneuvered daily through and around check points and the National Guard. Bringing food and water allowed us in our own small way to help our neighbors and some local pets.

We're all together now and back at home. Once again the garbage is invaded, cat fights fill the night and your plotting continues. Life is thankfully getting back to normal.

Love Scott & Lisa

Janice and her black Labrador retriever, Malik, at the WNBC News Channel 4 Studios at Rockefeller Center in NYC.

For Malik —

You're name means "KING" in arabic, and you are truly the King of our castle. Each day, you take your place on your throne (the top of the stairs), to guard and watch over your Kingdom (the front door), hoping that the next person who rings the bell and crosses the threshold will become your new playmate! Your yellow tennis ball is never far away (usually under your graying chin) and you are always ready for action.

I miss you when I'm at work. Whenever I call home, my very first question is "How's Pooch?" or "Where's Doggie?" I love that you respond to all the little nicknames I have for you. You love to lie on your back while I rub your belly, and you never miss the opportunity to treat yourself to any goodies that fall to the floor (your favorites are potato chips and all things crunchy). I'll never forget the time you swiped the meatloaf, the side of raw bacon, and grandma's sweet potato pie — you really know how to live it up!

I hope you live a very long time. I will miss you so when you are gone. Mostly, I'll miss holding your face in my hands, kissing the top of your head, playing with your velvety soft ears, and watching you dream of chasing squirrels. I'll miss the way you make me giggle at the silly things you do. But I believe that all doggies go to heaven, and when you get there you'll take your place on your throne, and all the other doggies will call you "KING!" — MALIK — or just plain "POOCH". ☺

love,
Mommy

117

Greg, with his bright red snake, Greg Jr., and his cat, Pearl.

Dear Pearl and Greg Jr,

I know you two have been trying to eat each other alive for many a year now. Pearl sits on Greg Jr's tank and you stare each other down in some Discovery Channel standoff.

I wonder who'd win in a fight. You're both quick and mean as hell. Pearlie's got those sharp fangs and claws, but Greggie's a strangler and could swallow a cat whole. Let's just call it a draw!

Enough of this sibling rivalry crap-or it is off to reform school for both of you. Anyway, I love you both the same!

xo - Daddy

Alfred 'holding' his chihuahua, Gibson; Elecktra, a chow chow/German shepherd/Labrador retriever mix, and Shannon with Diesel, their golden retriever.

Dear Elektra, Diesel, and Gibson,

Tell us again why we love you, as it's 3:00 AM... Cats knock over the glass vase – Crash – Wet - Dogs wake up. **Fire 1**: Bark. **Fire 2**: Dogs chase cats. Scamper. Scatter. The pursuit begins. More crashes. **Fire 3**: The third dog sounds the alarm, makes the announcement: Let the games begin! Bark. Woof. Howl. Meow. Each beast joins in, cheering his favorite contestant. Apartment no longer a home. Converted to a demolition derby. Humans up (reflex, not awake). Must referee the chaos. Too dark. Too tired. Too late! More crashes. All creatures - two-legged and four-legged – are up. Damage Report: Can't see it, but can find it by stepping in it. Tell me again why we love you?

When we thought about what we should write to the three of you as an expression of our love and devotion, we only had to think back to the many conversations we've shared, in order to capture a bit of the essence in each of you that touches our hearts:

"I can fly! I can fly!"
> Gibson, during his third week with us, as he realized that his legs were beginning to heal and that he could walk (his previous owner had kept him in a birdcage, causing his muscles to atrophy and the pads on his paws to become blistered and infected).

"You don't see me right now. I am stealing food from the countertop, but I am being *so* quiet. You cannot see me. You cannot hear me. You do not even know I am here. I am...Stealth dog!"
> Elektra, on any given day.

"Go up...up....over to the left...down...to the right...It's just **not** the spot*!*"
> Diesel, incessantly pawing at our hands, as we desperately try to find the spot that he *does* want scratched.

"Look at me! Look at me! I can go 'round and 'round and 'round...and 'round...and 'roooouund...and 'rooooouuuund...Ummm...I think I am going to sit now."
> Gibson.

"I *know* that you can hear me. I **know** that you can hear me. I KNOW THAT YOU CAN HEAR ME! **HOW ABOUT NOW? CAN YOU HEAR ME NOW?!!!**"
> Elektra, while trying to get our attention.

"Have you ever tried to carry a 90-lb dog? Go ahead...pull on the leash as hard as you'd like. I don't feel a thing. La te da, te da. I don't feel that. Nope, didn't feel that. I tell you that I am not moving. If we have to, we'll stay here all night. I am not moving until someone comes out from that door."
> Diesel, while securing a spot in front of Rescue One, oblivious to the fact that his friends, the firemen, are on a call and might not return for *hours*...and, that *Law and Order* is on in two-minutes.

"Psssst. He doesn't even know it's *not you*."
> Elektra, while taking my spot in bed, placing her head on my pillow, spooning Pappy, and wrapping her front paw around his shoulder.

"There *is* a certain regal charm about me, don't you think?"
> Diesel, after being adored by yet another passerby.

"I know that I am cute. I know that you love me. Yes, yes. I know that I am perfect. But, if you would not mind...I just *cannot* fall to sleep while you are staring at me."
> Gibson

...We love you all because no matter how many times you chase the cats at 3:00 AM, or place your head on the side of the bed as you bark us awake before dawn, we just couldn't imagine our lives without you.

PS: Sir Beaureguard, Lady Astor, Miss Chelsea, and Baby Dickens send their love, but wish to inform you that the score is now 'Cats 4 - Dogs 3'.

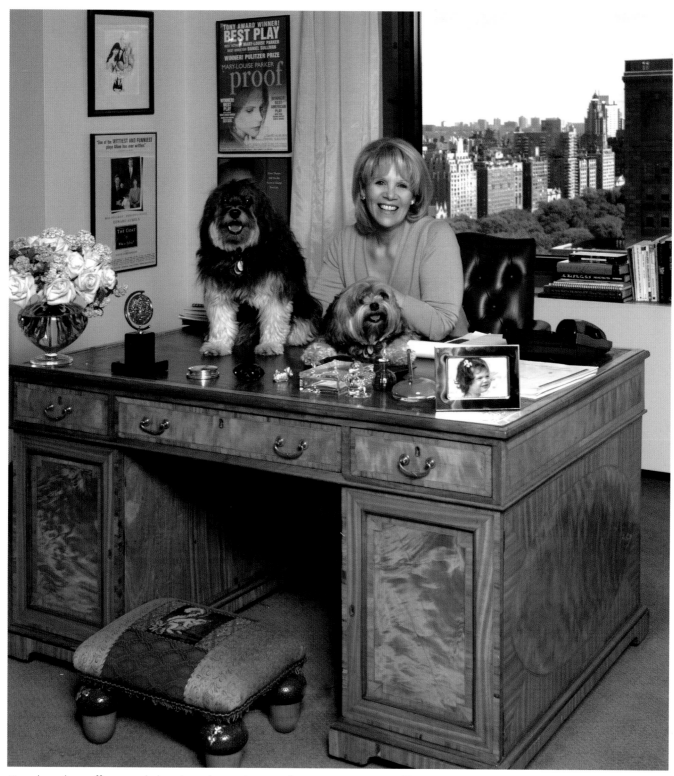

Daryl, in her office, with her Löwchens, Leo and Lucy.

My Dearest Leo (and Lucy too),

Your presence in my life is monumental... you mean everything to me. I look into your beautiful, soulful brown eyes and feel a love that fills my heart. Being near you gives me a sense of calm, comfort and warmth.

Leo, you arrived in my life when you were just four months old, thanks to Amanda who drove across three states to meet the breeder from whom you came. She brought you home to me as I was still mourning the loss of my dear Sheltie, Barkley, who died after fourteen wonderful years in our family. Your arrival was a very happy day!

From the moment we met, you possessed a special, all knowing, Zen-like calm; Like that of a wise old soul. That first impression proved to be your very nature. Now, eleven years later, it is obvious that we've become co-dependent in the best sense. I feel we understand each other's moods, highs and lows, and offer care and consolation to each other. Your head on my lap, or your soft furry body curled up to me is the best feeling in the world.

Three years ago I had the feeling that you might be sad and lonely when I left the house each day. Circumstances presented a special opportunity to adopt little Lucy. You welcomed this frisky pup into your life with the grace and dignity befitting your princely personality. I hope she has proved good company... you are a kind and good-natured big brother to Lucy, not allowing her puppy ways to disrupt your peaceful nature. Lucy is a doll, more doggy and playful, while you are more human in your very being.

Leo, I love you deeply, and am grateful every day for your companionship. I believe you are my soul mate and I adore you.

Love,
Mommy

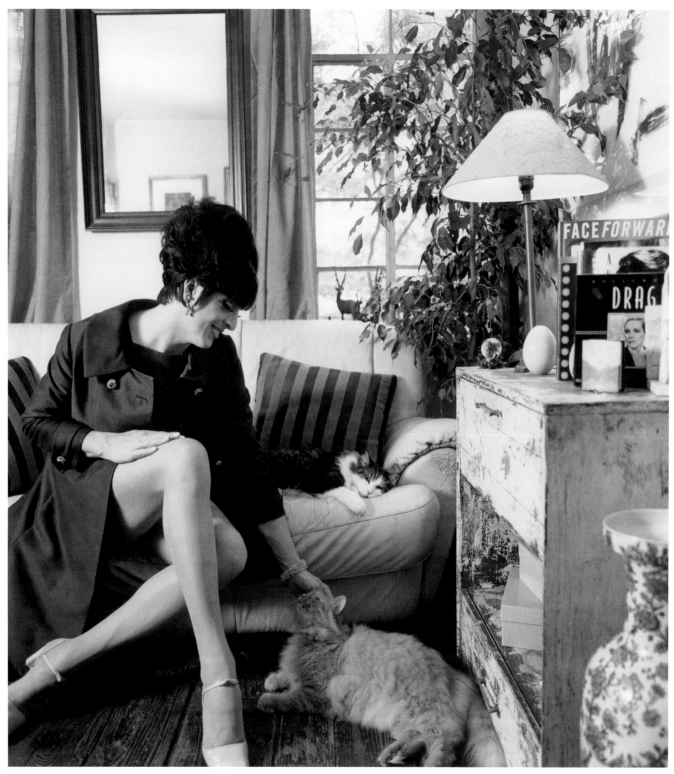

"Edie" with her Maine Coon cat, Skookie (on couch), and long-haired, orange tabby, Booger.

Dear Skookie and Booger —

I love you. I know you know that. I know because the look in your eyes is the same as mine. (Except mine aren't always filled with sleep. At least I know what you're up to when I'm gone.)

Skookie, you are so graceful. So majestic. I was there at your birth 16 years ago and we've been together ever since. You are the perfect companion. But I have just one question for you. What is your obsession with rubber bands?

Booger — so silly. So playful and loving. But a bit of a brat! Always trusting, your human qualities far outweigh your feline qualities. You are the only cat I know who wakes up groggy. I love it.

I feel so lucky we all found each other. I love waking up with you both by my side, waiting for my eyes to open so we can all start the day together. So sweet. But I'm onto you. I know all you are really waiting for is food! But that's OK with me.

I couldn't love you more and look forward to many, many more years together.

♡ Edie

125

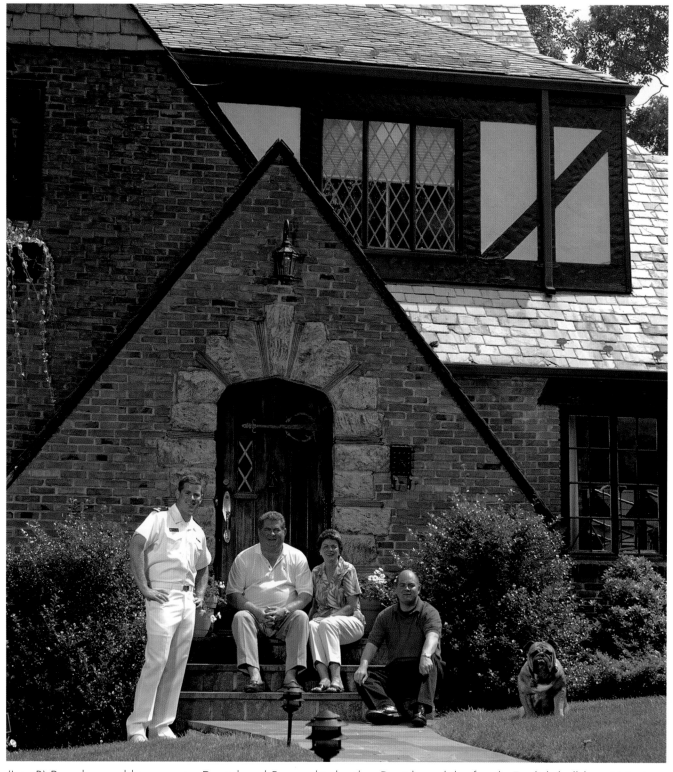

(L to R) Brendan and his parents, Daniel and Peggy, his brother David; and the family English bulldog, Winston, in front of the family home.

What can I say about a dog who won a blue ribbon at the
Greenwich Connecticut Dog Show in the category "Looks Most Like His Master".

What can I say about a dog who snores like a jack hammer waking you up out of a
deep sleep, while needing someone to wake him up in the morning.

What can I say about a dog who sits out on the top step waiting for you to come
home. Then waves his butt so fast that a belly dancer would be impressed.

What can I say about a dog that wears his food and water on his jowls and
affectionately wipes it on you and sneezes on you to say hello.

I say his name is Winston and he makes us laugh.

We love you Winston,

The Gemins Family

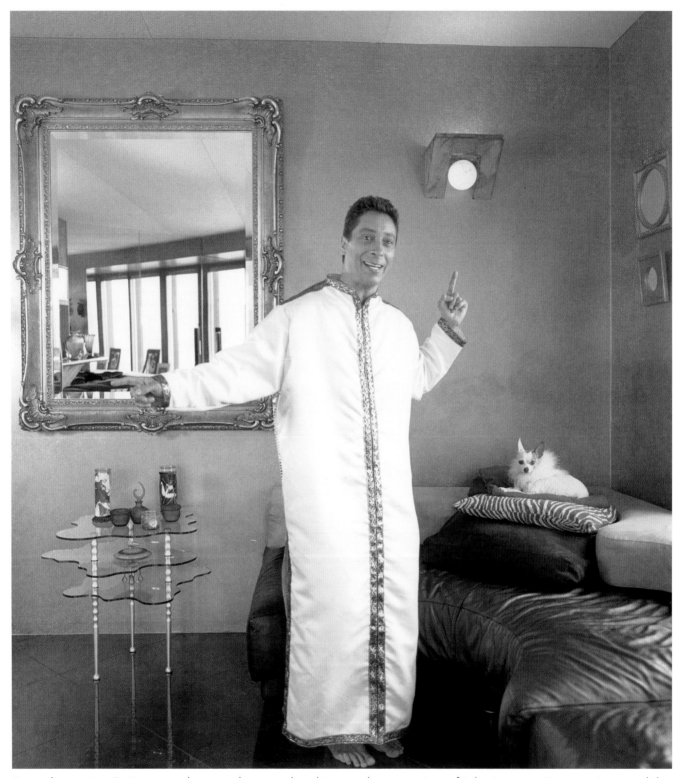

Recording artist, Sir Ivan, made music history when his pop-dance version of John Lennon's "Imagine" entered the Top 40 Billboard Dance Chart 30 years after the original. Sir Ivan with his chihuahua, Chiquita, in their Manhattan apartment.

Chiquita,

Now I know why they call it " puppy love". I'm crazy about you and from the looks of it, you feel the same way about me. I'm a very lucky guy!

You bring me happiness, love and joy. You cheer me up and make everything right. You are sweet, tender and gentle. You are beautiful inside and out. You have so much energy and life.

If you were any cuter, I'd eat you up! Now, if only I could find a real girl like you, a human angel!

<div align="right">

Love,
Sir Ivan (daddy)

</div>

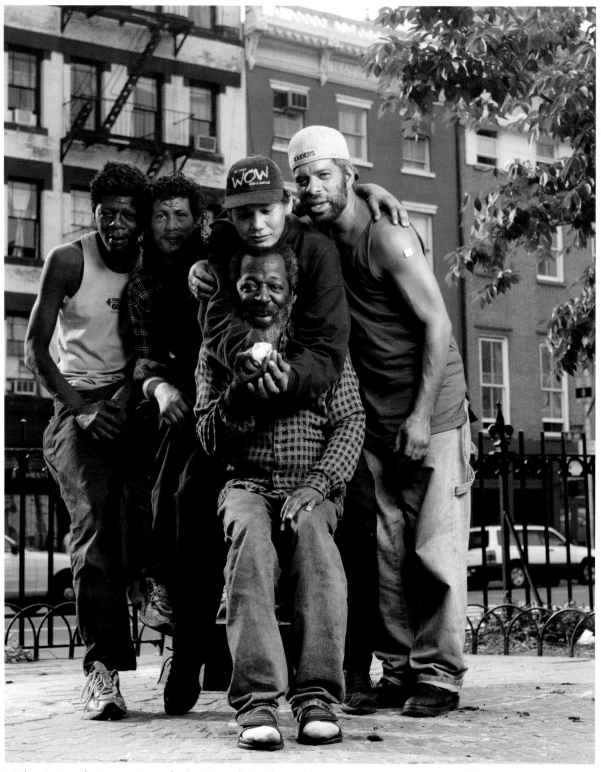

(L to R) "Blue," Angel, Spirit, Steve (below), and Wesley with pet rat, Stewart, in a Manhattan West Village square they call home.

Dear Stewert,

It's me Fabian and Wesley,
I want you to know we loved you
when we saw you.
I love you.
Every time you kiss us,
makes me love you more each day.
I'm sorry we're homeless,
But we try, I want the best
for all.
many times I felt alone you
were there to kiss me, and all
the homeless,
We all love you,
Blue, steve, angel angel, wesley
and me.

P.S.
Never
Stop the
Kisses

♡♡ Lot's Love

Love
From
The homeless
Famely,
who
cares

131

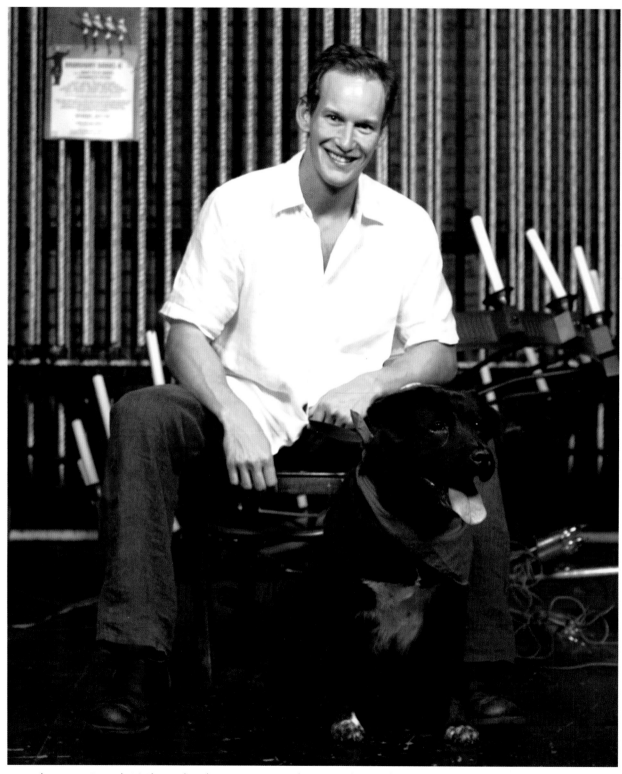

Actor and singer Patrick Wilson, backstage at Broadway Barks, with Laguardia, a stray found wondering the airport of the same name, and rescued by Bobbi and the Strays.

LOVING TOUCH, INC.
P.O. BOX 650404 FLUSHING, N.Y. 11365
(718) 224-8629

www.lovingtouch.petfinder.org

Paul Eiseman - President Doreen Eiseman - Board Member Zulma Cruz - Board Member

Loving Touch is a non-profit organization pursuant to section 501 (c) (3) of the Internal Revenue Service. As such, we are totally dependent on donations and proceeds from fund raising events. All donations are *tax deductible* as permitted by law.

We are a small group of concerned animal lovers based in Flushing, New York who are making a better way of life for many lost, abandoned and stray animals. Our organization is staffed totally by volunteers. Our knowledge in rescue and animal care is derived from a combined 36 years of experience in our field.

Loving Touch was formed and incorporated in February 2000 when we felt the need to form an organization that would do more hands on rescue. Duchess, our first rescue and mascot, gave us the determination to form our group. The elderly, pregnant, flea and tick infested junkyard dog from the South Bronx won our hearts and the hearts of many animal lovers. Her rescue and adoption is one that will never be forgotten.

Aside from rescue we are dedicated to educating people in all aspects of pet care and animal responsibility. We stress the importance of spaying and neutering of all pets. When able, we will take in stray/abandoned animals. Once rescued, each animal is vet checked, tested, vaccinated and altered. Because we do not have a shelter of our own each animal must be placed in a boarding facility or foster home until ready for adoption. We do our best to place each animal in a home that is most suitable for both the pet and the new owner. If ever an adoptive family can no longer care for one of our animals, we will *always* take that animal back into our care.

We have met many wonderful people who share our love and concern for animals and look forward to meeting many more. We have had the pleasure of being a part of many events such as panel discussions and book signings along with well-known authors. We have appeared at Broadway Barks and have been featured on NY1 Cable TV as New Yorkers of the Week.

Our struggle to provide a better quality of life for all animals is supported by volunteers, foster homes and contributions from caring individuals. Without that support we would be unable to help the animals that are waiting for a Loving Touch. Our long-term goal is to have a sanctuary of our own which will enable us to help many more animals than is currently possible. Until then we take great pride and satisfaction in helping one animal at a time.

Peggy and her golden retriever guide dog, Kelly, backstage at a Broadway theatre.

Dear Kelly:

Writing this letter to you will finally give me the chance to let you know just how important you are to me. First, I want you to know that it was love at first sight. We were told not to allow the dogs on the bed and what did you do, you immediately claimed the bed as your own. It hurt me when I had to discipline you in those first few minutes. But being the forgiving creature that you are, you did not hold that against me.

Then there was the time when we were crossing the street, I gave you the command to go and you refused. You were practicing intelligent disobedience. You saved my life.

Everyday you risk your life for me and I want you to know that I love you and am truly grateful. Without you, I would not be able to negotiate these mean streets of Manhattan. I would not be able to negotiate the New York City subway system without a great deal of fear and trepidation. It is because of you that I can go to work each day and become a contributing member of society. You give me independence and love all at the same time. Your loyalty is undying. Would I risk my life for you, yes in a heart beat.

Keep up the good work. You are very much appreciated and loved. I am looking forward to many more years of team work. Thank you.

Sincerely,

Peggy Eason

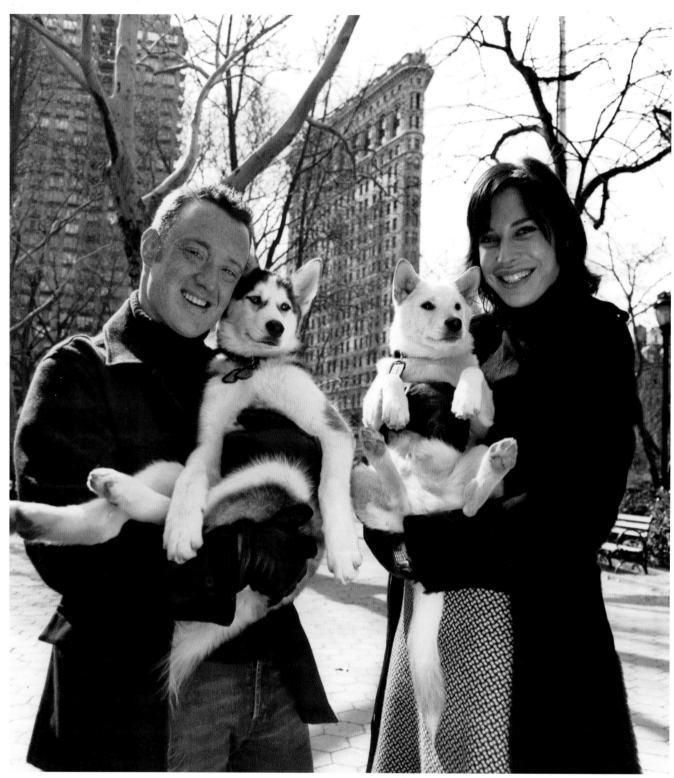

Marc and Andrea with puppies Monty, a shiba inue (in her arms), and Emma, a Siberian husky, at the dog run across from NYC's Flatiron Building.

Why We Love Emma ...and Why We Love Monty

Generally...

Because you're a tomboy

Because you're a ladies' man

The Cute Factor...

You have no clue

... and you know all too well

Sleeping...

You look like a little wild thing when you curl up on the sofa

... and you look like a drunk when you pass out on the coffee table

In the morning...

You howl as soon as the alarm clock rings

... and you nip our ankles if we don't feed you right away

At the dog run...

You go from dog to dog, to "check ID" and confiscate toys

... and you go from person to person, to be pet

Begging...

You're missing that gene. The head-tilted-sideways, sad-blue-puppy-eyes thing is a tad obvious

You're the born con man - conspiratorial winks, smile and all

Scavenging...

You're a master. You eat your treats, then take away Monty's

Sorry, Emma is immune to conspiratorial winks and smiles

In Love...

You jump all over any short male who walks on four legs

... and you jump all over any tall female who walks on two

We love you just the way you are,

Andrea and Marc

137

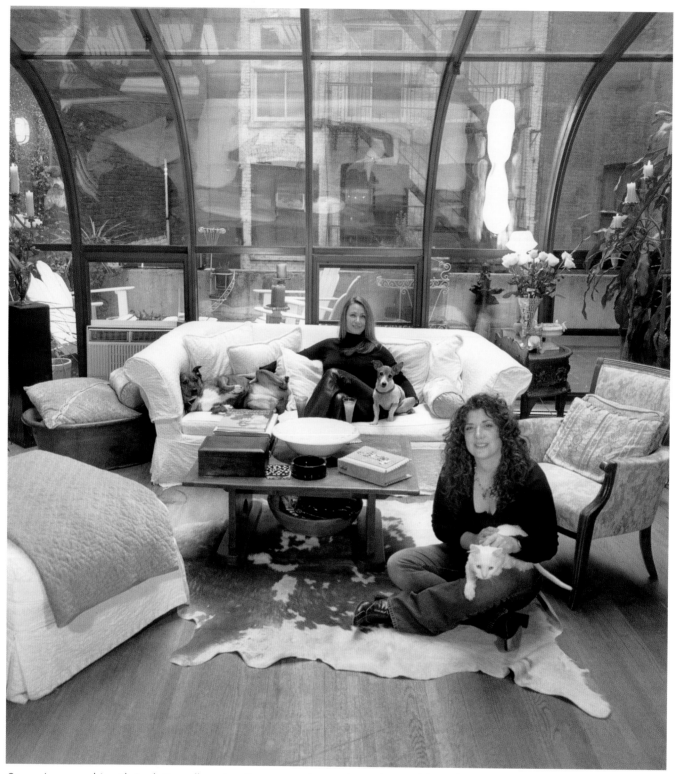

Stacy (on couch) with Jack Russell terrier, Bessie, and an adopted mixed breed stray, Lucy; and her partner, Karin, with their three-legged rescued cat, Gimpy.

Dear Gimpy, Bessie and Lucy,

We know you didn't ask to have your picture taken. It's just another example of how you indulge us.

Gimpy, our little three-legged beauty, you were especially put to the test. You are so small and brave. You know how to turn our one bedroom apartment into a jungle with endless places to hide and hunt and explore. We wonder if the photographer's tripod caught your attention?

If only this were true for our two amazing dogs. Bessie, you first of course, yes, you are the boss of us all. A tight and tiny package with the force of an Atomic bomb. You've decided you'd like a house in the country, an endless game of Frisbee, and a giant yard. But while your mother's work towards that goal, you remain in diligent, if tedious training. Our downstairs neighbors' thank you for the carpet you asked us to install.

And, you, our sweet Lucy, the tiny puppy bought from a junkie for $20. Brought to us in a shoebox, with a belly full of worms and a hernia to boot. How big and healthy you have become, only 25 pounds more than the vet initially predicted. Your gratitude for being loved is forever on the tip of your tongue, and forever returned.

We really didn't mean to get so sappy Gimpy, Bessie and Lu. But since we rarely write, we wanted you to know how much more we like our family portrait because we are five, altogether, not just two.

XOXO
Your Two Mom's Stacy + Karin

Rue and Morrow relax at home with their American short-haired and Siamese mix, Miss Bianca. American Indian Spirit Sticks, designed by Rue's son, Mark Bish, adorn the walls.

Tell me, Bianca, why do you scatter your dry food all over the kitchen floor? And suddenly go plunging down the stairs at ninety miles an hour?

I'm glad you like to dance with me, and sleep on our bed on your heating pad — though I could do without the bites when my foot strays too close. Is that your Siamese blood showing? So it shows in all that talking — "Meow, I'm in the room, hello, everyone, meow, please open the closet door so I can explore; mee-e-ow, oh pleeease let me into the attic so I can climb around and come out covered in schmutz; knock, knock, open the door so I can drink from the faucet; meow, let me out now; obey! drawers to scratch open! Lingerie to scatter! And oh, fresh catnip to graze on! And even better, rose petals! Yum! Now, let me at those scratch posts! Of course, a random swipe at the chair arm or sofa back is sometimes necessary, to assert my independence. Meow, talk to me, and I'll talllk baaack, meeeow ~ "

Oh, Bonkers, you're a good kitty; I love our friendship. And we know morrow is only kidding you when he makes those remarks about your I.Q., don't we? (Oh, come on now, time to chase a ribbon around the floor! Here we go!) —— Rue

FACT IS! WHERE ELSE COULD I FIND A NINE-POUND COMPANION WITH THE GOOD TASTE TO SIT IN MY LAP AND WATCH THE YANKEE GAME, OR RERUNS OF NYPD BLUE AND - OF COURSE - THE GOLDEN GIRLS! Morow

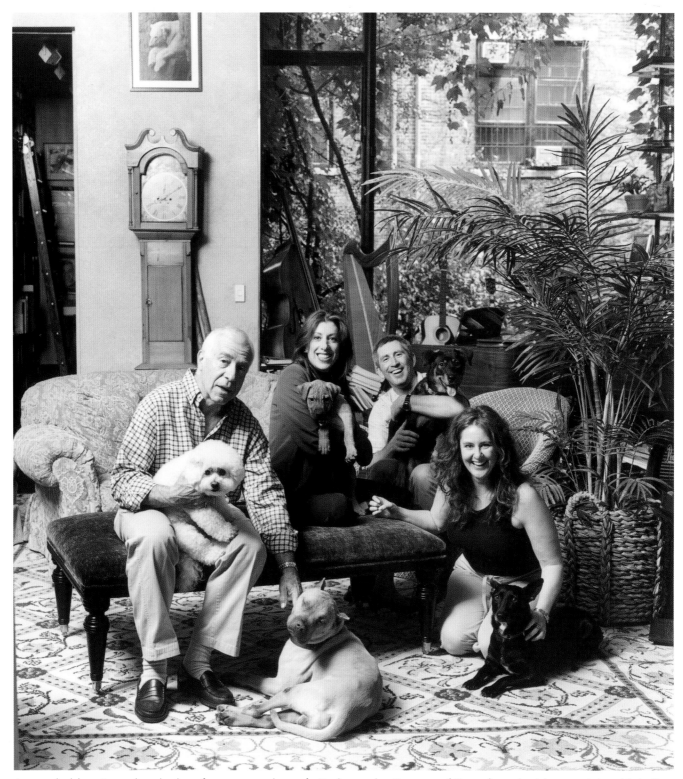

James, holding Lucy, their bichon frise, next to his wife Barbara, the Director of Stray from the Heart, a New York City animal rescue organization. She is holding Pogo, a Chinese Shar Pei mix puppy up for adoption. Volunteers, Richard and Dana, sit with several of the organization's dogs. Stevie (front) is a pit bull that was blinded as bait in a dog fight.

My Dearest Lucy and Winky,

I'm so happy to have a chance to write you guys a letter. For years, I've been expressing my love for you first hand -- or rather hands-on. But putting my feelings about you in writing presents a great opportunity to put into words exactly how much you mean to me.

Lucy, since you're the oldest, I'll speak to you first. Twelve years ago, Daddy and I went to pick you up from the breeder in Massachusetts. You were just two months old. I've never seen anything so cute and wonderful in my entire life. In the long car ride back to our house, as I held you on my lap and nursed you through your first bout of motion sickness -- or was it homesickness -- I knew I was in love. I've never had children, but I can't image a greater love than mine for you. For a dozen years, we've taken walks and runs together, gone on play dates, shared our bed, our food and our lives in every way. We've endured vet visits and thunderstorms, when you shake and drool so much that I fear for your life, but we've managed to get through all that stuff.

Five years ago, when you and I were on one of our nightly city walks in a miserable rainstorm, a scrawny little kitty appeared out of nowhere and followed us home. Daddy and I decided to let the kitty stay in the basement overnight -- we needed to be sure she wasn't carrying any diseases which she could pass on to you. After the kitty received a clean bill of health the next day, I brought her home to try to find her a new home. By that night, Daddy and I were captivated, and Winky has been with us ever since.

Winky, I know that living in an apartment took some getting used to on your part, after your time on the street. We'd come into a ransacked kitchen each morning -- where every piece of bread or cracker or other food left on the counter having been consumed. But pretty soon you learned that your food would always be there, and so would an abundance of love and playtime. And it wasn't even that hard for you to get used to Lucy, once the dog learned who was boss! The two of your have lived together ever since in what Daddy calls "a wary co-existence".

My love for you two has grown over the years to include almost every dog or cat I came into contact with. Several years ago, along with two friends, I started an animal rescue organization which we named *Stray from the Heart.* To date, we have successfully rescued over 400 dogs from the streets of New York and other horrifying conditions of starvation, abuse and neglect. Each has been placed in loving homes with caring parents. I wanted to show off, in the accompanying picture, some of our wonderful rescues. Readers can see all our available dogs on our website, **www.strayfromtheheart.org**, where you'll also read about some of our incredible success stories. For more information about our organization, please contact me at Stray from the Heart, PO Box 11, Ansonia Station, New York, New York 10024.

But Lucy and Winky, you'll always remain first in my heart.

All my love,

Mommy

Jessica with Hailey, a German shepherd and golden retriever mix; Megan, a golden retriever; Mark and Jessie, a chocolate Labrador retriever.

Girls,

Thank you for teaching me what life is about,
And thank you for reminding me when I forget.

You are my angels
♡mom

Kevin with Dobermann pinschers, Sugar (sitting) and Boudreaux ("Boo"), in their apartment in the Chelsea section of Manhattan.

Dear Boudreaux,

Whenever I begin to feel blue
Thinking about how much I miss you
I stop and wonder...
What my life would have been like had I never met
"The Boo"

You were the pick of the litter,
A classic "show dog" your breeder did say
Except for one small defect
And you lost your balls along the way ☺

A blessing in disguise
A blessing for me
To experience a dog
The best that can be

Smart and powerful
Fast and full of grace
You never left my side
No matter the busy pace.

Boudreaux: The Cajun Dog of New York
People's lives you did touch
How could a Doberman
Contribute so much?

I miss you, Boo...
We all do.

Kevin, Dave, & Sugar

Victoria and her rescued German shepherd mix, Jesse, on her apartment terrace in Manhattan's Murray Hill section.

Little Jesse,

You have been with me since the first year I moved to New York City, and we have shared many life experiences together. The past nine years would have been so much harder without you. I love to see your little fuzzy face every morning when I first wake up!

The day we met, you looked so sad and skinny shaking in the corner pen at the animal shelter. You had mange, kennel cough, and terrible memories from your first home and life on the street. It took several minutes before you even let me touch you! Finally, I was able to give you a hug. Ever since that moment we have been inseparable buddies. When I took you home I thought I was doing you a favor but I soon learned it was in fact the other way around. Isn't it crazy to think I only had to pay a thirty dollar half price special for years of your unconditional love?

The first years were hard for you. You inhaled your food because you were afraid there might not be any more later. You were petrified outside, and you pulled so much in the direction of home that we could barely walk to the end of the block. It was not until you met your best friend, a big husky named Blue, that you started to enjoy walking to the park and playing with other dogs at the dog run.

On several occasions you seem to have had a guardian angel. The worst of these incidents was a fire at our apartment. It remains a mystery how fate brought me home that day only twenty minutes after I left for work - just in time to open the door and see you and Blue emerge from the apartment covered with ash and frightened, but otherwise just fine.

I want to thank you for your company through many hard years in grad school and when I started my business. I knew no matter how late I went to sleep you would have my covers warm and help my worries fade away with that wagging tail. You were also such a comfort during the horrible events of 9/11. It helped me keep my spirits up to watch you happily playing with your neighbor, a Boston terrier named Toben, while I watched CNN in fear of what might be next.

You have a good life now and are as extremely spoiled as you deserve to be! You are with me all day while I am working so you don't have to be alone, and you get to play often with your many friends. We eat take out together for lunch and dinner, (I believe sushi is your favorite), and you have enjoyed many wonderful vacations. You have been swimming and hiking along the coast of Maine, running on the beaches of Shelter Island, floating on a raft in a swimming pool in the Hamptons and on the weekends you run and play in Woodstock. You have also been several times to Spain to visit your friend Blue, and enjoy nights at Doggie Village where you listen to live jazz music while playing with your friends. Even so, I think your favorite place of all is still Mom and Grandma's house where you are excessively spoiled and can get a piece of turkey just for giving Grandma that irresistible puppy face look.

I hope in the coming years I am able to give you as much love and happiness as you have given me, but that is probably impossible.

I love you, little Jesse!

Adam and his son, Lennon, with Carly, a rescued stray he adopted from Puerto Rico.

Dear Carly,

We were so lucky to have found you freshly rescued from the streets of Puerto Rico to a shelter in the woods of western Massachusetts. With your sweet disposition, your gentleness, and your loving nature - we thought we'd found the perfect dog. Which we did! We love you so much. We even love you when...

We love you when you shake and quake for hours from the sound of the dryer-- after which you vomit all over the house, and then proceed to have diarrhea for days. We love you when you shed all over the couch (excuse me, your bed), and then eat your own hair. We love you when in the middle of the night you chase after skunks and get sprayed in the face. We love you when you refuse to eat your dog food for four days after having been given a yummy table scrap-- hoping you'll get another. We love you because your breath is fetid.

But most of all, we love you because you're our four legged furry baby!

Love,

Adam Pun + Family

151

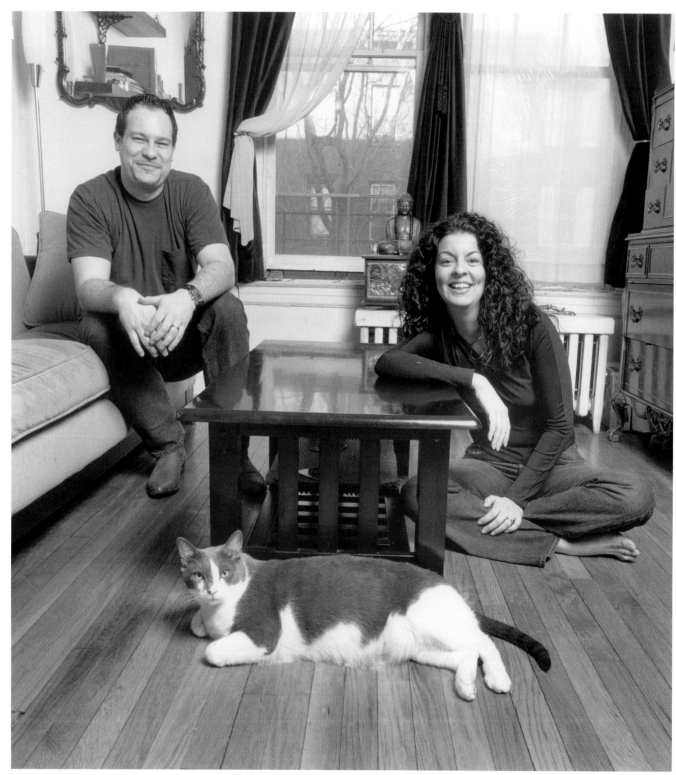

Marie with her husband, Joe, and their Siamese mix, Jax.

Dear Jax,

Or should I say Jax the Cat?...... or as you're more fondly known lately... "un vunder boy!"... You see, we just can't stop coming up with new names for you. We can't help it. You inspire us. From the twitch of your ear to the wink of your eye, we read you Jax loud and clear. Although you can't speak in people language, your friendship and love shines through. You're our companion when we're sick, our champion when we need encouragement and our own personal three ring circus when we've got the blues. You're always ready to listen to our stories and know how to keep a secret. Now... you know our relationship is not always full of bliss. You do piss us off at times. Especially at 5a.m when you start banging the cabinet door because you're hungry. But you are our son and have turned us into a little family. You put the sweet in home sweet home and we love you for it.

Big kiss and scratch behind the ear...

Love always,

Mom and Dad

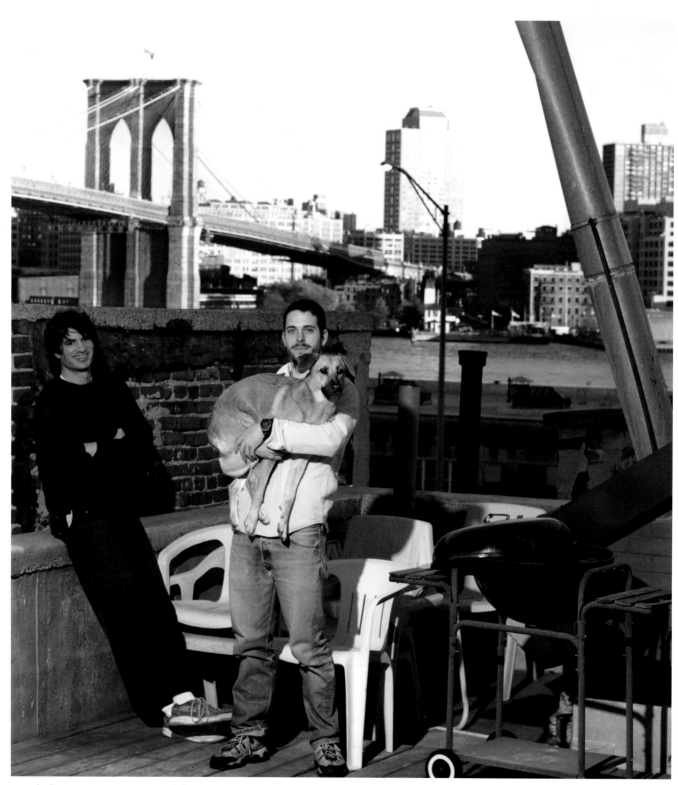

Mark (leaning), Django and their "mutt," Rosa, on the roof of their apartment building with the Brooklyn Bridge in the background.

Dear Rosa,

I think Spongebob said it best when he sang:

F *is for freinds who do stuff together*

U *is for you and me*

N *is for anywhere and anytime all,*
 down here in the deep blue sea (port)

F *is for frolic thru all the flowers*

U *is for Ukulele*

N *is for nose picking, sharing gum, and*
 sand licking
 down here with my best budd-y

♡ *Django*
 MARK
 xxxooo

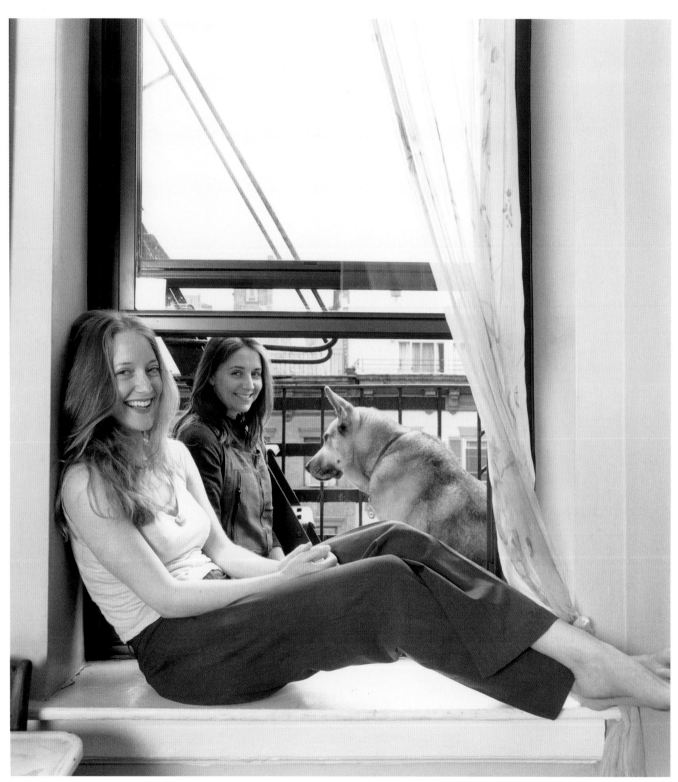

Roommates, Dara (on windowsill) and Erin, with German shepherd mix, Junior.

Our dearest, darling Junior:

(yes, Mamas?) You see, we can't even write you a letter without hearing your absurdly high little baby voice in our heads. It's taken us so long to write this letter partly because we spend all of our free time walking you. It has been a choice: walk you or write to you – and we knew what you'd prefer. *(That's right Mamas. Walk me. Walk me!)* At this moment I, Dara, am stealing a rainy moment to write.

Junior-Dog: we love you so much. *(Yes, yes. Walk me.)* You are truly the perfect dog. You are not a perfectly behaved dog: you pull us all over the place on your leash *(sorry)*; you gobble up street-scraps *(it's rough on the streets!)*; you sneak onto the sofa when no one is looking *(speaking of sneaking – who's the one that pretends she's blind and that I'm her seeing eye dog so we can SNEAK onto the subway and go to Central Park??)*; you beg shamelessly, dripping sticky drool-strings all over everyone's dry-clean-only clothes *(now that you mention it, what are you eating? Sure smells good)*; you yowl piteously when bathed or when we take car trips and you're not allowed to sit in the front, on my lap, with your head out the window, while I'm driving *(ok this is embarrassing. I'm glad my dog friends can't read this – you are threatening my malehood, and I thought you already "fixed" that)*.

You are also not a perfectly convenient dog. You are huge *(they told me I was full grown at the shelter!)*. You shed astonishing quantities of hair year-round, both black and white hairs to cover all your bases *(pretty neat, huh?)*. You can never be walked enough, and commence to looking bored and baleful as soon as we arrive home *(if only I could walk myself!)*. You are only comfortable in Arctic winds, or standing in the ocean with your webbed feet in their perfect first position. And you are stubborn as all get-out *(hey!)*.

I complain about you endlessly, and I love you even more. We know we act put-upon *(yes, you do)*, and tell ourselves that we should let you live on a nice farm in Vermont – but the truth of the matter is that we are certain many a New England farmer would joyfully make you his farm dog. That's not the problem. You are a highly coveted animule. The real obstacle is us. We love you too much to let some other family have you. It's all selfishness on our part, but you were found in Queens, and in New York City you will stay. *(Except when we take those fun trips on Metro-North! I love me some hiking.)*

You are the doggie, the Flumper, Flumpus, Flumpus Moose, Floos, Fluffernutter, Potato Bug, Junia Petunia, the fluffy bunny, Beastie, Weasel Schmeasel. You cheer us up, you wake us up, you get us outside and playing and laughing. You are a guaranteed audience for our morning pee. You throw your own toys for yourself; you spit out foods you don't like *(like grapes, you mean?)*. You make us take life less seriously. You make us talk to strangers – and so many of them become friends. Indeed, so many of our closest friends in New York have come through you – it's embarrassing, really – but then, why should we be embarrassed that we make friends through this open, charismatic and handsome dog? Heck – you have so much charisma that I, Dara, am indebted to you for helping me get my SAG card, making friends with that film director and wheedling your way into Craft Services *(did someone say Craft Services?)* – you've since been in other movies and on TV – sometimes without me – and you were our little breadwinner last summer = while we were unemployed, answering the phone "Ladies of Leisure," they sent a car to pick you up and take you to Connecticut for your role in that movie. Everyone who has come into contact with you adores you and lights up when you re-enter their lives.

So, we say you are a perfect dog – not perfectly behaved, not perfectly convenient, but perfect at being a dog. So many people say their dog is an angel or a person in dog form. You are decidedly not. You are not like that at all. YOU are a DOG in dog form – and you are perfect at being a dog. Wherever your soul was before, wherever it is going in the future, right now, right here, it is exactly where it belongs. In your dear dog body, with us. *(It's true. I act tough, but I love being coddled by two mamas.)*

We love you, Junior ~ ♡ + Dara

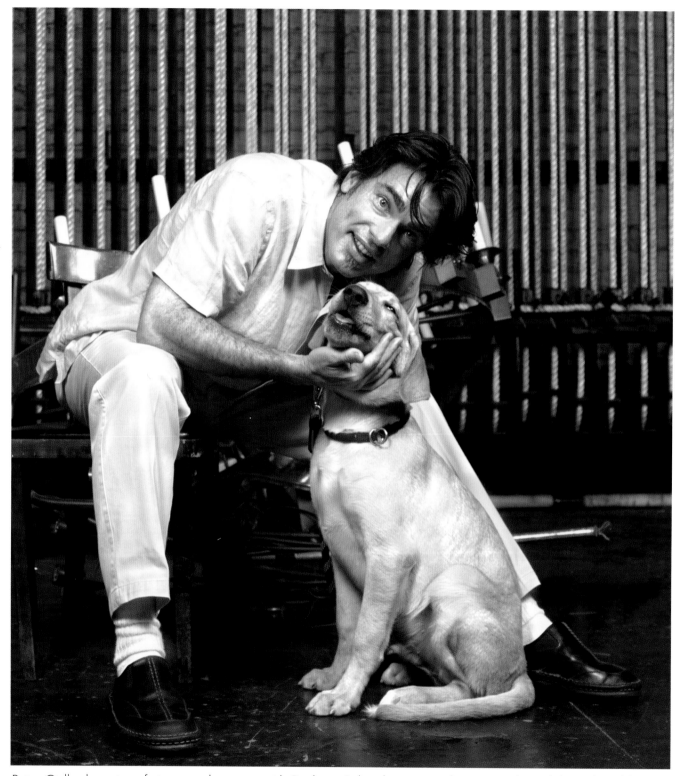

Peter Gallagher, star of stage and screen, with Rocky, a Labrador puppy, that was adopted through Bobbi and the Strays at Broadway Barks.

Stray From the Heart is a nonprofit organization dedicated to the rescue, rehabilitation and adoption of homeless and abused dogs. We provide veterinary services, emergency shelter or foster care, training and socialization for each rescue. We also provide training and education regarding the protection and care of dogs, as well as ongoing support to the individuals and families who adopt from us. Stray from the Heart is committed to the placement of rescues in permanent loving homes where the attention to long term companionship and safety is evident.

Stray From The Heart has rescued, rehabilitated, provided veterinary care, foster care and found permanent loving homes for over 300 dogs. Stray From The Heart has been able to fund every stage of rescue, including spay/neuter and temporary kennel shelter, through fundraising events, personal donations and a network of volunteers. Our volunteers include dog walkers, trainers and foster parents who support our efforts to rehabilitate and socialize each dog before a permanent home is found. SFTH also provides training and education regarding the protection and care of animals, as well as ongoing support to the individuals and families who adopt a dog from us. SFTH has a "no questions asked" policy in cases where a dog must be returned to us. Our main concern is the health and safety of each dog we rescue.

phone:
212.726.DOGS

snail mail:
Stray from the Heart
PO Box 11
New York City, New York
10024-0011

adopt@strayfromtheheart.org

Veronica and Mark with their English bulldog, Brutus, in Brooklyn, NY.

DEAREST BRUTUS, MONSTER-BOY, BUDDY-DOG,

AT OUR FIRST INTRODUCTION YOU WERE SIMPLY KNOWN AS "PUPPY #7" BUT WE IMMEDIATELY FELL FOR YOUR STOCKY, WRINKLED BODY & EXPRESSIVE FACE. WE KNEW YOU WERE THE ONE DESTINED TO BE OUR FIRST PET TOGETHER, AND YOU JOINED OUR FAMILY. IT TOOK US AN HOUR TO COME UP WITH A NAME THAT LIVED UP TO YOUR POTENTIAL.

YOU ALWAYS GET ATTENTION WHEN OUTSIDE. FOR YOUR ANTICS: CHASING STICKS (INCLUDING THE CANES OF ELDERLY PEOPLE!); DEFENDING US AGAINST THOSE DANGEROUS WHEELS FOUND ON INLINE SKATES, SKATEBOARDS, BIKES, SHOPPING CARTS; GUARDING THE HOUSE FROM ANYONE COMING NEAR WEARING GLOVES; AND THE "HAPPY DANCE" WITH WHICH YOU GREET FAMILIAR FRIENDS. AND, JUST FOR BEING LOVABLE YOU: ATTRACTING KIDS LIKE A MAGNET; THE "WOW IS HE UGLY" COMMENTS AND THE "HE SHOULD LOSE WEIGHT" CRACKS FROM PEOPLE WHO DON'T UNDERSTAND YOUR BREED. THE EXTRA PETS, PATS, AND BABY TALK DIRECTED AT YOU. WE FEEL SORRY FOR THE PEOPLE THAT CROSS THE STREET TO GET AWAY FROM "THE DANGEROUS DOG" BECAUSE THEY LOSE THE OPPORTUNITY TO GET TO KNOW THE REAL YOU.

YOU HAVE TAKEN CARE OF US WHEN WE WERE SICK: NEVER LEAVING OUR SIDES AND ALLOWING US TO USE YOU AS A COMFORTING PILLOW. YOU HAVE CHASED INTRUDERS OUT OF THE HOUSE, CAUSING THEM TO RUN FASTER THAN THEY KNEW THEY COULD! ("SORRY MISTER, WRONG HOUSE" - DAMN RIGHT IT IS!). YOU HAVE MADE ORDINARY THINGS LIKE USING BROOMS & VACUUM CLEANERS A NEW EXPERIENCE! YOU MAKE TAKING A CAR RIDE FEEL LIKE AN ADVENTURE. YOU HAVE SUPPLIED US WITH ENDLESS STORIES TO SHARE WITH OUR FRIENDS.

YOU ARE THE EMBODIMENT OF DEVOTION, DEDICATION AND STEADFEST LOVE, AND AS A RESULT, BRING OUT THE BEST IN US. WE LOVE YOU, TOO....

Mark & Veronica

161

Shauntay and her pet turtle, Tyron, on the harbor in front of The Statue of Liberty.

Dear Tyrone the Super Turtle,

Wooo-whooo! It is awesome having you around. You have added so much value to not just my life, but all of my family and friends lives as well. Ever since I saved you from your "turtle soup demise" on Canal Street, NYC, you have brought such good luck to me! Did I win Miss USA because you are an Asian symbol of good fortune? Who knows??

A lot of people can't go too long talking to me without asking about you. I think Regis and Kelly have got to be your biggest fans.

I'd like to thank you for being an excellent listener. You are not afraid to turn your back on me when I began to talk nonsense. Thank you for being a great travel companion. Where will you go with all your frequent flyer miles? And finally, thank you for being a turtle! You being an introvert and me being and extrovert I think forms a spectacular team!

Love Ya,
Chauntay

163

Rita with Rottweiler and collie mix, Abby, in her Manhattan factory.

Ray Murray inc.

Fine Custom Upholstery • Curtains • Reupholstery • Wall Upholstery
Manufacturing Decorator to the Trade

Dear Abby,

Adopted and returned to Bide-A-Wee once before, your special needs were not a good choice for someone about to divorce, nor, as I was advised, was there room for you in my newly fractured life.

Against prudence, we forged a new life together, and our new family was defined around you.

As my life unfolded into extraordinary opportunities, the courage and strength that we gave to each other expanded our lives in a myriad of ways I would never have imagined.

You have exploded my consciousness, my sense of being, and my concept of love.

We took the road less traveled..

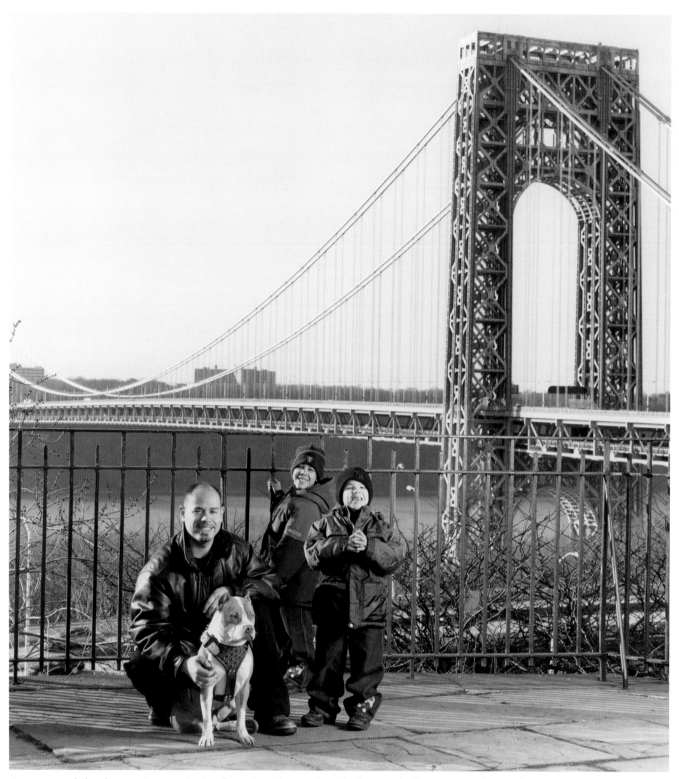

Antonio with his boys, Antonio Jr. (on fence) and Angel, with their pit bull, Nena, in front of the George Washington Bridge in Washington Heights, NYC.

Dear Nena

 I am thankful for the day we crossed paths, it must have been fate. That day in the pet shop when I first saw you, those beautiful green eyes and big blocky head.

 Born in Miami and raised in New York the changes you over came were not easy but like a true Pit Bull you adapted. Your company is priceless and my children love you for the warmth you have given them. Playing tug of war and getting attention from everyone are your favorite things. Remember Nena our bond will never be broken.

 Love!!!!!!!!
 Antonio Melendez

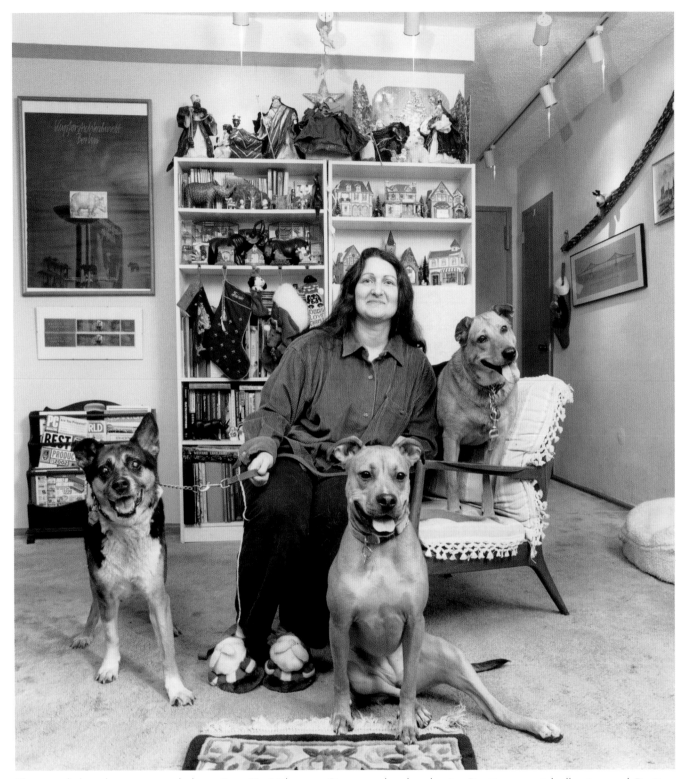

Thea with her three rescued dogs (L to R): Mikey, a German shepherd mix; Destiny, a pit bull mix; and Dottie, a German shepherd and Chinese Shar Pei mix.

Dear Mikey, Dottie, and Destiny,

You each have made indelible tracks across my life. I am so glad to have this opportunity to say how much you mean to me and to thank you for all that you have taught me. I have learned that there is a lot of truth in cliches.

Mikey, you started it all when I took you off the street in 1986, when you were about 9 months old. From you, I learned stealth, speed, surveillance, and that the best defense is a good offense. Dottie and Destiny share the latter belief, no doubt because you were all physically abused. Each of you scares easily, while Mikey and Destiny have knee-jerk reactions. Yet, in many ways, you have reacted differently to your past experiences. Mikey, after all these years, you are still unable to trust anyone completely, not even me. You have been the greatest challenge and the greatest joy. Because of you, I have met many wonderful people; learned dog training, hand and object desensi-tization, carpet cleaning and wound dressing; found out about factory farming, rethought my philosophy, and stop-ped eating meat. That came full circle, because you, and all the dogs that have lived with my parents or me, also became vegetarian. How much you like broccoli, asparagus and beans amazes me! (We'll continue working on convert-ing Grandma and Grandpa. It's much harder to teach old humans new tricks.) When I found you, you were malnourished and covered with ticks. It soon became evident that you were handsome, agile, and intelligent beyond belief. I'll never forget the time you managed to turn the knob and push open a solidly closed door. You would jump from a standing position onto the hood of my '76 Cutlass, where we spent many happy hours watching the world go by. Now that you're nearly 17, I'm learning about the infirmities of old age and marveling at how calm and friendly you've become. Every morning when you awake, I think how grateful I am to have another day with you.

Over the years, I've taken many dogs, and a couple of cats, off the street. All but one found good homes with wonderful people. I have kept what are called the "special needs" (read hard to adopt). Sweetie, the very pregnant, very large, Doberman was the unfortunate exception. Having apparently spent her life as a puppy fac-tory, she came when I had less ex-perience, courage, and the slight insanity I have now. I continue to be haunted by the fact that, despite appeals to several breed rescue groups, she and those inside her were destroyed at the pound. I am honored to have this chance to pay her tribute as well. Her death was not in vain, because it led me to others who aid ani-mals, like those at Rondout Valley Kennel and Adoptions, who helped me rehabilitate Dottie.

Dottie, you in-spire me with your ability to trust and love, despite having been abandoned in middle age, tied near garbage dumpsters in 1993. Just as you continue to do with strangers, you growled at my hand when you first saw me. By the end of two weeks, you let me pet you and cried when I left you. You taught me never to lose hope, to be wary of first impressions, and that persistence pays. Ever by my side, it is no surprise that you are sitting on the chair with me in this photo. Thanks to you and the East Village Vet, I came to believe in homeopathy. Since 1997, you fought lymphoma, survived chemo, and lived beyond all statistics with the help of a nontraditional regimen! It's hard to believe you're about 13 now. I still get a kick out of how you love to rub yourself on those pesky perfumed catalogue inserts!

Destiny, you came to us last fall from the kind people at West Chelsea Vet, who took you from your owner when she brought you there at age 6 months, claiming you had fallen off a counter (yeah, right)! Both of your back legs and your right hip were broken. They fused your joint and put pins in your legs. You'll never sit or walk normally, and you can't squat, but you've overcome your injuries to move like a bullet and jump up high. You are a bundle of energy and mischief, and so cute that no one can be mad at you. Despite a lot of sadness in our family over the last year, you keep us smi-ling. I can't wait to see how the rest of our lives will unfold to-gether. Too bad that you will never know Trixie and Copper. I wish they could be in this picture with us. Copper was an old dog when I found him. I asked my par-ents to house him for a couple of days. He stayed with them until his death 8 years later! Trixie was only 8-9 weeks old when she was found on a subway platform, hairless from mange, and wearing a flea collar. She became the most beautiful Shepherd-Collie mix. I kept her after an adoption failed, but she was so sweet that she should have been welcome in any home. (At the time, she seemed to me the "dumb blonde" of dogs.) Later, it became evident why she remained with us: cancer ne-cessitated the amputation of one of her legs and, despite the odds being in her fa-vor, it spread, and she died last spring. She adapted to her ordeal with amazing grace and dignity, teaching me the most important lessons of all: never judge a book by its cover, and appreciate what you've got before it's gone. I don't understand why people want designer dogs and AKC papers. Like all of God's creations, you are each perfect in your imperfections. The greatest gifts rarely come without a struggle, and you are surely among them. Every day with you is like Christmas, full of joy and surprises. You are all forever in our hearts.

LOVE, Thea (and Grandma & Grandpa, too)

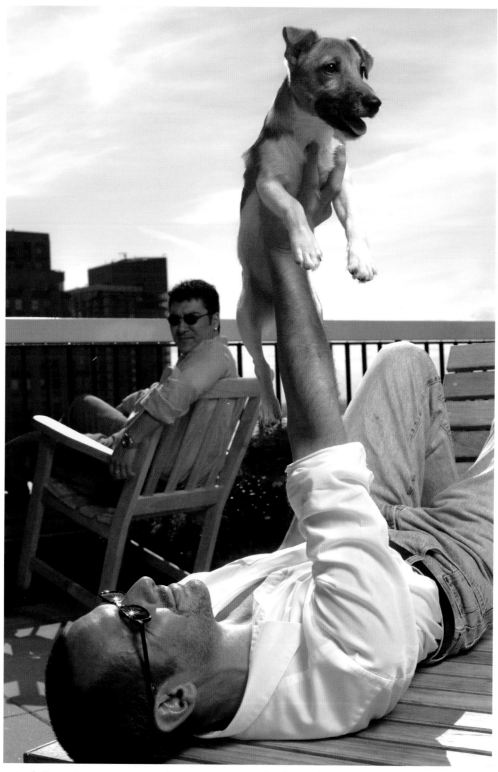

Robert holds his Jack Russell terrier puppy, Oscar, as Danny looks on from the rooftop deck of a Lower Manhattan apartment building.

Dear Oscar -

You came into our lives so unexpected — so innocent and rare.
Your personality was forming already, and we knew that as new parents, it would be our ongoing responsibility to teach you how to be a proper member of our new family — without forgetting that you were a puppy...soon to be a full grown dog.

The joy you have brought to me, to us, is immeasurable so far —

Please know that our lives are changing everyday as you grow with us, and that although sometimes our actions may seem foreign, and our words sound like blah, blah, blah...
Our love is for you.

Tomorrow we can start another day together — may God bless you and keep you in his favor — "Daddy"

Dear Baby!!

How nice for the first time to say, "baby". You came to us August 16th to complete a relationship that was growing. We as students, tried to learn how to live our lives, having you there.

No one told us that two days after this picture was taken, you were going to be my support, my companion, and my love. September 11 came, the day that we will never forget. You were there with me seeing the devastation – crying because we didn't know where Daddy was, feeling the nerves when we got evacuated, and how lonely we felt walking on those streets. Just me and you, and how you listened to me in that boat, when you were the only one I could talk to about Daddy. I held you for more than twelve hours in my arms, but never my arms felt better, and how you felt the happiness when you saw Daddy walking through the door. You have become our, my "baby". I am so proud of you. I wish I could erase everything that may scare you in your memory of that day. I love you baby boy... "Papi"

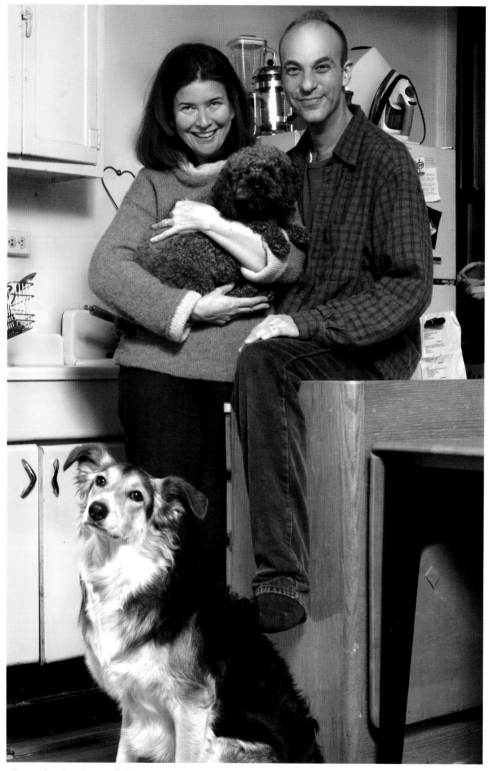

Michael and Sally in the kitchen of their apartment on Manhattan's Upper West Side. Sally holds Red, a miniature poodle, while Sisco, a collie mix, sits in front.

Dear Mom & Dad with two legs,

I've been with you for 2 years 10 months and 2 weeks now. I remember Mommy picking me out of the many puppies she saw at the shelter — and I put my head on her shoulder as I knew she was the one for me. You both took care of me when I was very sick as a baby and then at 7 months when I had to go through my two hip operations. I love running around now especially in circles — because now I can. And, I love going in the car and playing in the sand and sleeping in the grass. It's great you got me a dog, Red. He's a pest but I love him.

I hope all the rescued dogs are as lucky as me!

UMFUMFWA — Cisco.

Hey Mom & Dad,

I'm 2½ now. When I was one I was put on a huge, noisy, metal animal with wings. I didn't know where I was going so I had to run away from you in baggage claim — I had to get back to Texas — I'm glad you caught me! I have a lot of fun with my friend Cisco — I love her — she's cool — I like to chase her and bite her tail. She licks me a lot! Can you get me a squirrel to chase of my very own? or even a cat?

Licks, Red

173

Catherine ("Cat") and her rescued animals: (L to R) Peanut, an Abyssinian cat, Chick, a chihuahua, Buttons, a Jack Russell terrier and beagle mix, and Boo Boo, a miniature pinscher (Murphy, a Siamese cat, declined sitting for the portrait).

My Precious Little Loves,

I always wonder what people are talking about when they ask me why I didn't have children. I have eight of the best kids a mom could ask for. With all of your distinct personalities, you add so much joy to my life. You make me laugh every single day. You center me. Whenever I go on vacation I can hardly enjoy myself because I can't wait to come home to you. And all you ask, is that I feed you, and walk you, and love you. Men should be so easy.

Love,
Mom

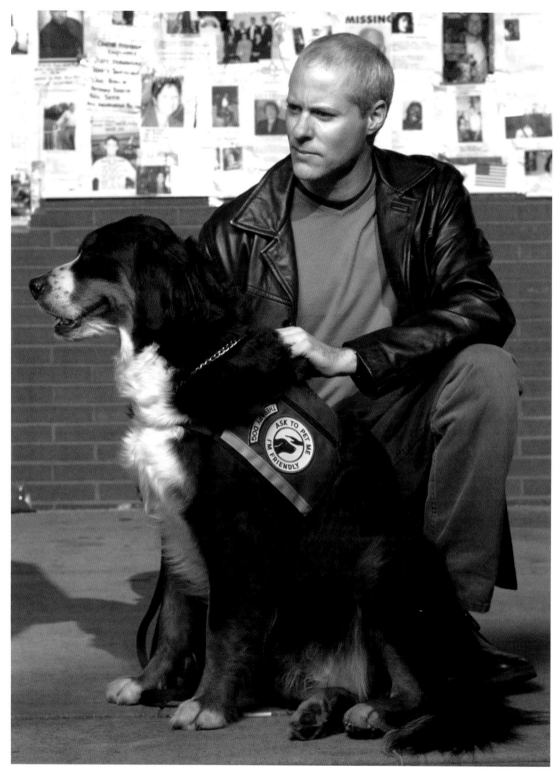

John and therapy dog, Abby, a Bernese mountain dog, in front of the memorial wall at St. Vincent's Hospital.

Abby,

Stay…

…forever…

…good girl.

Anthony and his Italian greyhound, Uma.

Dear Uma:

You little eight and a half pound beauty. Who are you? Sometimes I look at you and can't believe that you're mine. My preconceived notion of how you would be and who you are, were two entirely different things. I had a schedule that you were suppose to fit into- neatly. I was going to be the perfect daddy and you were going to the perfectly trained little dog (the book said so). But you brought your own set of doggie rules, and I didn't have the manual.

At four months when you shredded the bathroom tissue, and chewed the rug edges, I was OK. At seven months, when you decided to relieve yourself on my new sheets in the middle of the night, I wasn't. Finally, when you chewed a hole into the couch three times your size, you were getting a new home.
After nine months together, my anger and resentments outweighed any kind of affection that I had for you. I was thoroughly sad about this conclusion. How could anything so cute and small create so much havoc?

Things have changed At fourteen months, I wouldn't know what to do without you. You a such a sweet and beautiful little girl (who still enjoys a good tissue shredding). You have taught me so much about sharing, forgiveness and of course, unconditional love. You're my little friend who gets so much pleasure from just sitting on my lap or being in the same room with me. It's amazing, I look forward to coming home and playing with you everyday. When you make mistakes, I don't know why, but they just don't matter. I think it's because you're really a part of my life now.

I love you, you little noodle head.
Daddy

Jim and Nanette with their three children: McKenzie, holding her 11 year-old bunny, Rex; James ("Bubby"), with his yellow Labrador retriever, Rooskie; and Kayla, holding her two hamsters, Zadoveme and Mashu.

Hi! My name is McKenzie Morrison, and my rabbit here is named Rex. We gave him that name because he is a type called a dalmation rex rabbit. Rex is a very loveable bunny who gives lots of kisses and loves to be itched on the back. I've had Rex for two years now, and I've even drawn a picture of him that looks like a real photograph. He loves to eat carrots and other green vegetables, and we give him something almost every day. Rex is the 3rd rabbit we've had and he is lucky for that because we know alot about rabbits.

~McKenzie

My name is Bubby Morrison and my puppy named Rookie is my best freind in the whole world. He kisses me and sleeps in my bed and he loves me. He's a boy and this is why I love him,

— Bubby

My name is Kayla Morrison I'm 8 years old. I love my hamsters because they love me. They are cute and soft. They don't bite either. Their names zadoveme and Mashu. Zadoveme is a boy and Mashu is a girl.

—Kayla

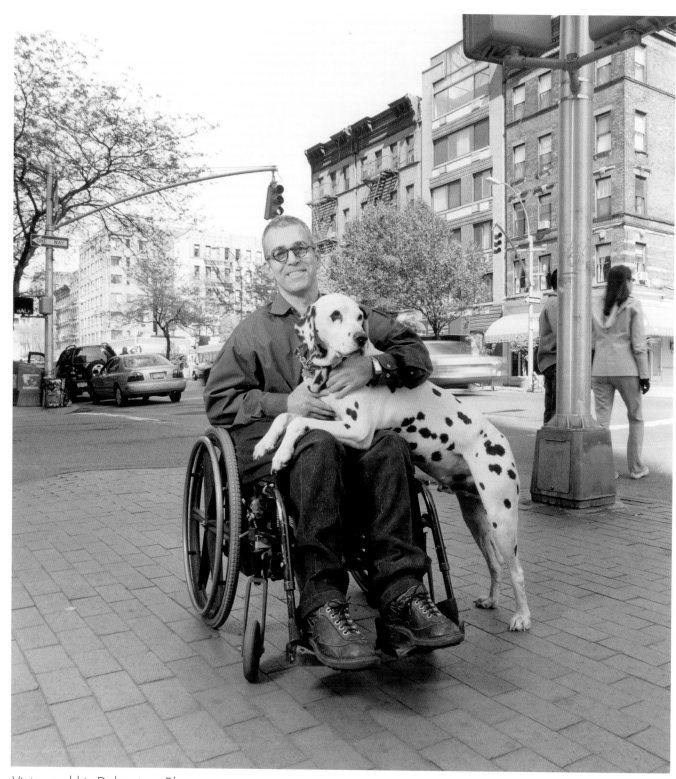

Victor and his Dalmatian, Blaze.

Dear Blaze,

You are totally Dalmatian; loyal, impulsive, and the most loving creature I have ever known. I am amazed by your capacity to love, and always want to be with me. Even after I've scolded you for digging in the garbage.

I love taking you for walks and seeing the pleasure your presence brings to people, of all ages. How often shouts of "Pongo" is heard from children who are delighted by you, what a gift!

I will always remember how you pull me and the wheelchair up hills (especially when we were in Maine). You save wear and tear on my shoulders. What a friend.

When you are running in an open field or along the beach you are so beautiful. And at the end of the day, lying in bed watching TV or reading with you snuggled up next to me is very comforting. I love how you never let me out of bed in the morning; by throwing yourself across my legs, so I can give you hugs and then roll over to make sure I don't forget to rub your belly. You really are my big baby.

You've had to learn how to get through doors and tight spaces while allowing for the wheelchair, and it never made any difference to you. Not minding the difference is a lesson people could learn from their dogs.

Thanks for all your love and adding pleasure to my life.

With love from your daddy,

Victor
x o

183

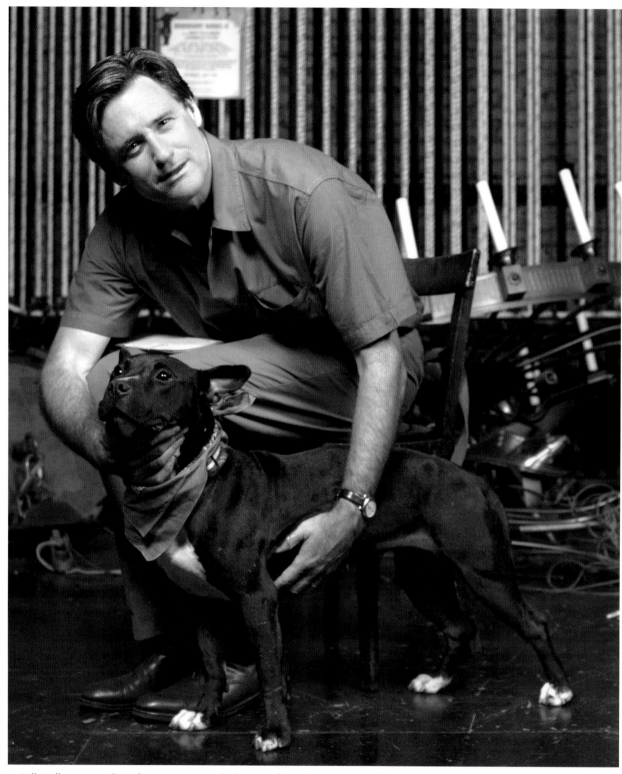

Actor Bill Pullman, with Sylvia, a rescued dog up for adoption.

Suffolk County SPCA For The Prevention Of Cruelty To Animals (SPSPCA)

The Suffolk County SPCA is a volunteer organization incorporated in 1984 under Section 402 of the Not-for-Profit Corporation Law of the State of New York. It is chartered to operate under the Agriculture & Market Laws as an agency for the prevention of cruelty to animals and is the only agency authorized to do so in the County of Suffolk. The Suffolk County SPCA maintains its value to the public through the services that it provides at no direct cost to the residents of the county.

The Suffolk County SPCA's Service Programs

Humane Division
The Suffolk County SPCA, working with local municipalities and the North Shore Animal League, provides a yearly rabies clinic. Several thousand animals per year are inoculated. We also provide animal food for the pets of needy senior citizens. We work closely with the Nassau/Suffolk Veterinary Association and are part of Suffolk County's Disaster Planning Team. We also have 2 licensed veterinarians on our staff.

In cooperation with the North Shore Animal League, we provide a feral cat spay and neuter clinic. To date, we have prevented the unwanted birth of over 1,000,000 cats.

We recently became the proud recipient of a mobile spay-neuter clinic from the County of Suffolk. This mobile clinic is a 40' bus that was converted into a mobile animal hospital called **M.A.S.H.** (Mobile Animal Spay Neuter Hospital). With the cooperation of local municipalities, it will be used for animal adoptions and spay/neuter services.

The SCSPCA mobile medical unit is one of three units in the US. At the request of the NYC Police Canine unit the SCSPCA responded and arrived on site at Ground Zero at 6 PM on 9/11. The unit was operational 24 hours per day and staffed with federal, NYC and Long Island veterinarians and Vet techs.

As the lead animal support agency the SCSPCA established a MASH unit to treat the dogs involved in the rescue project. Because the SCSPCA was located two blocks from ground zero, we are able to provide a rapid turn around for dogs that need veterinary services. A rapid turn around means the dogs can spend more time on the pile locating and rescuing survivors. We treated more that 600 search and rescue dogs. We also rescued animals from abandoned buildings within the perimeter, reunited them with their owners and provided medical treatment for these animals if needed.

Law Enforcement Division
The Suffolk County SPCA provides numerous services to the residents of Suffolk County. Our law enforcement division is made up of fully trained and certified New York State Peace Officers. In addition to responding to thousands of animal cruelty and neglect complaints each year, our agents have shut down puppy mills and have made arrests for cock-fighting rings. Our investigation and subsequent arrest of a subject who was making "Animal Crush Videos" and selling them online, led to a successful prosecution by the Suffolk County District Attorney's Office. This case gained nationwide attention and was helpful in the passage of NY State and Federal laws making intentional cruelty to animals a felony.

***The Suffolk County SPCA is not affiliated with the New York City-based A.S.P.C.A**

Public sector support is needed to provide expanded service to the county and to fund the type of services we provided at the World Trade Center. Tax-deductible contributions should be sent to:

Suffolk County S.P.C.A.
363 Route 111
Smithtown, N.Y. 11787
(631) 382-7722

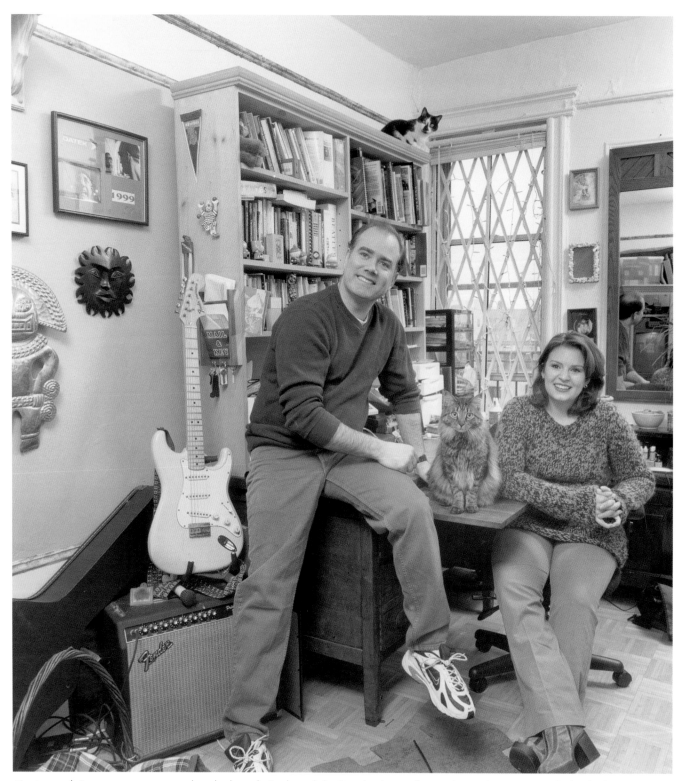

Kevin and Anemone sitting at the desk with Riply, while Sati looks on from above (not pictured, the hiding Dr. Fu).

Ahhhhhh...

Our little kitties...

Dr. Fu, Sadi, and Ripley.

We do love you so. Where would we be without you. Without Boo (Dr.Fu's alias) jumping up in our laps while sitting at the computer, or Sadi sleeping on Anemone's stomach thru the night (I don't know how she does it, I'd have to turn over,) and last but not least Ripley.... Ripley, Ripley, Ripley... Et tu Ripley. We love you, but oh, you teach us tolerance. Especially at night howling at the moon, or the stars, or maybe just the ridges on the wall. What the hell are you howling at?

Yes my kitties each of you is special. When we decided to get Sadi two sisters, people thought we were crazy. 3 cats!?! Yes I did have visions of full cat boxes, vet bills, and clawed up furniture (all of which you gave us,) But you're worth it, Even building shelves on the walls so you monkeys can climb all over.

187

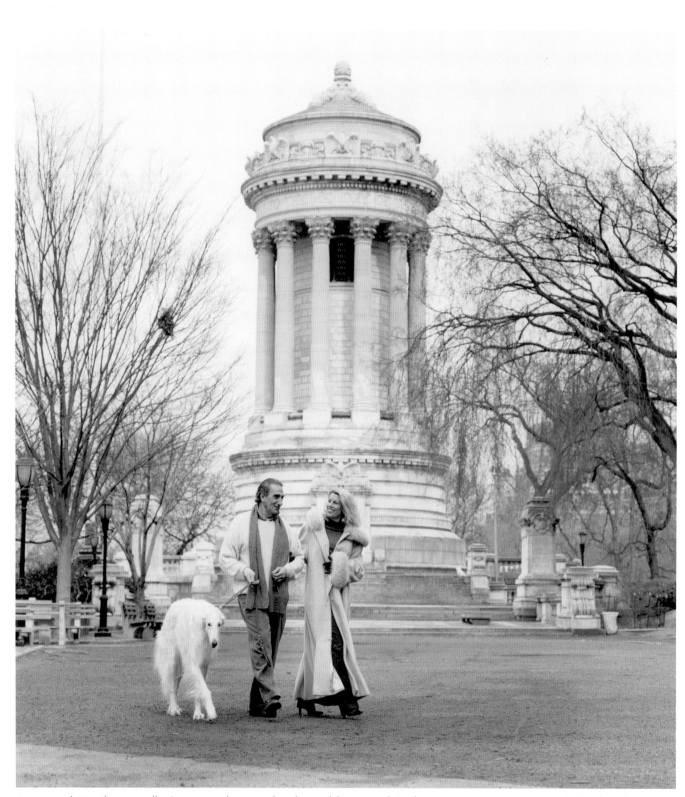

Janet and Matthew walk Gentry, a borzoi, by the Soldiers' and Sailors' Monument in Riverside Park, NYC.

Gentry

Hello there,

Let me introduce myself. I'm Gentry. That's me on the end with the long, luxurious hair. To put it plainly, I am the center of their world. I am what brings them love, joy, and happiness on a daily basis. But in keeping with my royal Russian bearing, I would never let on that they are the center of mine. "Always keep them wanting more," a yappy, little terrier once told me. And it works. Just when they think I will become all twittery because they are speaking baby talk or tossing a silly toy my way, I sashay off.

But food. Ah, food is another matter. I will do anything for a delectable morsel. I will even give kisses–but not on the lips. Do you know how dirty people faces are? I admit it: Je suis un slave de gastronomie. I am exquisitely attuned to the sound of every major appliance. The opening of the microwave and refrigerator is music to my well-coiffed ears. And then there is the thrill of the delicate click of the cabinet where my cookies are kept.

My Uncles Alan and David say I am spoiled. If spoiled means that I have my own bedroom with a queen-size bed in Connecticut; my own bedroom in the city; get a bath, which I love, every week; have two horses to play with; and am paraded around Riverside Park twice a day to the oohs and ahhs of gaggles of admirers, then, yes, I'm spoiled. All my family and friends say that they when they're reincarnated, they want come back as me. Please. Who says I'm willing to give up this gig?

Kisses (but only if you have food),

Gentry Roselli

Story by David Leite

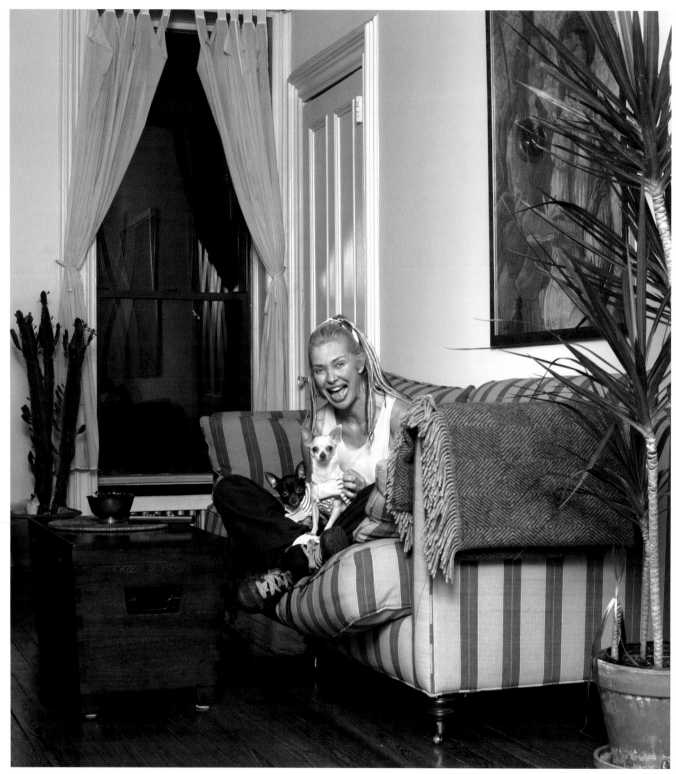

Tyler with her two chihuahuas, Ratface (the white one) and Applehead, in their apartment.

Dear Mommy and Daddy,

Applehead and I are writing this letter to tell how much we love you both. The care and attention you give us is more than we could of ever imagined.

But....

Can we talk? That dog food is tired day after day. We want more steak, chicken or pork. You know people food. We have fun on our walks and I know you both mean well but can we try different streets sometimes, I smell the same old dogs over + over again Applehead prefers to stay home when it's cold out + pee on the carpets, he does not appreciate being punished for it. One other thing can we have more friends over? We love you

191

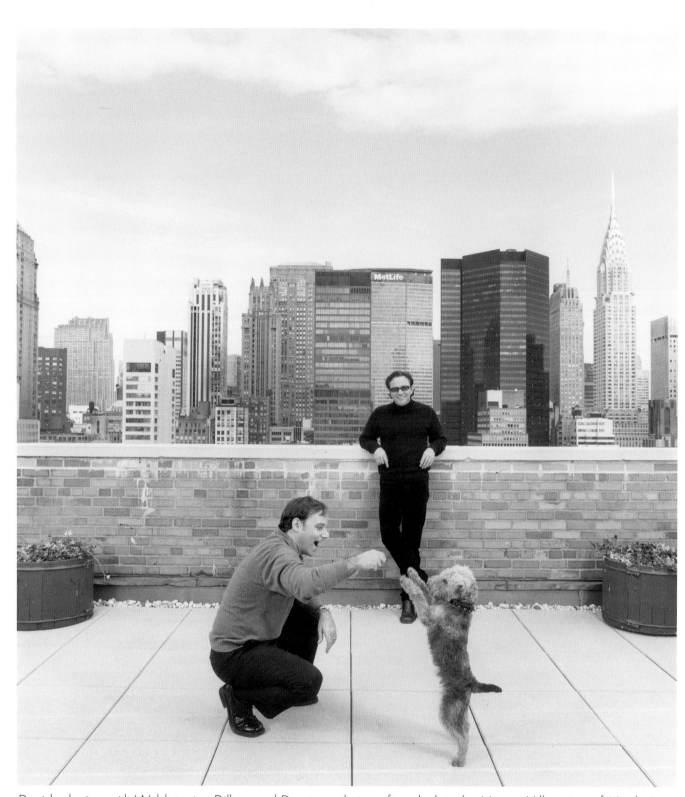

David, playing with Welsh terrier, Dillon, and Dowie on their rooftop deck in the Murray Hill section of Manhattan.

Dear Dylan: March 2002

As I write this letter, it's just 2 days past your first birthday. I remember the voicemail from the breeder, this time last year, telling us that you'd been born, and how excited we were that we'd have you with us in just a couple more months. Michigan's an odd place for a Welsh Terrier to come from – at least to a Wales-born Welshman, like me.

Oh how we agonized over what to name you. I wanted to name you Gwilym (pronounced "gwil-lim"), after my late father, but David thought that was silly, so we compromised on Dylan, after the legendary Welsh bard, who like you and I, also found a home in New York City. Anyway, it seemed oddly appropriate.

When you arrived at La Guardia, a frightened little ball of fur in that big crate, and I first held you in my arms, it was love at first sight. You turned out to be everything I had hoped you would – a playful, affectionate, happy-go-lucky little guy. I took you out of the crate in the airport parking lot, and you rolled over onto your back immediately – unconditional trust and surrender – you melted my heart.

Just looking at you makes me smile. Caring for your needs makes me feel like a better person, and reminds me that giving love is the key to receiving love. You helped me through the horror of 9-11 and showed me that love is stronger than hate, and whilst our country was at war, we (you and I) could be at peace.

As we face an uncertain future, together, there is one thing I know – whenever I come home, you'll be there waiting for me, happy to see me and full of joy – a bouncy, boisterous, furry little balm for the soul.

Daddy Davie

Dear Dylan: March 2002

How my life has changed since your arrival! I do not even know where to begin to express my love and adoration for you. I resisted the urge to get a dog in the city for many years. But as you get older, priorities change – and it became clear that it was a good time to get a four-legged companion. The struggle was to identify a small breed that could comfortably live in a snug, New York City apartment, yet still had the attributes I was looking for in a dog.

While researching the options, all signals pointed us in the direction of you. After a lucky coincidence, we were directed to a leading breeder – and just in time to sign up for an upcoming litter. A few agonizingly long months later we got "the call" that you had been born. And ever since then, my life has been changed in the most dramatic and positive manner. Suddenly Manhattan has become a small town. Because of you we have many new friends here in our building as well as in our Murray Hill neighborhood. You were such a spectacularly beautiful puppy that people actually went out of their way to stop and say hello to you during our walks. As you grew up, you became impossibly more handsome – and had the disposition to match. Today, over one year later, a stroll though our neighborhood is punctuated with numerous stops to play with your many dog friends, while I catch up with their owners. Having you in my life makes the city seem calmer, nicer and more livable.

I can only hope that the joy you have brought to my life is being returned to you equally and as freely. Somehow, I think that it is.

Daddy David

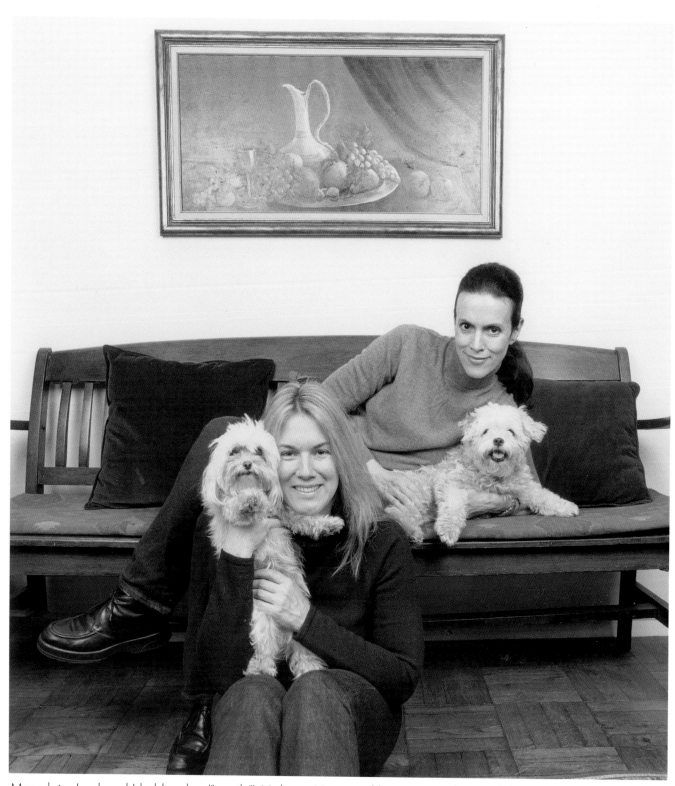

Maryclaire (on bench) holding her ("mostly") Maltese, Maja, and her sister, Bridget, with her ("truly") Maltese, Bessie.

Dear Maja:

When I was a little girl, one of my favorite movies was "Born Free", a true story about a lioness cub named Elsa and the couple who rescued and loved her. From that day on, I knew that someday I too would have my own "Elsa"; however my "cub" would come in a much smaller and different package than that which was depicted in the film!

Maja, from the moment I brought you home (although I acted like a neurotic new mother with her firstborn), I knew that you were the best thing that had come into my life. You have the power to make me laugh uproariously with your antics from frolicking in the snow to becoming a "dingo dog" on the attack.. Your sensitivity and ability to feel my pain is extraordinary. I don't know how I would have gotten through that awful day in September had it not been for your love and kisses. When you see me cry I wonder if you just like the taste of tears or is it that you know that a few licks of love from you can brighten up the moment? Your big dark brown eyes tell a multitude of stories – I daresay that you've been here before and are indeed a very old soul.

I often tell you that I hope you'll outlive me as the pain of such a loss would be unbearable. However, the truth is, I know we'll always end up together wherever the life beyond this one takes us. For now, let's just live in the moment and enjoy those freeze dried liver treats!

I love you with all my heart

You know, Bessie, in the past six years I've come to learn that there is NO difference between love for a human and love for an animal- you have taught me that. Before my sister brought us together (for my "surprise" birthday present…and what a surprise that was!) I wasn't sure about real love. But having shared my everyday with you all these years now, I sometimes feel overwhelmed with the love I have for you.

From the time you were "kidnapped"(yes) and had to be rescued by the NYPD (the absolute truth), through the many times we shared in the ER room where the diagnosis was a continuous "not gonna make it", I knew you were one tough little package, albeit five lbs. of tough. Your continual snapping at any other four legged creature weighing NO less than 200 lbs. is sure sign that you know who you are and no one's going to push you around! But beneath that stealth exterior is one damn funny little ball of fur, with a snore to wake a thousand soldiers and a sense of humor to cause me to belly laugh out loud! Though I had always hoped for a little girl of my own, you have not been a "substitute" rather you have been the greatest gift and I hope that we will continue to share many more days….walking (or should I say, carrying lazy you) through Central Park, going to foreign films together (you in your bag) and just enjoying life in our home, New York's smallest apartment on Madison Avenue. I love you!

The Amazing Kreskin and his three cats (L to R), Squeaky, Bugsy and Miss Kitty.

My Dearest Ms. Kitty, Squeaky and Bugsy:

I am writing you this letter to tell you how I feel about you and how you have added immeasurably to my life. It's neat to know that each of you have been with me within a week or so after you were born.

The ten years that you, my gorgeous Miss Kitty, have graced our home have been special. Every time I return from a trip, you call to me. Whenever I walk into the house you always call me, asking me to pick you up. People who I have spoken to have never heard of a cat that loves to lie on her back over someone's shoulder as you do with me.

Then of course, my darling Squeaky, within only a week or two after arriving at our home and as tiny and miniscule as you were, you walked around everyone's feet squeaking. Hence the perfect name, Squeaky was easy to affix on you. You are an incredible beauty with silky beautiful black fur, snow-white paws and chin. You are quite a contrast to Miss Kitty with her amber and earth toned luxurious fur. Squeaky, you are as active as ever happily celebrating six years of living on this planet.

Then of course there is the "baby" of the family, two-year-old Bugsy. Named after the infamous gangster, Bugsy Siegel, as you never seem to lose interest in stealing or at least running away with items about the house. You, Bugsy inhabit a certain savoir-faire that I admire, joie de vie that is contagious and deep, soulful eyes that move me so. A handsome little fellow you are with your silver, gray and black markings.

All three of you give me special joys! On almost any night that I am home, I walk into the family room at about 2:00am for a respite of twenty minutes, my own catnap, if you will permit me the pun! Invariably, you Miss Kitty are sprawled across the sofa, and, Squeaky you seem to prefer curling up next to my right leg while Bugsy is curled up to my left. The only exception to this idyllic setting is when you, Miss Kitty decide to lay down next to my left leg and you invariably put your right paw on my leg and sleep very contentedly! As always is the case, until at least two of you decide to move around, I am unable to move off the sofa!

Everyone has to stop the world and get off. I find one of the greatest and special resources I have to escape to a peaceful and joyful mood is being with the three of you. Of course, Squeaky, I have to accept that you will first of all reach up on the coffee table and knock one or two of the feather dusters down so we can play for the next 15 minutes a game of your chasing the duster along with Bugsy as I move them around the table.

While as a mentalist and thought reader I would be the first to admit that I can't "read" specific names and dates etc. in your thoughts my little friends, I can sense feeling, mood, affection and love. The three of you have been the reason I have often said about our pets with whom we share our lives that the great thing about animals is that they don't betray people. We are all blessed that you three are part of our family.

Much Love,

Marisa and Michael with her brindle pit bull, Eve.

Dear Eve (a.k.a. Steve)

We love you!!

Even though you ate the Gucci loafers before they were ever worn, ate a bottle of herbal phen phen and had to be rushed to the emergency room, ate the silk sheets after your first bath, diarreahed at our dinner party in front of all the guests making one of them physically ill, bit our friend Pat on the nose, ate and digested a roll of plastic bags resulting in an unusual tug-of-war of love, slept while a thief stole our bike out of the hallway, failed doggie school 101, got kicked out of the Mercer Street Dog run after 1 day (wimp), and almost had your leg amputated after a failed attempt to catch the neighborhood cat.

We love you eventhough you insist on steak, break wind on long car trips, destroy chew toys in under 5 minutes, leave the chew toy mess all over the apartment, have a complete inability to catch a mouse, bark at silence, refuse to bathe or brush your teeth, pee inside when you see an old friend, eye our food, drool while we eat, distribute 'dead weight' when we try to move you from the bed at night, insist on sleeping in the bed, insist on sleeping across the bed and take the car without asking.

We love your soulful eyes, your sad eyes, your playful eyes, your pouting eyes, your scared eyes, your smiling eyes, your dirty sleepy eyes but mostly your James Dean eyes.

We can't tell you how happy we are that you got hit by that bus when you were a puppy.

Love,

Marisa and Michael

Colleen and husband Steve with their 12 year-old, American Eskimo, Asha, on their terrace on Manhattan's Upper West Side.

Asha,

Boo Boo, Baby Bops, Schlumpkin, Her Oneriness, Ferocious, Tumble Weed, Cotton-Ball, Q-Tip, Ridiculous, Skunk, Bear, Tennis Ball Head, Dumpling, Little Fuzz Ball,

We think you hung the moon!

Love, Mom + Dad

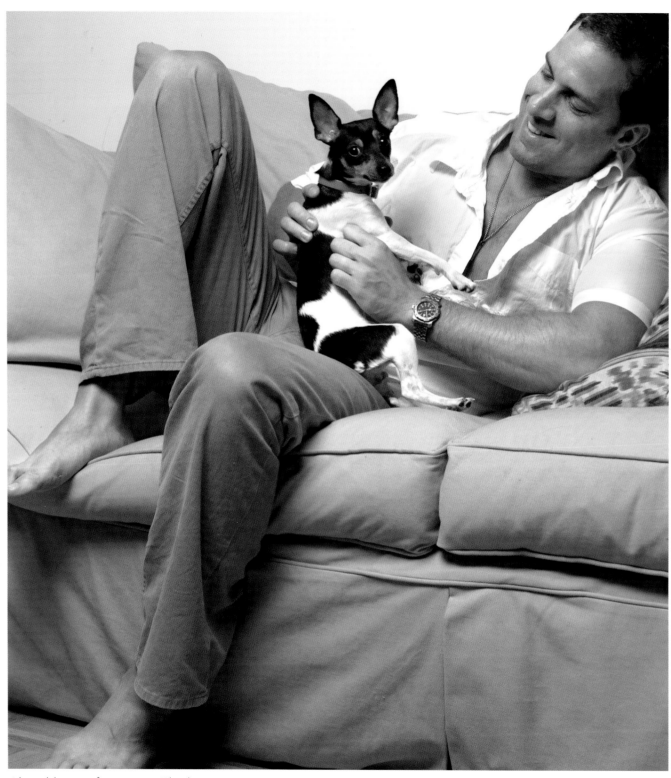

Al and his toy fox terrier, Charlie.

Charlie,

Never in my entire life could I have
imagined that such a little being would bring
such enormous love and joy into my life.

Your warmth is electrifying.
Your presence is irreplaceable.
Your love is unconditional.

You are a blessing.

xoxo,

Daddy

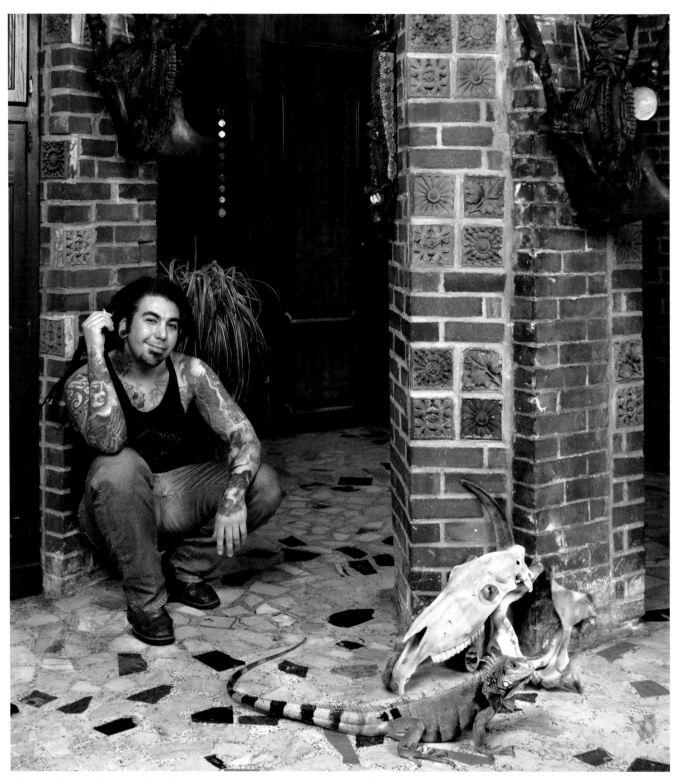

Alessandro with Hercules, the house iguana, in the kitchen of the mansion in Staten Island, NY.

Dear Hercules (a.k.a. "The Lizard"):*

You came into my life with the house. Your original owner was a girl living in a basement somewhere. She felt bad for keeping you in a small aquarium and that is how you came to live here. This place is a mansion with plenty of room for an iguana to grow. One of my former housemates was dating a construction worker and he built you your current abode. You live in a gazebo with mosaic-tiled floor and walls and a carved copper ceiling. There are curved glass windows looking out on the grounds and a tree for you to climb around on and perch. You have plenty of room and yet it isn't enough for you. You regularly scale the wall of your enclosure and explore the rest of the house while we sleep. I've even woken up to find you sitting on my chest. You have no official owners, people come and go in a house this large, but you remain the constant. To live in this house requires you care for Hercules. I guess this is your house now and we're all just staying with you.

One of your temporary guardians,

Alessandro ("Alex")

*as told to Michael J. La Rue

Frank and his wife, Carla, with their miniature Yorkshire terrier, Chopp, and their daughter, Annie (sitting up on floor); and Carla's niece, Clea (holding her plush dog, Phoebe).

FRANK & CARLA PELLEGRINO

August 16, 2002

Chopp came into our lives via a vacation to Brazil. A long time ago my wife Carla, a native Brazilian, had a miniature Yorkshire terrier named Minu. He was probably the best behaved and loving dog on the planet, and never left Carla's side. Unfortunately, he passed away some time ago, since then Carla always wanted to get another Yorkshire. Secretly during our vacation in Brazil, my wife found a breeder of Yorkshires, before I knew it we were in this woman's apartment in Rio de Janeiro surrounded by a bunch of newly born Yorkshires and their parents and older brothers. I knew at that moment I had no choice but to take one home . . . Upon meeting Chopp there was an instant connection between all of us, he wouldn't leave our side and was constantly vying for our attention.

Coming up with a name for our new pooch was pretty easy, in Brazil their national drink is a draft beer called Chopp, given our dogs ecstatic personality we thought that it would be a suitable name, not only because he's always happy, but would remind us and him where he came from.

A few of Chopp's favorite activities with us include playing fetch, going for walks, getting dirty, and meeting other dogs of all sizes. Chopp also has a girlfriend, her name is Patches, a Boston Bull Terrier that belongs to my parents, they play for hours together almost every weekend.

Chopp is an intricate part of our family who brings a great deal of joy to our lives.

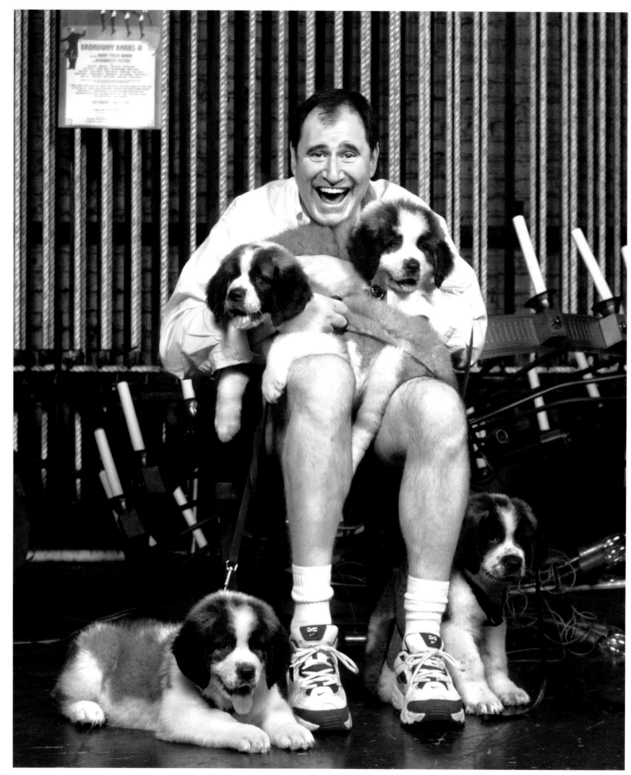

Actor Richard Kind of television's *Mad About You,* with Lulu, Horatio, Hudson and Barnaby; St. Bernard puppies up for adoption at The Humane Society of New York.

The Staten Island Council for Animal Welfare (SICAW), a non-profit organization founded in 1972, is committed to the rescue, care, shelter, and adoption of stray, abandoned and unwanted animals on Staten Island. We are also dedicated to furthering the public's education concerning the issues of proper pet care and the importance of spaying and neutering.

Staten Island Council for Animal Welfare, Inc.
Post Office Box 120125
Staten Island, NY 10312-0125
Email: blackie502@aol.com

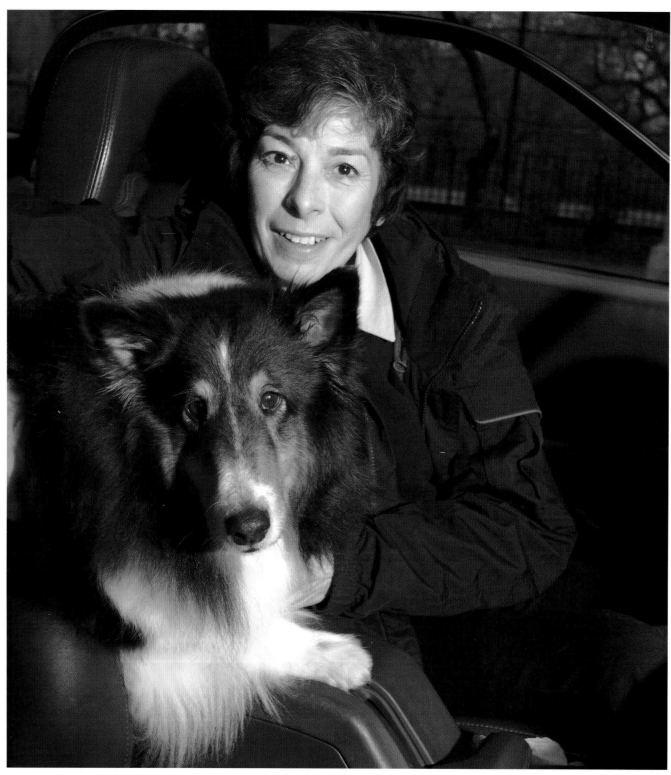

Beth and her Shetland sheepdog, Emma Peel, in their car.

My Dearest Kim, Emmy, Emma, Mouse, Shrimp, Little, Fuzzbutt, Emma Peel (when you're in Trouble), My Love etc., etc., etc.,

First of all, it's really hard to fit everything on one page, so I have to write small...

Remember that day - 9 years ago when I walked into the kitchen at the farm to pay for my eggs? I do, very clearly, since it was a day that totally changed my life. You raced over to me, and looked me right in the eyes. The look said, "I AM GOING HOME WITH YOU." Then you turned around and sat down on my foot. I didn't stand a chance. You have been my constant companion since that day. You have brought so much joy and love to me and to everyone who knows you and I feel so blessed to call you my best friend.

One thing that is very clear to me to me is that our extraordinary friendship happened because you understand English (and possibly French & Spanish since you watch PBS during the day). Not only do you understand English, but you also read my mind. You're always doing things I never taught you. When I leave you, I know you trust me to always come back and I hope you don't get too upset.

I'm not the only one who thinks you are an incredibly special creature. Our friend Dolores always said "Beauty is as beauty does." Friends and even people on the street constantly stop to say how beautiful you are, and then you wag your way up to them for a pet and they find out that your real beauty is in your spirit - sharing your love with anyone who needs it.

You do so many things that are not very dog like. You cuddle with bunnies and let parrots walk on your head. You sit by the feeder in Ohio and watch the birds and other little creatures go about their business - it doesn't occur to you to chase them. And you are so sensitive to what is going on around you. You gave Mom so much peace when she was sick, patiently staying by her side so she could just reach out and touch your head.

There are so many things I love about you. I love that you turn into a fur ball of mush when I give you a little message - it's really funny when you go all limp and your eyes roll back in your head. I love that you want to play Frisbee in the dark. That you share your toys. That you love to have your teeth brushed (even if it is poultry flavored toothpaste. And that you actually like to be brushed, and you fall asleep when I dry you with the hair dryer.

The very best thing though is that YOU ARE ALWAYS SMILING, and that makes me smile. No matter what kind of day I've had, when I get home you're here and you give me that look that says "I'm here with you wherever you go, so let's go!" — and so we go, together. I know you're glad I finally got you a nice car with lots of room for your pillows and a really great air conditioner so you can travel in luxury.

You taught me how important loving and being loved is. The sight of you warms my heart and lifts my spirit. I wish I could be more like you.

I send you a thousand kisses every day,

Beth

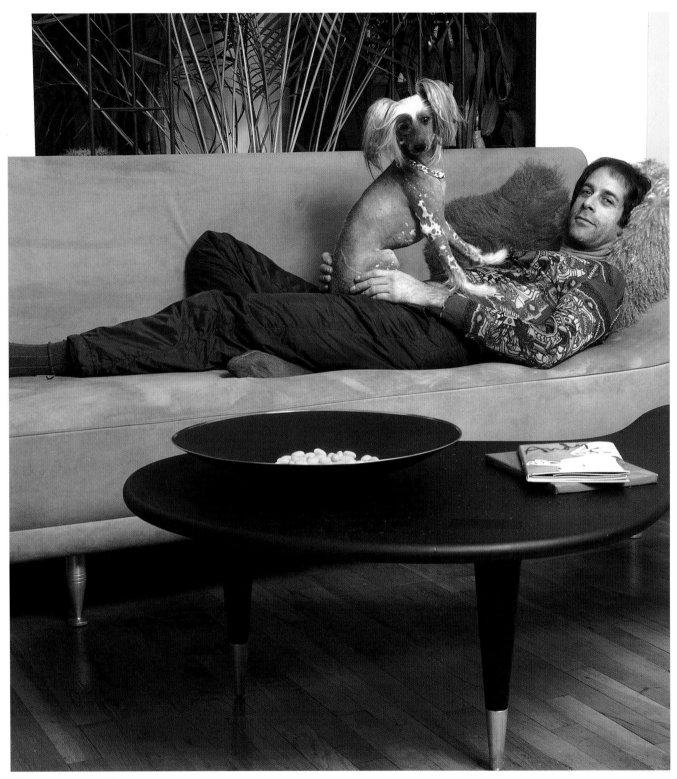

Gregg and his Chinese crested, Puc.

I Remember the Day — It was Four years ago...
'Twas just days before Christmas - How was I to know
THAT A DOG I BOUGHT BLINDLY, In fact O'er the Phone
WOULD INDEED CHANGE MY LIFE - TURN MY HOUSE TO A HOME.
I DROVE OFF TO THE AIRPORT IN ANTICIPATION. Imagine my Awe Seeing you a the station
IN Animal Cargo. "Sign Here!" "HE'S ALL yours!"
We got into the Bimmer — I closed both the DOORS. WE DROVE BACK TO THE CITY
To where I call Home, and announced YOUR ARRIVAL! I BOUGHT you a Bone,
and A BED & some Toys - Not A THING was forgotten! (It would be
THE START OF my spoiling you Rotten!)

A WALK DOWN THE BLOCK, OR A jaunt to the BEACH, THERE WAS NO PLACE TO GO
WHERE OUR PRIVACY, Breached for uncountable times, and invaded, for sure
'SOMETIMES FOOD IN MY MOUTH - AND MY PATIENCE QUITE POOR!)...
THEY WOULD SCREAM FROM THEIR AUTOS "WHAT BREED?", "LOOK HOW PHAT!"
"HEY MISTER, WHAT KIND OF A DOGGY is THAT?"
AS I'D SAY, ONE MORE TIME — WITH A SMILE (JUST AN ACT!)
"HE'S A Crested, my Dog! CHINESE HAIRLESS, IN FACT!"
"DO you SHAVE HIM THAT WAY?" They'd most certainly ask,
"ME? DO THAT TO A DOG? A most unpleasant task I'd imagine,
BUT, NO. I ASSURE YOU TODAY - THAT ITS NATURAL. IN fact -
God's will MADE HIM THAT WAY!

THEY'VE CRIED AT you "ROCK STAR", "THE WARHOL OF DOGS"
they've clamoured for photos - you've set them agog!
Some SAY you ARE UGLY! Oh Really? INDEED?!" "You Are
Certainly not an aesthete of the Breed." I find saying to them
"Read a Book! Smarten up!! How Could you not love the visage of my pup?
OR HIS AQUILINE NOSE? BIG "BROWN Eyes? SHARP WHITE TEETH?"
AND JUST LOOK AT HIS BUILD! From the GODS HIS PHYSIQUE!!
But more gorgeous to me than your TAIL, Crest & socks —
More Important to me than a FABERGE' Box - Is your Love
true & tested - and one thing for certain — You're one Chinese Crested
LIKE 'OZ, 'Hind the curtain' — whose magic is not of the kind
you can Label — It's worth? More than Gold. It's feel?
Better than Sable!

I Love you Mon Puc! I HAVE right from the Start! & I'm
GRATEFUL TO GOD! You were BORN OF my HEART!
You're my Seussian Side Kick — my Sorcerer's Apprentice —
My love for you knows not of boundaries or tenses!
Love Daddy.

213

Leandra and Anthony with their Jack Russell terrier, Bella, in Astoria, Queens, NY.

My Bella Marie,

I knew when I brought you home three years ago my life would change immediately. I still remember holding you in one hand. I mixed milk in your food so you could digest it better; house broke you (in only three days,) taught you how to swim, and held your paws through you first visits to the vet. You are my baby girl.

We've been through a lot, you and me...three states, five apartments, one car accident and the loss of my father. Through all of this, you were my constant friend. I knew no matter what kind of day I had, I had you to come home to. I could take a walk with you or play with you, cry or laugh with you, or just have your company watching TV. Things just seemed to be easier with you to cuddle up to.

I love you Bell. Thank you for being my friend. You may be hyper, needy and have a stubborn mind of your own, but there is no way I would change anything about you. You demand love and I respect that. You have loved me from the beginning, no matter what my life has put you through.

And finally, thank you for accepting Anthony into our life. I told you he was a good guy!!! I understand your pickiness; you just wanted the best for your mommy.

I hope you know that I will continue to do my best to make you as happy as you have made me. I am truly blessed to have you in my life.

Love,

Leandra, your mom

Bella,

You were not my friend when we first met. I think you thought I was stealing your mommy away from you!
When your mommy and I were first dating I 'd come to pick her up and we'd be gone for what I'm sure seemed like days. It must have been those lonely nights in that small apartment. "Who's that strange man taking mommy away from me?"

You got back at me by chewing holes in my velvet couch and Egyptian cotton sheets!

I soon realized what you needed. Love. You live for love. At first I thought you were mommy's chaperone. The way you always sit between us on the couch craving warmth and love. When I kiss your mom, you need them too! As if to say, "don't leave me out guys!"

We can never leave you out. Bella you little beauty! You look at me and tilt your head to the side. I can't resist when you show up with a toy in your mouth wanting to play. You always want to give kisses on my mouth and face and in my ears. You kiss me morning, noon and night.

It's safe to say we've come a long way since we first met. No more chewing "incidents."
Now you greet me at the door. You cheer me up after a rough day. You sleep under the covers with us at night. You're the best watchdog. You always bark when you hear an unfamiliar sound or see an unfamiliar face.

Yes you are high maintenance. Yes you shed all over the house. But you're my dog, my friend and my companion.

I just hope that when your mommy and I get married that you'll take my last name too.

Love,

Anthony

Bert and his teacup Yorkshire terrier, Duffy, in their Midtown Manhattan office.

Dear DUFFY "Doodle Bug",

You came into our lives small, sick and in need of love. You were the runt of the litter and since you have grown strong, healthy and so very beautiful.

You come to work with me everyday. You meet and greet all my clients and depending on the client you either curl up on their lap or bring them toys to play with you.

You sit and stare at us exactly at 12:30 everyday until your lunch is served and you spin and dance for your treats after you go to the bathroom.

Thank you for always being there unconditionally. It goes both ways......... unconditionally.

Love from, me & Bobby to you.

Helen (lounging), holds Indigo Blue Velvet and strokes Mocha Minx, Pomeranians; while Eva holds both Taz, The Tazmanian Devil (left), and Miss Holly Go Lightly, papillons.

Our Dearest Babies (Minx, Holly, Indigo and Taz),

We love you all. You give us unqualified love and affection. You make us crazy sometimes but you also give us our greatest joy. We try to only do good things for you but we sometimes feed you things you should not eat and we cannot always give you as much attention as you want. You each have your own distinct personalities and it really is sometimes impossible not to give one of you more attention than the others. You are all loved equally, although at fifteen years old, Minx, you have been loved the longest and we are just a little partial to you.

To Minx, our oldest, you are still the most opinionated, stubborn, loud, and determined. You also are the most beautiful and were the most outgoing in your youth. You spirit still shines through and you still look and sometimes act like a puppy. You will always be our miracle dog. Your ability to communicate with us and smile when asked always makes our day.

To Indigo, our youngest, you are our smartest. You train yourself and are too smart for your own good sometimes. I guess you could say you are our most spoiled. Your broken leg as a puppy made it easy to spoil you. You have many traits in common with Minx being the same breed but always with your own individual twist. You love to eat fabric and are consequently the only one of our babies that is ever locked up in a cage. You, however, love your cage and go into it yourself without prompting when you see us getting ready to leave the house. Your beautiful blue eyes and loving personality make you very dear to our hearts.

To Holly, our shyest baby, you are only five pounds but have a sweetness that weighs a ton. Holding you when you are getting your shots and a physical exam is like holding onto an ell. You also alert us to your outrage by your squeals and barks. You are certainly our most highly-strung baby. You have wonderful markings but could never be shown because you would not let anyone touch you in the manner judges must. You are the gentlest of our family.

Taz, you are the most lovable of our babies. You love to greet everyone whether they want you to or not. You are the biggest and take advantage of it to push both Indy and Holly around sometimes no matter how hard we try to prevent it. I guess the most unusual trait you have is your love of Minx. You have smuggled her food when she was not to be fed for 24 hours due to illness. You always make sure she is unhurt after anyone touches her and have bitten Indy for trying to take something away from her. I guess you could say you are the most demonstrative of our family and we love you.

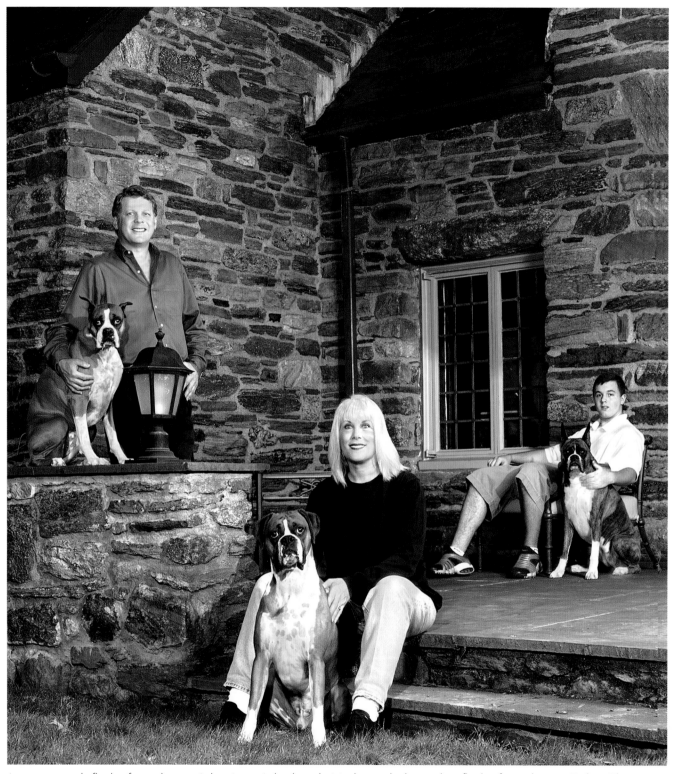

Jamie sits with flashy fawn boxer, Luke. Jamie's husband, Mark, tends their other flashy fawn boxer, Babe. Their son, Matt, is seated with Zena, a Brindle boxer. The family was photographed at their estate, Boxer Haven.

Dear Babe, Xena, and Luke,

A day does not go by without the three of you adding a great amount of pleasure to our lives. We in turn do everything we can to do the same for you.

You are all different but still typical of the breed we love.

You are responsible for motivating us to help many rescued Boxers through our veterinary work and our efforts with Northeastern Boxer Rescue.

We thank you for touching our lives in a way no human can.

We love you.

Jamie, Mark, & Matt

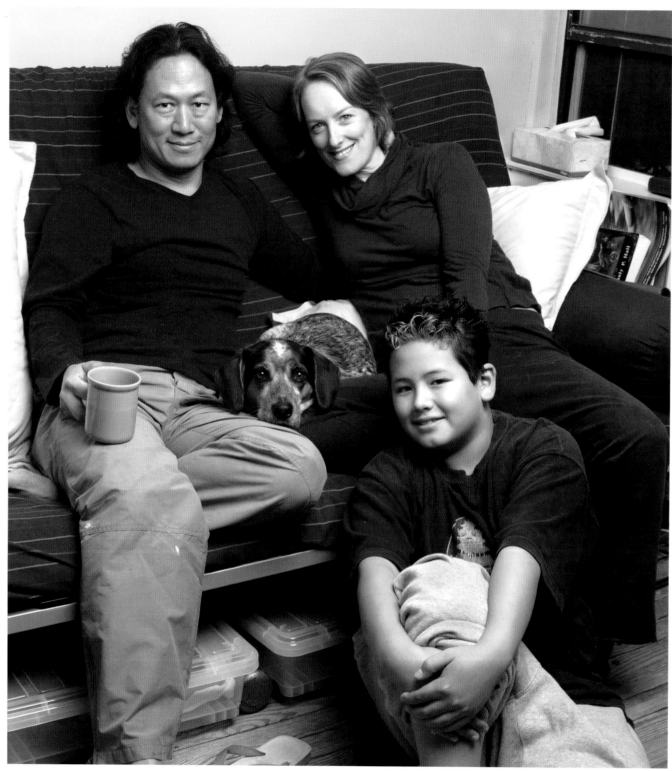

Anne and her boyfriend, Sam, with his son, Kaih, and their Australian blue heeler mix, Kelly.

Dear Kelly,

I remember the first day we met you. We were on our way to an animal shelter in Brooklyn that spring day not sure of exactly what we were looking for. Anyway, we pulled up and there you were, being walked by a volunteer. We had eye to eye, do you remember that moment? And we thought, "what a weird looking dog, perfect for us", and you said... well we don't really know what you said, but something did happen at that moment.
We didn't know you were from the shelter, but once inside we couldn't believe our eyes when there you were in front of us. We locked eyes for a second or two and we both knew that we were going to be together! You had been there twenty-nine days and your month was almost up and those of us that love animals know what that mean. And now that we think about it, you had really picked us, right there on the side walk outside the shelter. And now six years later you're still one of our closest friends. That's all.

We love you,
Anne, Sam and Kaih

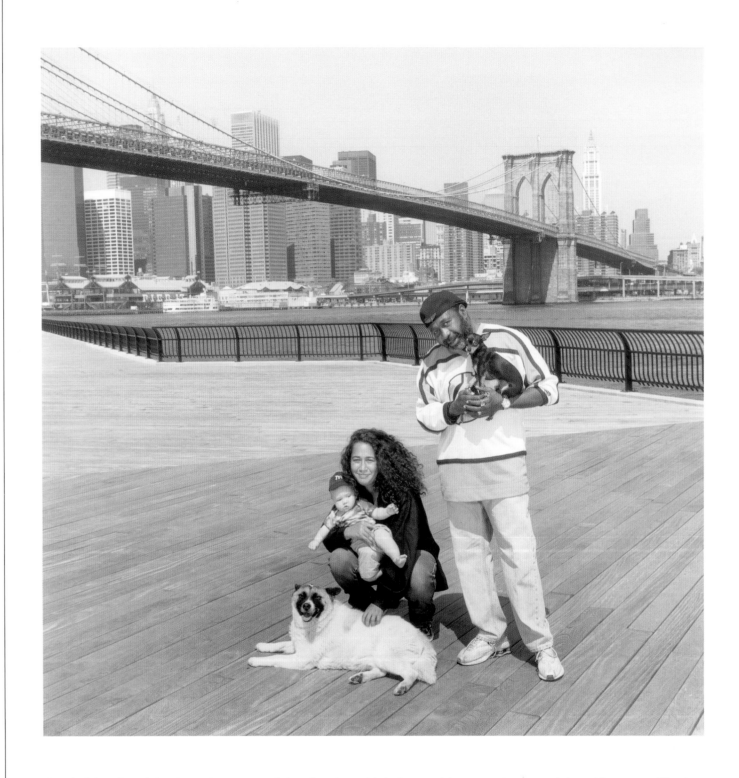

Ben holding his chihuahua, Auggie; with his daughter, Malaika, and her son, Ajan, and their Akita mix, Charlie, in front of the Brooklyn Bridge.

Dearest Charlie,

Thank you for coming into my life!!! Did I find you or you find me at the shelter in Burbank? You have been my traveling partner, my and Ajan's protector, our friend and companion, my exercise buddy, a friendly face when the world did not seem so friendly, my secret sharer. On the times we are apart it seems so strange to look around and realize that you are not with me, I am just so used to having you by my side, under my feet, at the door to my office, at the foot of the bed. I am so glad that Ajan will get the chance to grow with up with you around. It is so amazing, the way he looks for you in the mornings and how he always wants to be next to you. I will never forget the way you jumped on the bed when I brought him home, sniffed him, and looked at him as if summing up a new member of the pack and jumping off again. Only to return to his side when someone you did not know was around and stubbornly staying there until they left.

You have added so much love and joy to my life and I can only hope I have done the same for you.

We Love You Charles Om Vereen

With all our love,

Malaika and Ajan Vereen

Dear Augie,

My little Manager who manages my life with such joy! At times when I feel that I can't go on — you Jump into my lap reminding me that Life Is Good and I see it in the zeal in your eyes! You're a little dog with a Big heart. I've seen other dogs three times your size, but not with nearly the intelligence you have. You're patient, intelligent, your loving, and you're my friend. So Jump into this bag and Let's Get on to the Show!!!

Your Client,

Ben

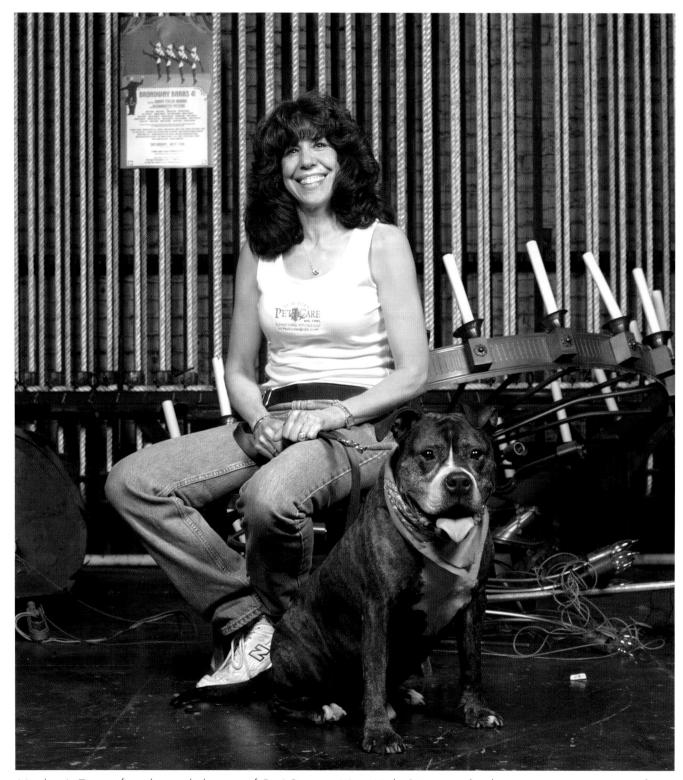

Marilyn J. Terres, founder and director of Pet-I-Care, a New York City animal adoption program; at Broadway Barks, with Bubba, one of the abandoned dogs under her care.

N.Y. Pet-I-Care Adoption Program, Inc.

Tel: (212) 614-7194
NYPetiCare@aol.com

Marilyn J. Teres, Founder & Director

N.Y. Pet-I-Care, Inc. is a charitable organization pursuant to section 501 (c) (3) of the Internal Revenue Service Code.
All donations are tax deductible as permitted by law.

Dear Bubba,

As I write this letter I find concentrating a bit difficult, as my mind wanders aimlessly and drifts to a time that only you can divulge its darkest images and secrets. Bubba, how did you ever come to me, to Pet-I-Care? Why were you one of the lucky ones? What hardships did you experience along the way? What cruelties did you witness and have to endure? How deep was the fear and loneliness you felt being unloved and abandoned? Like so many of the stray and abandoned animals that are rescued by the numerous individuals and groups who care, we can only guess at what their stories would tell. Maybe we really shouldn't know and perhaps these images and secrets are best kept with them. Our reward is that loving look on their face and in the sparkle that returns to their eyes and that face-washing lick of their tongue, which is their way of telling us, we have made a difference.

Not every stray was as lucky as you Bubba. How unfortunate that your previous "loving" owner was moving and found you to be an inconvenience. Like the biblical "Pontius Pilot" he took you to the nearest animal hospital "to cleanse his hands of the problem and guilt" by having you conveniently "put to death". How fortunate that you were taken to an animal hospital that had on its staff a compassionate doctor named Avra Frucht. Dr. Frucht took one look at your adorable face and just couldn't end your life for "convenience" and became your new guardian angel. During the two years before you came to N.Y. Pet-I-Care, she paid out of her own pocket to find you a boarding facility where you could safely and securely stay, the best situation available to her at the time. Avra now works with us and she told me all about you. So here you are, a 6-yr-old bundle of deliciousness, somehow with no scars from your past, full of love to give, and up for adoption, to a real home this time, a home that will never leave you behind again… this I promise you.

You know Bubba, I can never really fathom what anxieties you and all the homeless pets must have gone through, with the sudden disruption and changes in the only life you ever knew. To go from a secure environment and then be tossed out, left behind, disregarded, unloved, has got to hurt. I wonder if you ponder sometimes why you were given up? Why did they suddenly not love me any more? What did I do wrong? Why am I so hungry and afraid? Why am I behind these bars, caged, and often abused? Am I the next one to die because nobody finds me cute anymore, or because this kill shelter needs my space?

So Bubba, I have to ask you again, why are you one of the lucky ones? I now accept that I will never know the answer, but I also know in my heart that I am really the lucky one…I have you now Bubba, you're a member of our Pet-I-Care family.

Love,
Marilyn

227

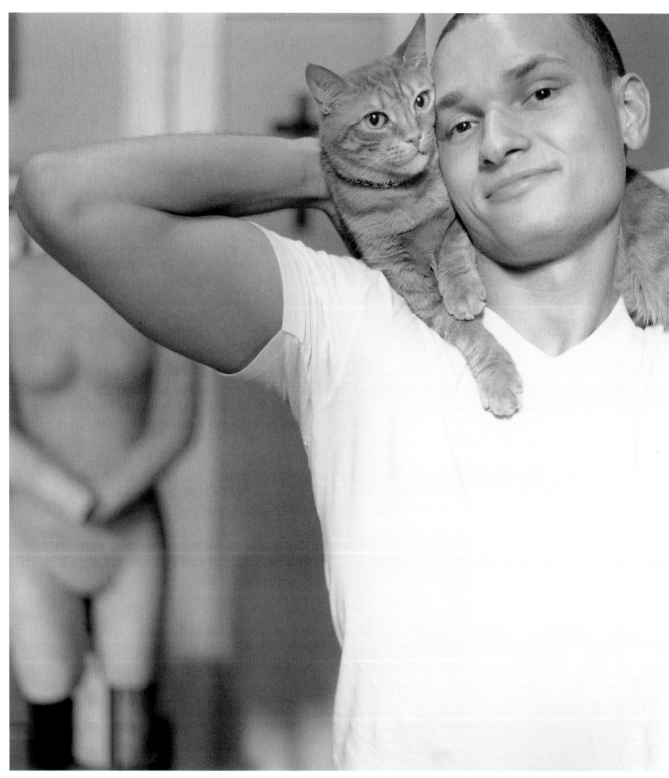

Vangeli and his tabby, Bella.

Bella, My Bella...

The pussy I love, cute and fluffy and so full of love. You can be somewhat bitchy when you need to be fed, but all in all I'm glad we share a bed. If you weren't around my life would be empty my night's would be peaceful, but still you are the sweetest evil. The scratches the bruises are worth all the pain cause I've come to realize that you are insane. And this is way we're together to share each other forever and ever...

Purr,

[signature]

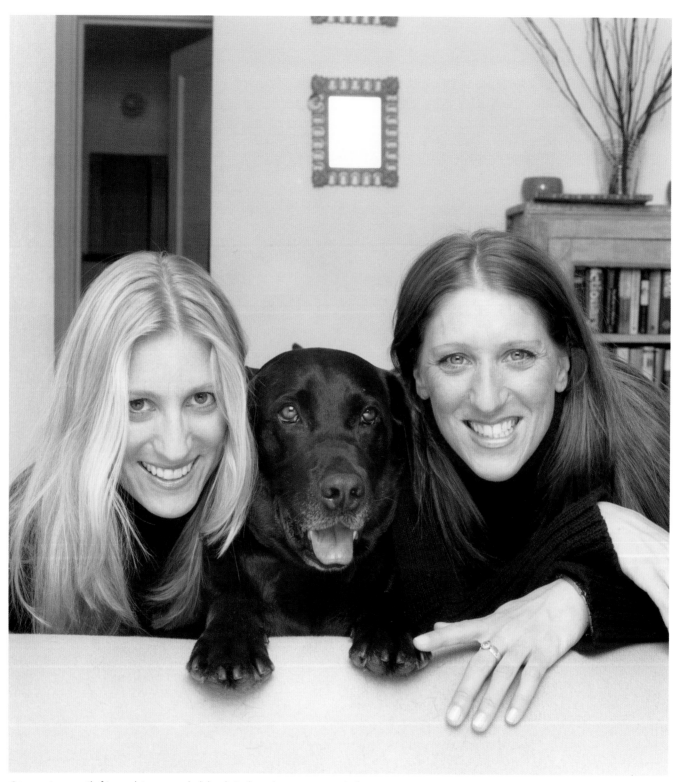

Sisters Jaime (left) and Jenn with black Labrador retriever, Jake.

When you were a puppy I remember...
 sneaking you into bed with me...
 scolding you for chewing on the side of the house...
 watching you clumsily trip over your paws...
 stopping during our walks just so I could hug and kiss you...
 watching you bury your food from Nick, so he wouldn't eat it...

As an adult...
 You are the most loyal and loving dog I know.
 When I am sad you comfort me...
 When I am happy you share in my joy...
 You follow me around as if it was the last day we would ever be together...
 I feel there isn't enough I can do to make you as happy as you make me, but for some odd reason you are...

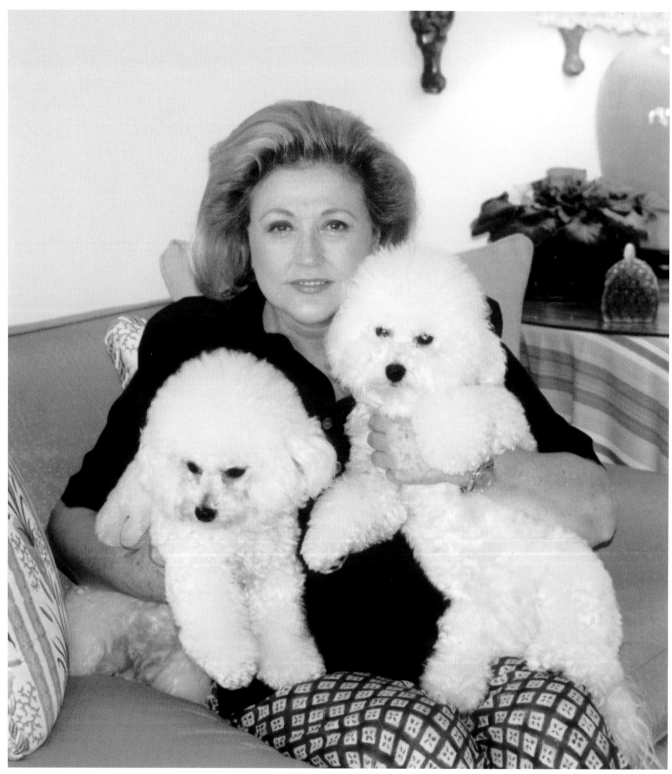

Barbara with her two bichon frises, Beaji and Chammi.

Dearest Beaji and Chammi:

Ever since we've had you Bob and I have come to understand what distinct and different personalities dogs have. Well, certainly you two do.

Beaji, you're older than Chammi by three months, and you came to us first. And doesn't everyone know it! You're the boss, no question about it. Whilst you are intelligent, placid, stoical and calm, you're also extremely jealous. We've seen you nudge Chammi out of the way; we've noticed how she'll drop a toy or a bone she is playing with and walk away, once you've taken a fancy to it. She knows how to handle that kind of situation. And being a clever little dog she'll use those moments to snuggle up and visit with us.

Chammi, you came to us four months after Beaji, and the day we bought you, Mimi Winkler, who bred you both, told us that you were very different from Beaji. And you are. You're as smart as she is, but your nervous energy is amazing. You're excitable, effervescent, and the friskiest thing on four legs I've ever seen ... dancing, running and jumping from bed to sofa to chair. The acrobat in the family! We've noticed how Beaji watches your antics with a kind of tolerant amusement, a wise look in her big brown eyes.

You are both proud little dogs, not only amusing but endearing, affectionate and full of that Bichon Frise charm that's hard to duplicate! No wonder we love you both so much. Just as you love each other and us. You bring joy and life to our home.

Love, Barbara

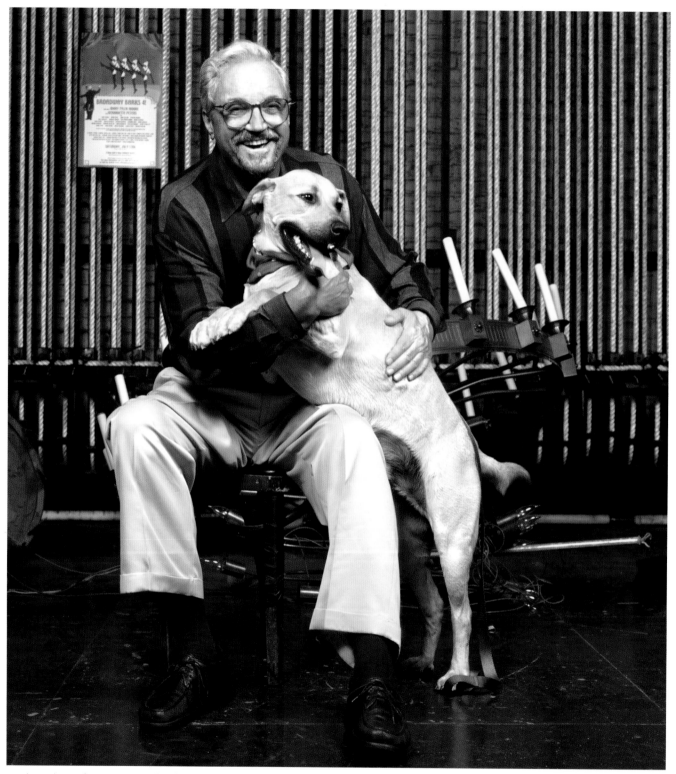

Hal Linden of *Barney Miller* fame, with a rescued dog up for adoption at Broadway Barks IV.

The Brooklyn Animal Resource Coalition, known as the BARC Shelter, is a private, no-kill, registered 501 (c) (3) not-for-profit organization that has been dedicated to caring for homeless and unwanted cats and dogs until they can be adopted since 1987.

The BARC Shelter is located in Williamsburg, Brooklyn, accessible by the L train to the first stop in Brooklyn, "Bedford Ave." at North 7th Street. We are open Monday-Saturday 11AM-8PM and Sunday 12-5PM. People interested in adopting should visit the shelter at least 1 hour before closing time.

The BARC Shelter is proud to be a lead member of the new Mayor's Alliance for NYC Animals, which is comprised of NYC shelters and rescue groups dedicated to getting our homeless animals adopted and eventually making this a no-kill city.

To learn more about the BARC Shelter, view some of our animals or to make a donation please visit our website at *www.barcshelter.org*.

BARC Shelter
253 Wythe Ave. (at North 1 st Street)
Brooklyn, NY 11211
718/486-7489
TonyBARC@aol.com

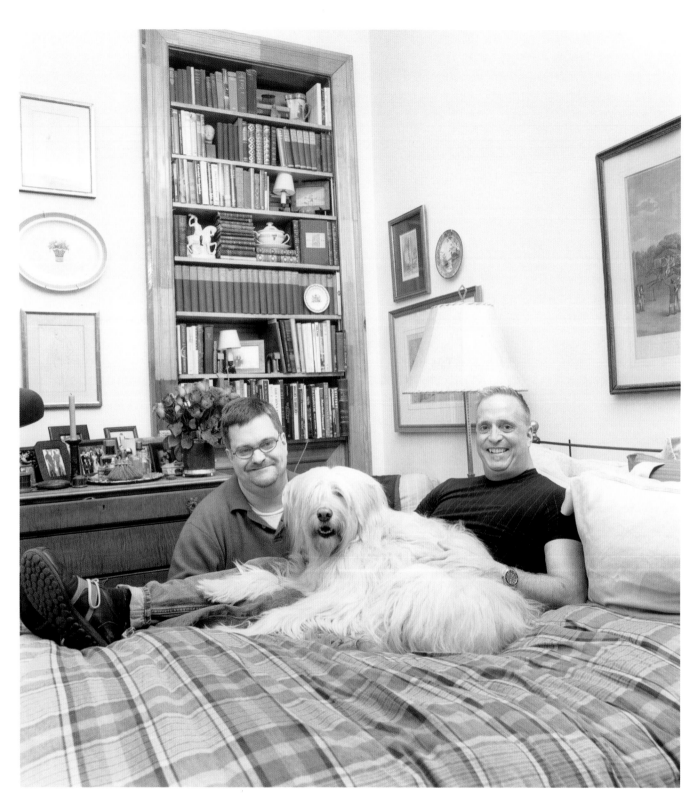

Dick (on bed) and Robert with Lady, a Briard, in their home in Manhattan's Chelsea section.

Dear Lady,

You're the best. (Every pet parent thinks this, but in your case it's true.) You are the most comforting, intuitive, trusting, and loving dog we've ever known. Not to mention that we get told every day by total strangers that you are the "happiest" dog they have ever seen.

Adopted from an animal shelter by our friend Arthur, you were so appreciative that you sat in his lap and licked his face the whole drive home. From the start you included us as part of your new family. When Arthur became too sick to care for you, we adopted each other.

You constantly delight us with your personality. You learned to whine, whimper, yelp, and sigh to let us know what you want. Talented __toutou__ that you are, you respond bilingually. One look from you can stop an inane argument in mid-sentence. One lick from that tongue or thump of your tail can instantly change a mood. People's faces light up when they see you coming toward them on the street. And despite what other folks might think, you don't miss a trick through that fluffy, blonde, Veronica Lake 'do.

You make us a family. Thank you.

Love,
Dick and Robert

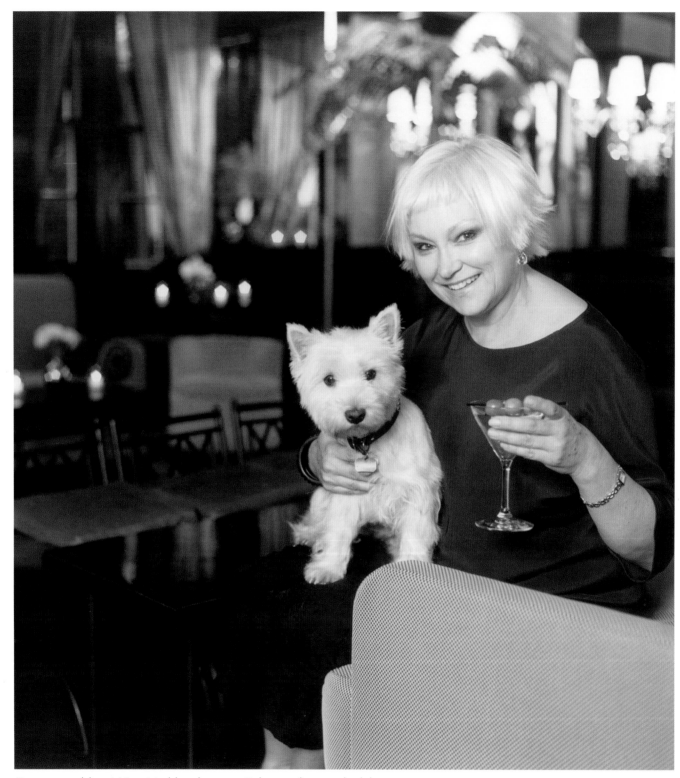

Serena and her West Highland terrier, Ruby, in their nightclub.

serena bass

To Ruby, we love each other with a great passion.

I first knew you would exist when I met your great Aunt Hilary, a fine figure of a West Highland White, terrier. She was so friendly and exuberant, I knew I wanted a dog that was related to her, so, I called Hilary's human parents and put in an order for the next womanly pup to come along.
Waiting, waiting, waiting….you were born and immediately deemed adorable.
(Scottish accent) "Och, wee'r oo'ver tha mune (moon) aboot this puppi, it's goon (going) ta be harrd ta giv har upp."

I went to England to get you, booked a flight to Scotland, booked a bed and breakfast and bought an extravagant collar and leash. BUT, because I hadn't listened properly, (stupid $$$ pouring down the drain) you weren't yet old enough to come with me and I had to go *back* to America and wait some more.

Eventually, the big "Little Westie Day" came. You were flying fast in my direction and I drove to La Guardia to pick you up. I knew you had been traveling for a long time - maybe fifteen hours - and I thought you might be frightened or shy. I opened your traveling cage and out you jumped, a delighted puppy with brown eyes and madly wagging tail. You were wearing a big, grey Scottish sock with red trim that your human parents had fashioned into a coat to keep you warm. From the very start, you were chic and unique.

I love virtually every thing you do. You sleep *very* nicely, all quiet and peaceful and I'm sure you relish your dreams as you feet run through the dream grass and your nose twitches at delicious, dreamy scents. You sleep on the pillow next to me, so I have watched you dive blindly into imaginary rabbit holes and climb trees after squirrels. (You wish.)

As noted, you are a first class traveler. No small talk, no demands about stopping for coffee, just the excellent habit of flopping onto your leopard rug on the front seat of my car and thinking quietly until I point out a passing cow for you to look at, or we share a meaty sandwich.

Walks with you in the country are how I imagine our mutual heavens must be. We set off in all weathers and no matter how fast I walk, I'm always behind you as you dash off in search of wild life, ponds or, your favorite unfortunately, other animal's poop. (My platinum blond angel is secretly…A DOG!) You're an exercise in investigation and being a good Scottish girl, nothing escapes your eagle eye and steely resolve.
Once, when you were about a year old, we were walking around a lake and came upon a big black lab retrieving sticks thrown into the water by his owner. Imagine my amazement when, after watching excitedly for a few minutes, you waded in, swam out and tried to fetch a huge stick yourself. The Labrador nearly drowned you as he dragged it out of your mouth but you didn't care and just swam back to the shore where you demanded more sticks thrown – "but a *little* smaller, please."

I feel surprisingly bereft when you go off to the hair and manicure salon. I glance at your empty basket ten times and call to see how you're doing, until the mutual joy of homecoming and your dazzling white furryness, wipes out the separation anxiety. Do you mind when I go?

Did I mention how embarrassing you are when you growl at children? Shall I report you for lunging ferociously at any big dog, that could **A.** kill you with one bite, or **B.** lick you to death, because they are *so friendly,* and the owners think your horrible behavior is *all my fault*??? Did I say that you bury bones under my pillow, fill my bed with grit from your paws and live to rid the world of cats? I didn't think so darling.

love, Mummy

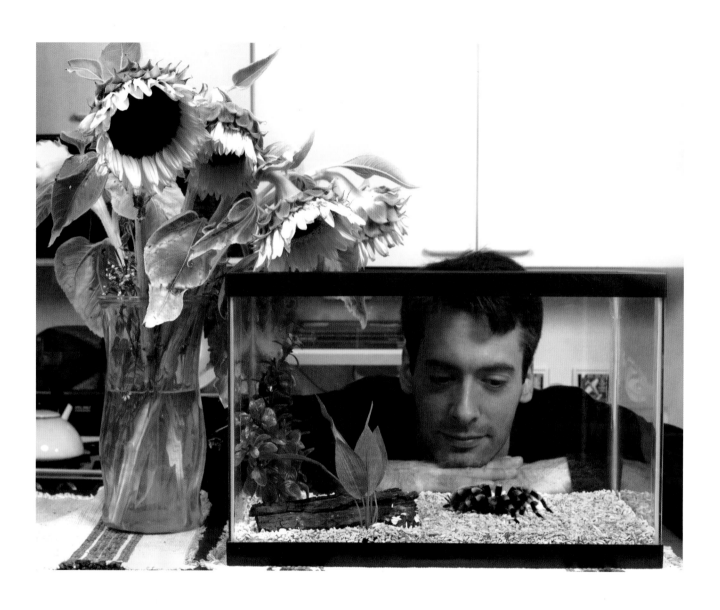

Shawn and his Mexican red-knee tarantula, Lucy (inset photo—with girlfriend, Michelle).

Dear Lucy,

I know you hear them, but please don't listen to what they're saying. Don't think for one second that they're right, and don't you believe that they really dislike you, because they don't even know you. If they did I bet they'd agree with something I've known the four years we've been together: <u>TARANTULAS MAKE GREAT PETS.</u>

Before you pass judgement on humans you have to understand that we have a long-entrenched (albeit unfounded) fear of spiders. Although we aren't born with this fear it is instilled in us from a very early age and it seems the older we get the deeper the fear becomes. In fact, I've seen plenty of grown men and women recoil in disgust at the mere sight of a house spider—an animal less than 1/100,000 times their size!

So, to clear your good name, I'm doing my best to inform our visitors the truth about you. And the truth is that you're no more dangerous than a pet rock and, contrary to popular belief, your bite is no worse than a bee's sting. And I always make sure to point out your brilliant orange and yellow striping on your legs. I even tell them how much easier it is to squeeze your 5½ gallon tank into my closet-sized Manhattan apartment than it would be a dog or cat (and you know I've tried the latter). But no matter how I try, I can't seem to convince anyone that you're just a cute, furry teddybear...with eight legs.

Maybe that's it. Maybe it's the eight leg thing that gets them. It is kind of weird, I guess. I mean, eight is a long way from the four of dogs and cats, and four times as many as we humans have. Or maybe it's the eight eyes that freak everybody out. Or the 1/4" fangs that you use to inject venom into those hapless crickets you call 'lunch'. Or maybe it's the venom in those fangs, which paralyze and then dissolve the poor, defenseless crickets before they've even had a chance to chirp their last 'goodbyes' to their families.

Could it be that everyone isn't so wrong for being grossed out by you? Could I have been deluding myself all this time, thinking I'd found myself the perfect Manhattan pet when in reality I'm harboring a creepy, hairy, carnivorous <u>MONSTER</u>??!!!

Cool.

Yours truly,
Shawn

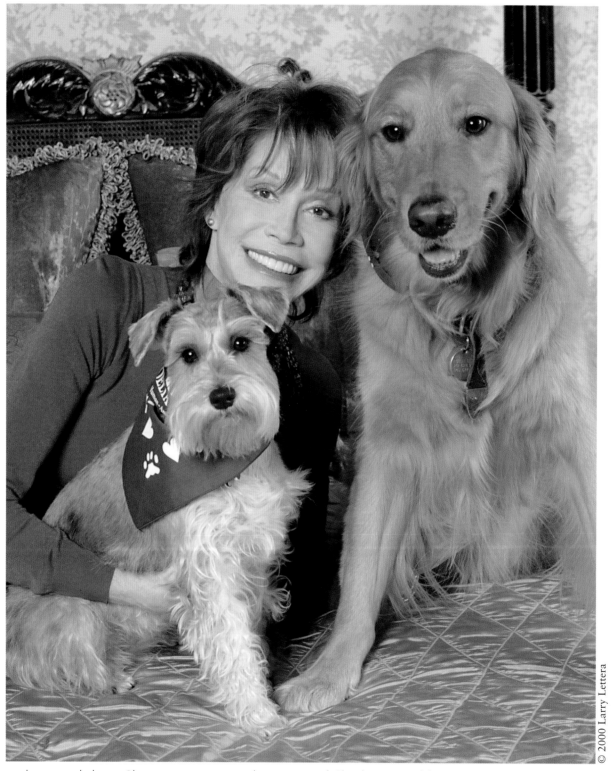

Mary with rescued dogs; Shana, a miniature schnauzer, and Shadow, a golden retriever.

My Shadow and Shana,

You're the Lion and the Lamb, George and Gracie, Laurel and Hardy. You make me smile, you nurse my wounds, and remind me that "Love _Is_ All Around."

Your Mam

Kenneth and golden retriever Seeing Eye Dog ®, Garrick, on Madison Avenue in NYC.

Garrick,

You have heard me say "you are worth all the money in the world" and "no price is too high for my Garrick." But, can you please explain these 2 checks? I realize your name is on my checks and I always say it is not just me but **'we'**. But seriously, $863.70 for meat at Dean & Deluca! What could you have possibly bought at PetCo for $1,415.33? I received a call from Cartier's asking me if the spelling on the 4-carat diamond and emerald collar was **Phoebe or Feebee** - the engraving to read "To Phoebe - a lil' bauble to you. Love, Garrick". You **CHARGED** this to my American Express account! I do realize you are my Seeing Eye Dog. Along with that comes the special privileges of being allowed to go everywhere; to the opera, always flying first-class (thanks to your cutesy act at the airport), eating at the best restaurants in New York City, attending auctions at Sotheby's and travelling extensively. You can't just go gallivanting all over NYC and spending all my money. You are my partner and my best friend and I will do anything for you, but this is out of control!!! Shame on you-- **Phooey**. And you didn't buy me anything. Try showing a little restraint next time which doesn't mean getting into your harness.
I love you. Daddy

KENNETH L. JOHNSON & GARRICK
NEW YORK, NY 10021

169

1-8/210 95

DATE 7/4/02

PAY TO THE ORDER OF _Dean + Deluca_ $863.70

eight six fwee. seven 0 DOLLARS

citibank®

CITIBANK, N.A. BR. #95
757 MADISON AVENUE AT 65TH STREET
NEW YORK, NY 10021

MEMO _meat_ Garrick MP

KENNETH L. JOHNSON & GARRICK
NEW YORK, NY 10021

170

1-8/210 95

DATE 7/20/02

PAY TO THE ORDER OF _Petco_ $1415.33

one four one five fwee fwee DOLLARS

citibank®

CITIBANK, N.A. BR. #95
757 MADISON AVENUE AT 65TH STREET
NEW YORK, NY 10021

MEMO _toyz_ Garrick MP

Deana with her St. Bernard, Mycroft.

Dear Mycroft:

This is a great challenge... how to make a short, perfect string of words capture your spirit and the pure joy I feel watching you 'let loose'... how to do it justice? I don't want to be mawkish or maudlin because that isn't the feeling... nothing tame or civilized about it. It's a reverence for your wild heart... that's what I love... and although I admit I could do without the lunging-after the bike wheels of large, humorless teenagers... or the lunging-at pitbulls with nasty, inward-turning spikey collars... or the bruising to both my dignity and my backside when I'm caught off-guard by your endearing displays of reckless enthusiasm... Still, I wouldn't trade a victory canter around Westminster with a perfectly behaved fluff-ball for one pulse raising, deer chasing race through the woods adventure with your impossibly stubborn, wild-spirited self.

Deana

247

Howard holds his bullmastiff, Nikko. The rest of the office staff are (L to R): Arthur, Derek, Florentino, Sal, Wayne, and Paul.

Dear Nikko,

I remember the first time I saw you, April 26, 1998. You were just 2 months old and when I walked into Kenny and Josh's house on Golden Beach you came running to greet me with your sister Schnell Bopp and your aunt Bessie Jane. I thought Bessie was the biggest, scariest dog I had ever seen, but when I watched the three of you together romping on the lawn by the beach, you looked like a pride of tigers. I fell in love.

Who could have imagined that just a month later you would be mine? I think sometimes Ken and Josh still regret letting me take you when they came back to New York. I remember that Memorial Day weekend in the Pines when I went to pick you up. You were 45 pounds and all big paws. You sniffed around the house and then curled up in my arms on the floor----that's still my favorite picture. I know you still remember the rest of your family, because all I have to do is mention Schnell's name and you're ready to pull me to their house, whether it's at the beach or in the city. But you and I bonded that first weekend and my life has been different ever since.

You were my first dog (we know what my Dad used to think of dogs before you changed his mind) and I wanted to do everything right. And I was so lucky, because you turned out to be the very best dog in the world. Every day on the street people stop to ask what kind of dog you are and to tell me how handsome you are. You introduced me to a whole world of dog people that I had never seen in all my years in New York. It made the city seem more like a small town than ever. And you have always been so very good with other dogs, no matter how mean they get with you. I am always so proud when some little rat of a dog starts yelping and goes into a furor as you go by, but you just keep your head up and prance along and wonder what the hell that dog's problem is. You disarm everyone so easily. Even my parents, who were never dog people, call you their granddog and send you birthday cards and presents!

Bringing you to the office was about the best idea I ever had. Everyone loves you (although some were pretty scared at first) and they love to play with you. Taking care of so many sick people, especially those with HIV infection, can be a pretty grim thing, but you've made the waiting room a place of laughter and conversation as everyone vies to play with you. You are definitely the lord of the manner here.

You've brought me companionship and unconditional love (as long as I have treats in my pocket) in a way I've never known and it's brought great joy into my life. Whether after 9/11 when we walked the Westside Highway together and saw the smoke rising and the wreckage near Ground Zero or during lightning storms when I've cuddled you in my arms rather than have you hide in the bathtub, we take care of each other. Thank you for that.

I had a terrible dream the other day when I was sick----I dreamed you jumped out of the window and I couldn't get to where you were laying, dead or badly hurt. It was one of the most horrible dreams I ever had, thinking that I'd never have you with me again. When I woke up and you were sitting there calmly watching me, I experienced my love and gratitude for you all over again and realized just how vital you are in my life.

With all my love and all my thanks my Nikkie Boy,

Love,

Howard

249

Cory and Alicia with their daughters, Chloe (foreground) and Annabelle, in front of their home with their golden retriever, Allie.

Dear Allie:

10 of our favorite things about you:

1. Your distinctive snore and morning stretch

2. Your patience and love for the children

3. The way you catch frisbees and balls (but never understand "return")

4. You rarely let anything from the dinner table hit the floor

5. Your tough bark guards our home, yet you always want to meet new friends

6. There always seems to be a smile on your face, and you never have a bad day

7. How you have taught the kids to "share" their toys with you

8. Your never tiring yet never successful pursuit of squirrels

9. The way you greet us when we come home

10. Where ever we are going is where you want to be, and we are always happy to be with <u>our</u> <u>best</u> <u>friend</u>

Love,
Alicia, Corey, Chloe, and Anabelle

251

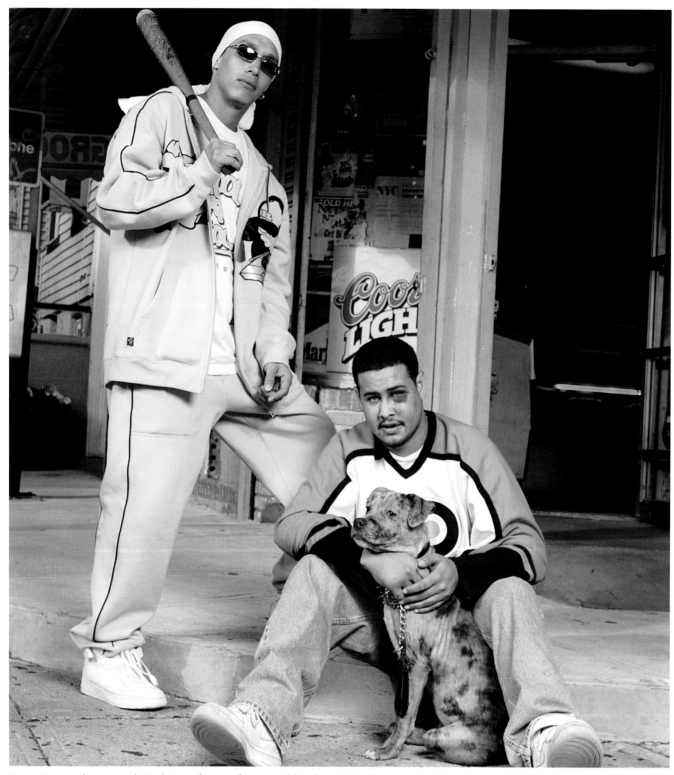

"Hoe" (standing) and "Little" in front of a neighborhood bodega with Taz, the pit bull they rescued from an abusive owner.

To my new found friend TAZ.

Ever since that crazy night I had to Hurt someone because they were hurting you, I have tried to take care of you in the best way's possible. Unlike other pitbull owners, I will not put you to fight, but I will teach you to defend yourself & your family. You will know respect, honor & most of all to me, trust & obedience. You will grow and mature & as you do, our family will be by yourside to the end. Remember. I will always be there for you in the time of need and I know you will be there for us. TAZ, get ready for a life full of love, trust, & family & most of all a life full of fun.

Love Always

J.M. Iglesias jr.
& Little

BROOKLYN'S FINEST!!!

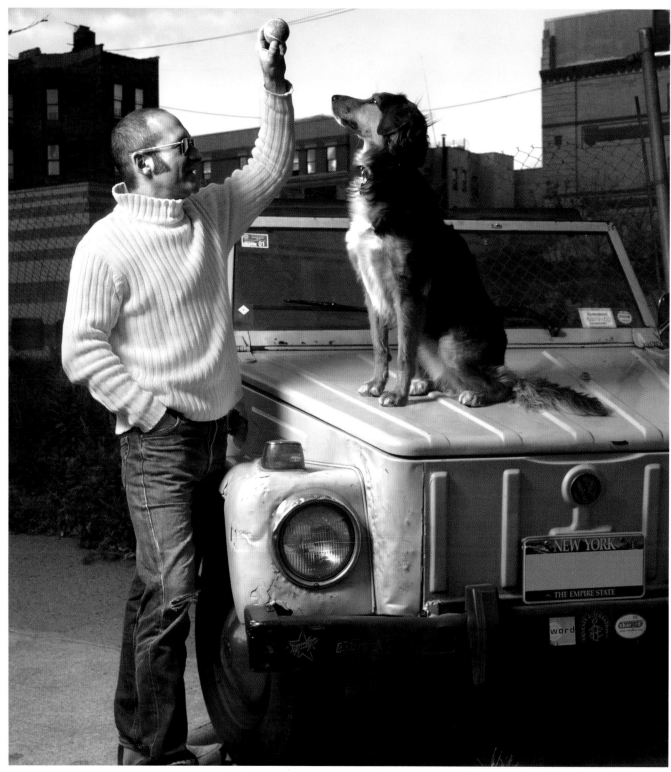

Stephen and his border collie/German shepherd mix, Lily, in their Volkswagen Thing.

Dear Lily the love bucket,

You are the yummiest (is that a word?) gorgeous doggy pup in the world and you bring love and passion to the human race! When I travel you are the one that I worry about (at least one of the ones, but high on the list) You are the softest of soft, happiest of happy, love licking lucious wonder dog! Thank you for putting up with me and being my steadfast companion.

with love forever
Stephen

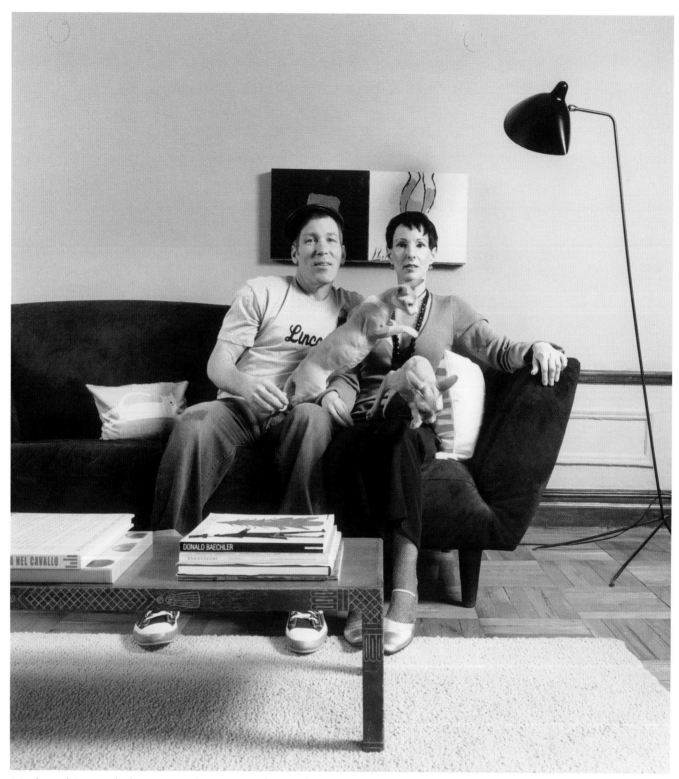

Mark and Lori with their two sphinx cats, Alva and Pee-wee, in the East Village, NYC.

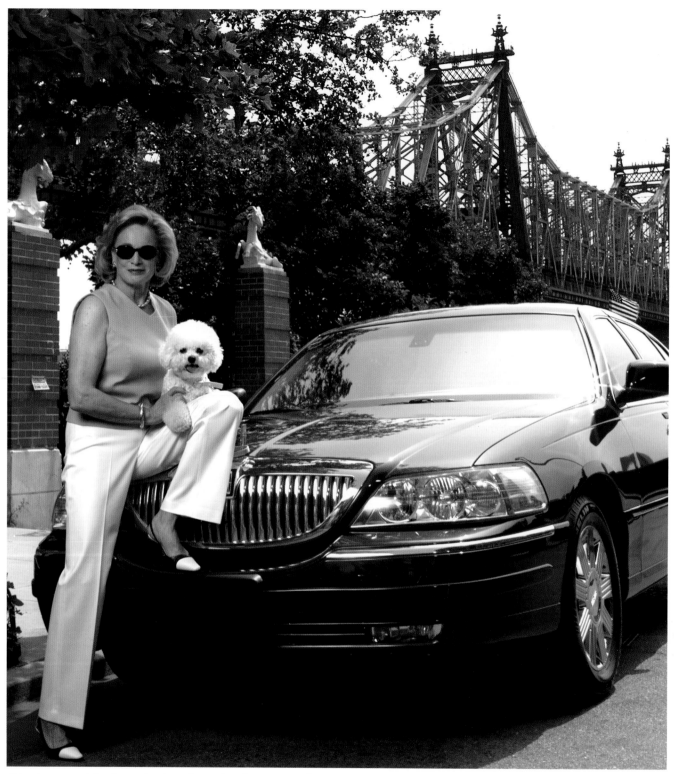

Charlotte and Sushi, a bichon frise, by the Queensboro Bridge in Manhattan.

July 24, 2002

To my sweet Sushi,

I can remember back to last summer, anticipating your arrival. It was such a long time since I had known the love of a dog. To be perfectly honest, I was a little nervous.

When I saw you, I knew you were the one! I took you home to Southampton and you were a little shy at first, but as we got to know each other, it was nothing but love, love, love!

Summer was over, and it was time to go back to New York. You shyly became accustomed to another new place.

It is always so much fun when you come home from being groomed - so excited - running and jumping around - showing off! Seeing your fluffy white tail wagging enthusiastically when I come home is the best unconditional love. I Love you, Sushi

Mom

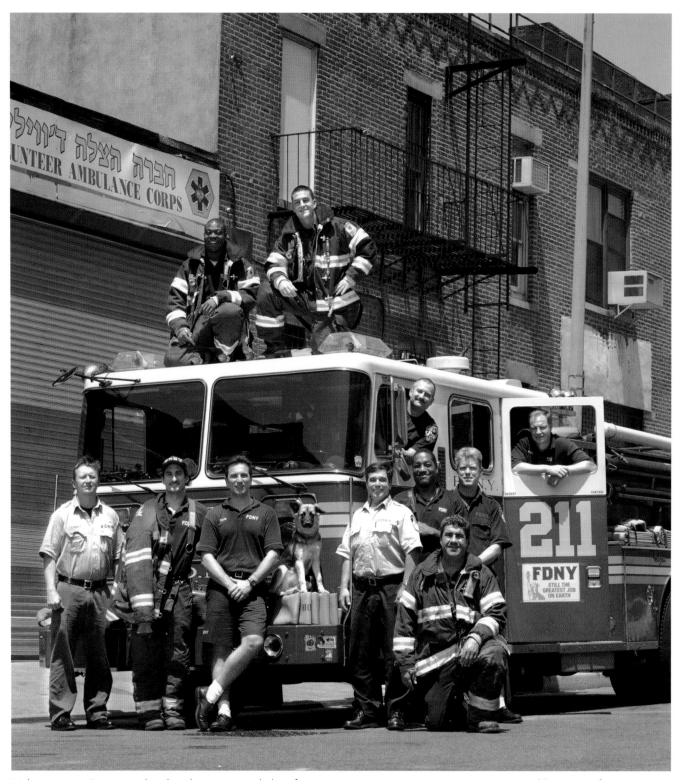

Valentine, a German shepherd puppy, with her firemen at Engine Company 211 in Brooklyn, NY; firemen (L to R) (on top) Jason, Billy; (standing) Lt. Murphy, Tim, Mike, Captain Lamberta and (kneeling) Patty; (clockwise around doors, starting with driver) Ralph, Anthony, Andy, and Dave.

Dear Valentine,

It was February 14; a routine night at the firehouse, no different than hundreds of nights before. When the alarm came in for a fire at the pallet yard we knew it would no longer be an average night. But, when we found you burnt, smoky, and covered with soot the night became special.

When you were brought back to the firehouse we weren't sure we could keep you. But, as everyone met you it became clear that you found a new home.

Since that day you bring a smile to everyone who meets you. You're the first one there to greet us as we come to work. You're a distraction on a tough day, and always a pleasure to be around.

Keep up the good work,

The Hooper Street Gang

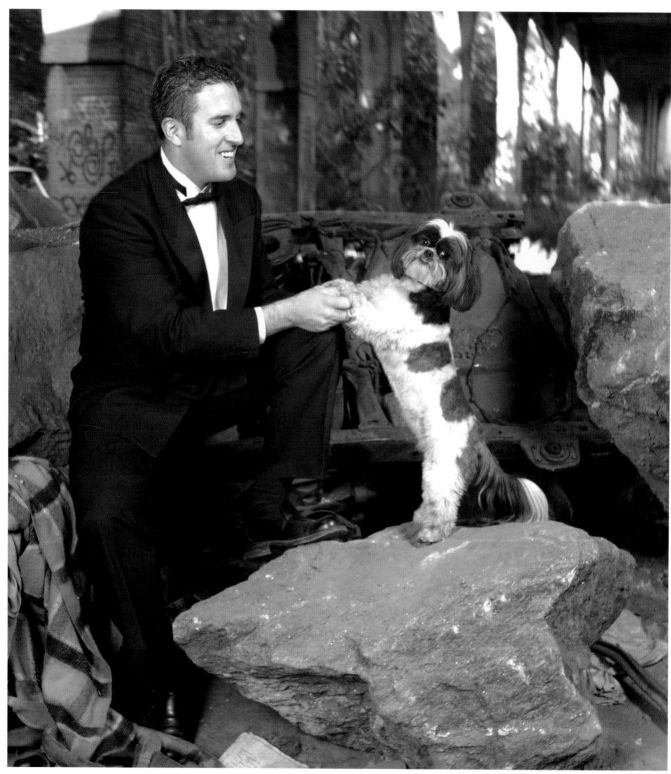

Michael and Lexi La Rue, a shih tzu, in Washington Heights, Manhattan.

Dear Lexi (a.k.a. "Beauty"):

I am grateful to have you in my life. I will not insult you, nor desecrate what we have together, by identifying as your owner. If I had to characterize us at all it would be more along the lines of kindred spirits.

Some days it can be rough out there in New York City. Those are the days when I can't wait to get home to see you. Those are the days I walk through the door, dump my briefcase/backpack/shopping bags/groceries, and whatever pain I may be lugging around, on the floor and lay flat out where you can get at me. You always jump all over and are so excited that you actually whimper and cry out. We roll around together whining and barking to each other (Yes, I try to speak your language). That is when you work your magic and touch that part of my soul that is best identified by a feeling of pure joy. All those "important" concerns and issues from my day out there in the World fall away and what is truly important emerges. It is all about Love and you remind me of that truth on a daily basis.

Thank you.

Your friend,

Michael J. La Rue

Michael J. La Rue

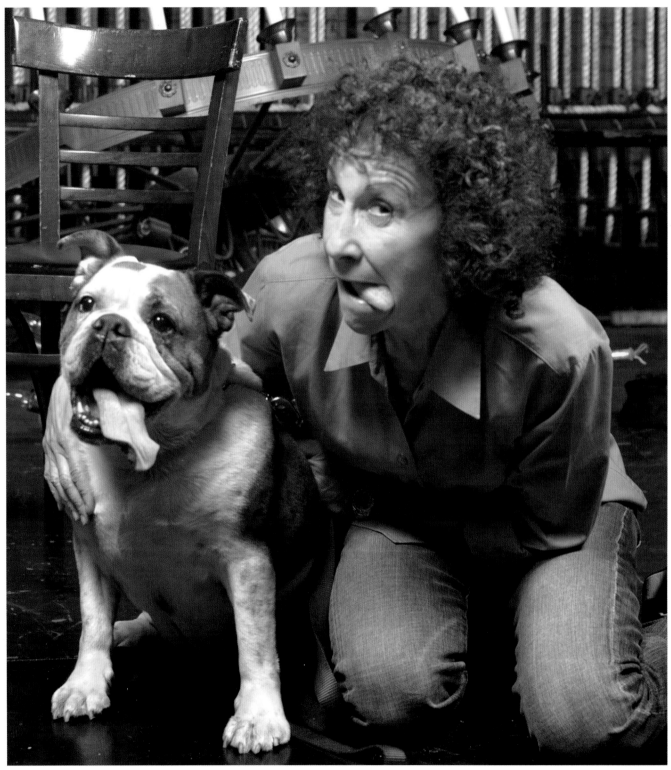

Rhea Perlman, of *Cheers* fame, bonding with Maxie backstage at Broadway Barks.

265

INDEX TO ANIMALS